DIGITAL ART
REVOLUTION

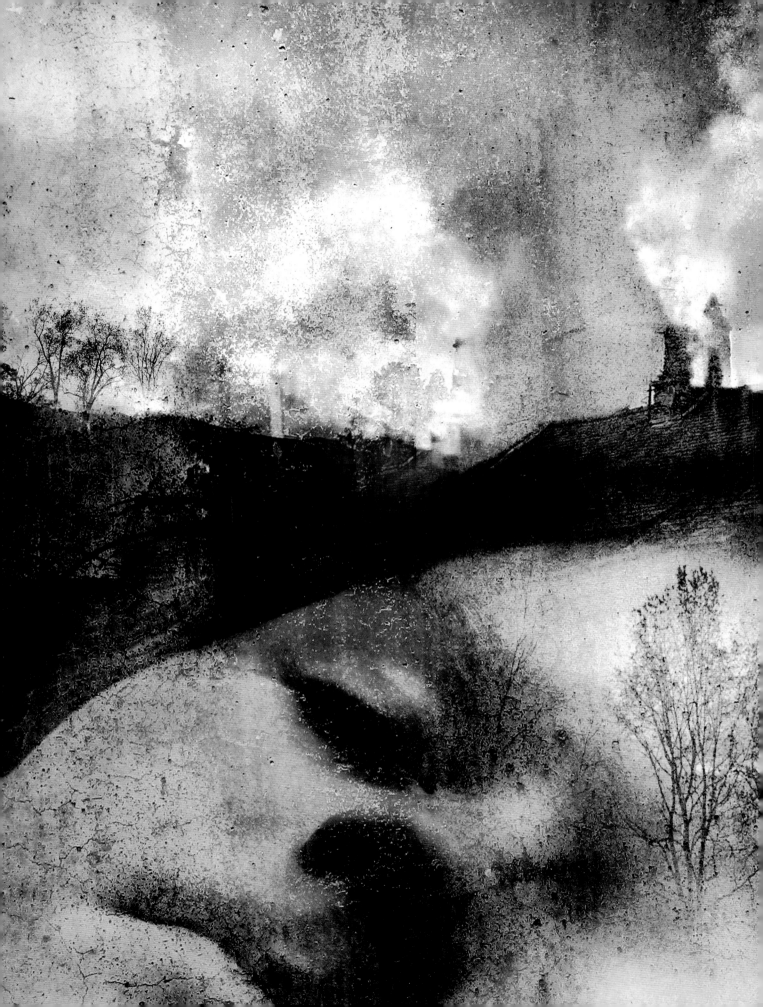

SCOTT LIGON

DIGITAL ART REVOLUTION

CREATING FINE ART WITH
PHOTOSHOP

WATSON-GUPTILL PUBLICATIONS / NEW YORK

Copyright © 2010 by Scott Ligon

Published in the United States by Watson-Guptill an imprint of the Crown
Publishing Group, a division of Random House, Inc., New York.
www.crownpublishing.com
www.watsonguptill.com

WATSON-GUPTILL is a registered trademark and the WG and Horse
designs are trademarks of Random House, Inc.

Ligon, Scott.
 Digital art revolution : the essential guide to creating fine art with
Photoshop / Scott Ligon.
 p. cm.
Includes bibliographical references and index.
 ISBN 978-0-8230-9536-0 (alk. paper)
1. Digital art--Technique. 2. Adobe Photoshop. I. Title.

N7433.8.L54 2010
 776—dc22

 2009022670

Design by Dominika Dmytrowski

Printed in China

10 9 8 7 6 5 4 3 2 1

First Edition

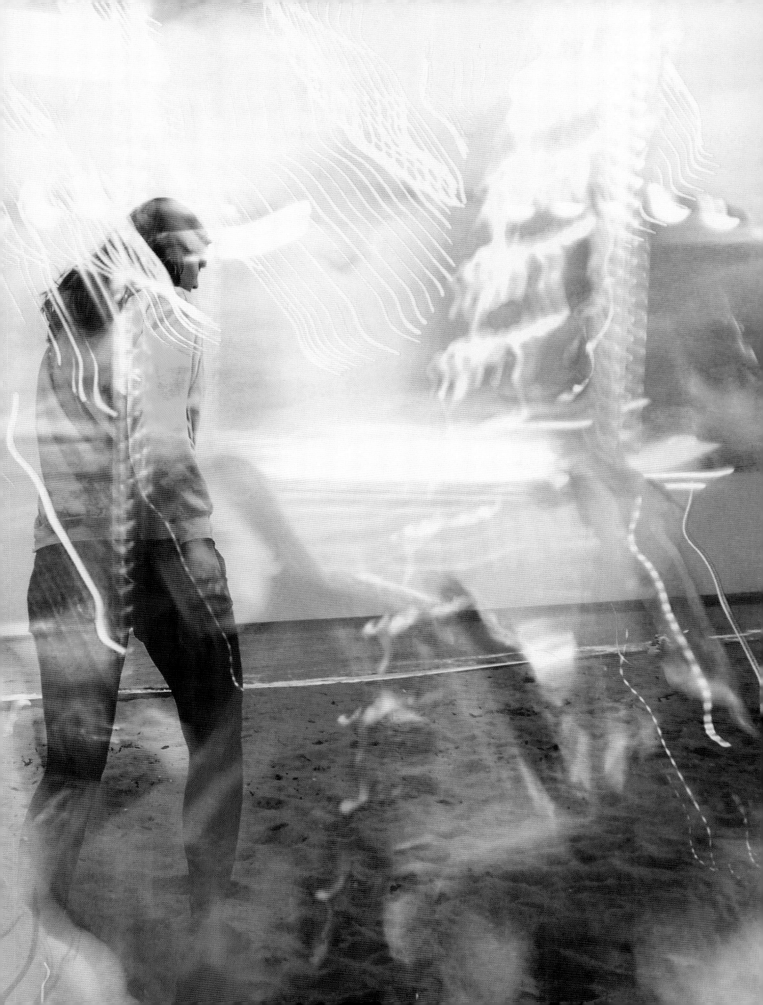

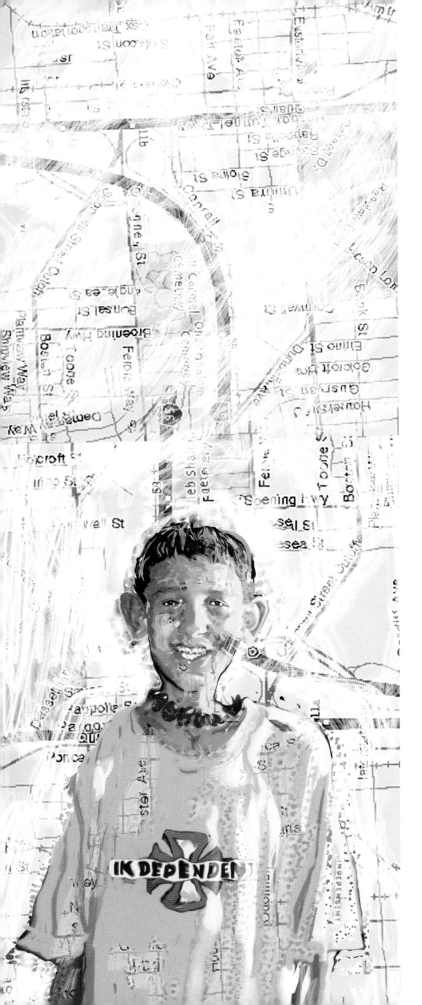

Contents

ACKNOWLEDGMENTS 8

FOREWORD BY MICHAEL W. DEAN 10

WELCOME TO THE REVOLUTION

Reason One: Everything Is Connected 14

Reason Two: Endless Experimenting 16

Reason Three: Process, Not Product 17

Reason Four: Eliminate the Middleman 18

Reason Five: No Limitations 18

Myths and Misconceptions 19

Is Painting Dead? 20

About This Book 21

CHAPTER ONE: UNDERSTANDING THE VISUAL LANGUAGE

Composition 25

Line 26

Shape 27

Value 29

Color 31

Space 32

Texture and Pattern 34

The Sum Is Greater Than Its Parts 35

CHAPTER TWO: MEET PHOTOSHOP

Why Photoshop? 38

A Pixel-based Program 39

Resolution 40

Opening a Document 40

Orienting the Image 41

Saving Your Work: The .psd Format 41

Color Modes 44

The Photoshop Layout 45

Adobe Bridge 51

Drawing Tablet and Pen 51

Wanna Make Something of It? 51

CHAPTER THREE: PHOTO BASICS

Exercise 1: Improving the Composition 55

Enhancing Value and Color 56

Exercise 2: Improving a Photo
with Basic Image Adjustments 58

Exercise 3: Converting a Color Photo into a
 Black-and-White Photo 63

Selection Masking 65

Exercise 4: Working with Selection Masks 66

The Magic Wand and Quick Selection Tools 75

Exercise 5: Creating a Selection Mask in the Quick Mask Mode 76

Photo Retouching 77

Project: Enhancing a Photographic Portrait 83

**CHAPTER FOUR: COMPOSITING:
THE ILLUSION OF REALITY**

Exercise 1: Creating a Composite Image 87

Putting Things into (Linear) Perspective 109

Exercise 2: Creating a Mural with Vanishing Point 110

Other Methods for Creating Perspective 112

Exercise 3: Using EDIT › TRANSFORM to Create Perspective 114

Project: Create a World 115

**CHAPTER FIVE: EXPRESSIVE NONREALISTIC
PHOTO ART**

Visual Themes 119

Exercise 1: Expressive Photo Art 121

Project: Manipulating Photographic Images
 for Expressive Purposes 135

Project: Fifteen Green Things 136

CHAPTER SIX: PAINTING WITH PIXELS

Brush Features in the Control Panel 142

Mixing Colors 146

More on the Drawing Tablet and Pen 149

Painting with Transparency 151

Exercise 1: The Traditional Renaissance Method
 of Painting 2.0 152

Project: Portrait with Sepia Underpainting 159

CHAPTER SEVEN: PAINTING WITH SHAPES

Exercise 1: Pixel-based Solution 163

Posterize 174

Sketch Filters 174

Exercise 2: Creating a Figure with a Filter and
 the Pattern Stamp Tool 175

Adobe Illustrator 177

Vector Modes, Tools, Paths, and Layers in Photoshop 178

Exercise 3: Creating a "Generic" Self-Portrait using Vector Paths 179

Converting Paths into Selection Masks 186

Rasterizing Vector Layers 186

Vector Masks 186

Project: Make Some Smooth, Flat Artwork 187

**CHAPTER EIGHT: MIXING PAINT, PHOTOS,
AND EVERYTHING ELSE**

Using a Digital Camera 191

Look on Your Hard Drive 194

Items from Your Other Artwork 196

Exercise 1: Mixing Paint and Photographic Reference 197

Photoshop Filters 201

Exercise 2: Integrating Photoshop Filters into Digital Art 202

Project: Photos and Paint 207

CHAPTER NINE: FINDING YOUR OWN VOICE

Mining a Vein 210

Reacting to the Outside World 212

Style vs Subject 213

Exercise 1: Copy/Analyze Someone Else's Style
 and Mine Your Vein 218

The Artist's Statement 219

Project: Commit to a Style and Method of Art-making 220

CHAPTER TEN: INTO THE REAL WORLD

Home Ink-jet Printing 224

Large Format Printing 224

How to Improve the Permanence of Your Printed Piece 225

Framing 226

Monitors, Screens, and Projection 227

Combining Digital and Traditional Art 229

Starting Analog, Finishing Digital 230

Exercise 1: Working from a Scanned Pencil Sketch 231

Starting Digital, Finishing Physical 236

Exercise 2: Applying a Digital Image to a Physical Surface 237

Exercise 3: Integrating a Digital Image into
 a Three-dimensional Structure 241

Type, Images, and Promotional Materials for the Artist 243

Project: Hybrid Art 244

AFTERWORD: SHOW US THE POSSIBILITIES 247

RESOURCES 248

CONTRIBUTING ARTISTS 250

INDEX 255

Acknowledgments

Thanks first and foremost to my wife, Laura Sherrill Ligon. She took photos and posed for photos used in the technical instructions in this book. Her painting *Fried Eggs* is used in the perspective exercises in chapter five. The waves and swirls used in the first exercise in chapter seven are based on a pencil sketch by Laura. She is a constant sounding board and source of encouragement for my work in general and for this book in specific. Thanks also to my sons, Sam and Max, for patiently posing for crazy reference pictures and generally humoring their dad in his projects. It's a pleasure to watch them grow into smart, creative people.

Thanks to Rhonda Coble, who took the photos of the Egyptian statue used as the examples in the instructions for exercises 1 and 3 in chapter three. Thanks to Kyle Coble, who took the photo of the girl and monkey used in exercise 4 in chapter three.

Thanks to Linda Abrahamsen, Jeff Bodovetz, Chad Cummings, Julie Cummings, Kevin Czapiewski, Richard Fiorelli, Kevin Kautenburg, Jacqueline Kennedy, William Leddy, John Spofford, and Vikas Srivastava for posing for the photos used in the composite exercise in chapter four.

Thanks to Neal Reed and Kathy Anderson for patiently posing for the digital painting in exercise 1 in chapter six.

Thanks to my sister, Pam Mayor, for allowing her old photo to be the basis for exercise 1 in chapter eight. Exercise 2 in chapter eight is based on a video still from "Figure/Ground," my perennial work in progress. Thanks to Ian Hinkle, my director of photography for the film, for capturing the image, and thanks to actresses Lindsey and Lauren Hyde, who appear in the video image.

Thanks to author/director Michael W. Dean for inspiration and specific help. In addition to the foreword for this book, Michael recommended the book proposal to his agent, which resulted in a great and propitious experience. Additional thanks to Michael and his wife, Debra Jean Dean, for proofreading the original book proposal and making helpful suggestions. Thanks also to Webb and Ricki Sherrill for proofreading, as well as for general help and encouragement!

Thanks very much to Margot Hutchison of Waterside Productions, my book agent for this project. She has been a pleasure to work with, labored mightily on behalf of this first-time author, and did an all-around great job. Thanks to publishers Watson-Guptill/Random House for the wonderful opportunity. Thanks to editors Joy Aquilino and John Foster for patience and informed guidance regarding this project.

Thanks to Adobe for making such great creative tools. I use them on a daily basis. Thanks to Wacom, Canon, and Kodak for providing images for this book. Thanks to Elizabeth Saluk at the Cleveland Museum of Art for help in obtaining permission to use images from art history. Thanks to Michael Pilmer for helping us to obtain permission to use images created by Mark Mothersbaugh . . . and thanks to Mark!

Thanks to all the artists who allowed their work to be included in the book. These visual examples are a big help in clarifying the instruction.

Thanks very much to my students in general, and more specifically those students whose works are included as practical examples of project solutions.

Thanks to the Cleveland Institute of Art and my colleagues there. It is a privilege to teach at such a great school and be surrounded by such smart, creative individuals on a daily basis. Thanks to the University of Mary Washington, where I was both student and instructor (with several years in between the two!). Thanks to Joseph DiBella, Richard Dawson, Dave Tanks, Petra Soesemann, and Kevin Kautenburger for providing teaching opportunities and for general guidance, friendship, and help. Thanks to Grace Hartigan for being a powerful and significant mentor, influence, and inspiration.

Thanks to Attorney Joni Davis and Attorney Andre Des Rochers for legal help and advice regarding this book.

ACKNOWLEDGMENTS

Foreword
BY MICHAEL W. DEAN

I first heard of Scott Ligon in 2006, when he wrote me a snail-mail letter and sent me a DVD of his animated short film *Escape Velocity*. The letter said that my book, *$30 Film School,* had influenced him to make films. My book had sold many thousands of copies, and was more than a simple tech book: it was, for many, a "bible," a way of life. I was amazed that this little message in a bottle that I'd written on my old laptop in a crappy, little studio apartment had touched so many people around the world. And it seemed like all of them sent me a DVD of the film they'd made as a result. When these DVDs started filling my PO box, I would eagerly watch all of them.

But I soon realized that the same truism I had discovered twenty years earlier when putting out vinyl of my own punk rock music—after listening to all the other punk rock vinyl put out by everyone else in the early '80s—was also true of digital filmmaking: when everyone can make a record (or in this case a movie), everyone does, and most of them suck.

The pithy little statement I'd come up with to describe this phenomenon was: "I'll fight to the death for your right to make your movie, but I don't want to have to watch it." This may sound callous, but the simple logistics of trying to have a life and moving on to my next long art project made it impossible to watch all of the films that were sent to me as a result of writing my book. I gave everyone an "A for effort" in my mind, but most of the films were not ones that I'd go out of my way to watch.

When *$30 Film School* went into a second edition, I was asked by the publisher to produce a DVD to accompany it, rather than the CD the first edition had. I pulled Scott's film out of the I'll-watch-these-someday pile by my desk. I remembered that I'd really liked his cover letter. It seemed very genuine, without kissing butt. And I was impressed that even though he said that his film was about his Attention-Deficit Disorder, there were no typos in his letter. Having a bit of ADD myself and knowing how hard it is to do proper written communication (even though I do it for a living), it impressed me. I popped his DVD into my laptop.

I was blown away. It was fantastic. I called Scott on the phone before the film was even finished. When I got Scott on the phone, he sounded a little starstruck to get a call from me, but I don't think he knew that I was actually a little starstruck to be talking to him. His movie had leapt off the screen and deep into my cortex, and I simply had to put it on the DVD that was to be included with the second edition of *$30 Film School*. Scott agreed, and I asked if he could edit a shorter, ten-minute version, because I was putting a lot of stuff, a few great films, and a lot of data on the DVD. He said yes, and with consummate professionalism he FedEx-ed me an updated DVD three days later. He not only included a video DVD, but also a data DVD, which made my job much easier.

I was impressed.

Scott and I have kept in touch over the years via e-mail and phone. I'm a fairly private person and don't give my home phone number out to many people, but folks as professional and talented—and funny—as Scott are the exception. We've worked on several projects since, and he's always been ultraproactive, amazingly talented and visionary, and kept to all his deadlines, whether the project is for pay or for free—all while making me smile and laugh, a lot. I'm honored to consider him among my few, true friends.

Scott is an expert in Photoshop on a level that few people are. Part of this is because of his background in fine-art painting, part of it is his unique worldview (some of that is taken from transforming his ADD from a burden into an attribute), and partly because he just looks at life differently than most people. His worldview and his take on life are refreshing. Scott is childlike, but with the skill sets of an adult genius. Most people give up when they grow up, to a certain extent. Scott has kept the best aspects of a child's inquisitive mind and retrofitted it around being an adult who is an expert at functioning in the modern world, even when he can't find his car keys.

Scott Ligon's experience as a college art teacher shows in all that he writes. He's the perfect guy to write a book that has the final word on fine-art Photoshop. In a world where "Photoshop" has become a verb, where "to Photoshop" is often synonymous with "putting boobs on the president" or "putting witty little text comments under silly photos of cats," Scott is reclaiming the verb "to Photoshop." He's putting it where it has belonged all along: in award-winning, world-changing videos, in museums, and now, in the hands of up-and-coming fine artists like you.

Scott is the perfect guy to write this book, because he's the only guy who could write this book. I don't say this lightly: this book is far more than a tech book; this book will change your life.

—MICHAEL W. DEAN

Michael W. Dean is a filmmaker and author of many books including *$30 Film School* and the coauthor of *YouTube: An Insider's Guide to Climbing the Charts*. He also directed the films *D.I.Y. or Die, How to Survive as an Independent Artist,* and *Hubert Selby Jr: It/ll Be Better Tomorrow*. He recently moved from Los Angeles to Wyoming to "get away from it all."

WELCOME TO THE REVOLUTION

Digital art's greatest advantage is its ability to combine elements from different sources into a seamless, unified work. Digital technology offers the single, greatest advancement in the possibilities inherent in art-making since, well, art-making began. Most of this introduction is devoted to five key reasons why digital technology is redefining the creative process. We will look at how it: (1) blurs the boundaries between mediums to the point of irrelevance, (2) possesses potential for endless experimentation and variation, (3) allows for infinite duplication with no loss of quality, (4) is able to reach large audiences directly with no middleman, and (5) contains no inherent aesthetic or technical limitations. It also addresses some of the fears and misconceptions associated with "new media" and gives you some basic information about the organization of the book. Welcome to the revolution! Now, let's look closely at some of the reasons why and how digital art is causing a revolution.

Reason One: Everything Is Connected

Everything *is* connected, inherently. Although I think of myself as a painter—my formal training is in painting—I've worked in many other media. Whether it is painting, filmmaking, music, writing, or any other creative endeavor, I very much consider them to be built upon the same inherent, creative thought process: (1) start with the central idea, (2) build structures, or themes, around the idea, (3) introduce secondary themes that run through the work that add complexity and depth, (4) use repetition in the themes to build stability and purpose, introducing variations on those themes for greater interest, and (5) place elements in your work in a way that leads you from one idea to the next in a logical fashion that draws attention and clarity to the central ideas.

Traditionally, the differences in art forms have been accentuated instead of their similarities. This is at least partially due to the vast difference in the physical tools traditionally needed for each art form in order to translate its creative process into realty. Painters needed paint, brushes, and a surface on which to paint. Photographers needed film, a camera, and a darkroom filled with toxic chemicals. Filmmaking required all of the above in addition to cumbersome and expensive machines to edit the film. Music required a group of people playing together in (hopefully) a well-rehearsed manner before a live audience. Later, the advent of recording equipment allowed live musical performances to be recorded and played again and again. With the invention of multitrack recording, it became possible for a single person to create music in layers, adding and subtracting textures like a painter in order to create a finished piece of work. Work in all of these art forms (and more) can now be done on a computer with a few interrelated software programs.

We are physical beings in a physical world. We still need a drawing tablet and pen to paint information into our computer. We need a scanner or a camera to capture still or moving images into our computer. A microphone or cable to connect instruments is needed to translate sound into information. But once it's in there, it is all information. It's all potential and ideas to be manipulated with hard work and the facility of thought. Regardless of its source, this digital information is all the same thing. It's all ones and zeros ready to be manipulated with no inherent divisions or limitations in possibility. Already, the borders between different art forms are beginning to blur. Over time, as technological abilities increase, this will result in the logical conclusion of making all art essentially one thing, one creative act.

Will your project be visual or auditory? Will it be still, move, or interact with its audience? Will it stand alone, or augment a physical activity such as theater or dance? These questions are part of a single creative decision-making process that is subject to change as the work progresses. Once you have the information on your hard drive, regardless of

whether it was originally photographic, drawn by hand, or drawn digitally, it is ready to be manipulated using the vast array of digital tools that are available to you.

To illustrate this concept, let's create a hypothetical body of work. Let's say that you have created twelve digital works that are to be printed on archival paper, framed, and displayed in a gallery. Nine of the works were digitally painted, completely from scratch, in a blank document. You had someone pose for you and then painted the person from life. You then used your laptop, drawing tablet, and the painting tools in Photoshop to complete the works done solely with digital paint. It would be reasonable to call them digital paintings.

Now what if one of the three remaining works contained an imported photographic texture as part of the work. Ninety-five percent of the work is painted, and then there is a nice, compatible photographic texture that visually supports and enhances the piece. Is it still a painting, or is it a collage? It seems reasonable that you can mix a photograph of a rusted metal texture into your paint and still call it a painting.

Let's say the remaining two works have started with photographs. In one of them, you used the photograph as a starting point, but have painted over it and added new elements, with the result being that the completed artwork bears little resemblance to the original photograph. In the last remaining piece, let's say you use several photographic elements that end up in the finished piece and that they have been altered and manipulated. In addition, let's say the photographic pixels have been pushed around like wet paint and mixed indiscriminately with purely painted elements, but strong, photographic elements remain.

When you look at the twelve, finished pieces, they clearly look like a consistent body of work, with repeated themes of structure, stroke, and color. They are printed on the same paper and framed in a uniform manner. Is it realistic to say that they are works in different mediums? Would it matter if what started out as a photograph of a shoe ended up as a painting of a horse? What if the works were displayed as images on video monitors instead? What if nine of the works were non-moving and three were moving? Are they different things? What if they only moved a little? What if they moved a lot? What if they had sound? What if one of the moving images seemed to tell a narrative story? My point is that although some pieces may be clearly painted and others clearly photographic, there are *no* clearly defined lines of distinction when it comes to digital art.

This concept mirrors the creative process itself. Visual, creative thinking is analogous thinking. Creative thinking considers things as connected, as relationships. Creative thinking takes individual elements already in existence and puts them together in a new way, making them function as a purposeful whole.

Art-making, in any one of its forms, uses whatever tools are appropriate to make the creative process happen. Any attempt to categorize and separate discourages many of the intrinsic possibilities within the digital medium. It's my hope that, instead, this spirit of exploration, inherent in human thought, will spill over into our "analog" endeavors, such as physical painting. How could it not, if the two mediums coexist and are interrelated?

Opposite page: *Big and Blue*; above: *From the Roof* by Max Chandler. Max really blurs the boundaries between media. His finished works are acrylic paintings on canvas, but they are painted by robots! Max uses Photoshop for palette and color planning as part of the preparation process. He premixes all of the paints and makes test charts to make sure the colors are right before he programs the robots and sets them loose.

Reason Two: Endless Experimenting

If an experiment has a high likelihood of aesthetic failure but would be very interesting if successful, there is a strong incentive for artists to exercise caution over courage in traditional mediums. You don't want to ruin your work. Sometimes, in my traditional physical paintings, I have a creative tangent that is too tempting not to explore. Even though I may not be sure what will happen and recognize that I might ruin my painting if I try my experiment, the lure of the "What if?" is often too strong to resist and I take the risk. Sometimes it is successful and produces something exciting (at least to me) and other times it ruins the work, and I have to start from scratch, or drastically rework the piece—often with less satisfying results.

Digital art allows endless "What ifs?": With digital art you can explore any tangent and simply hit "Undo" if it doesn't work. You can also save a file at a given point, save a

Top: *Freshwater Run*; bottom: *Tortoise in the Cactus*, digital painting by JD Jarvis. These images both originated as the same work entitled **Shapes** and were created in Photoshop and Corel Painter. Copies of the original file were saved under different names and then taken in divergent directions to create these two distinctive, but visually related, works.
COPYRIGHT © JD JARVIS

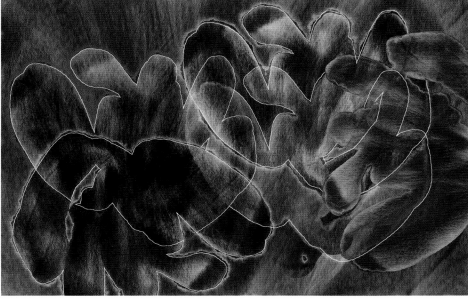

copy of the file under a different name, and explore an intended direction on the duplicate file. I often do this several times before I finish a piece. In the digital world, as long as you have the time, every possibility can be explored.

Reason Three: Process, Not Product

Since digital art is infinitely duplicable, it is possible to make any amount of copies of a digital file without losing any quality. So, while digital technology is a great tool for enabling the creative process, it makes the concept of a single, finished product artificial at best, which I think is great.

In traditional art, it is very easy for the creative process and its emotional expression to get usurped by the product, such as a one-of-a-kind masterpiece sold in an elitist gallery, reviewed in creative journals using language as hard to understand as a legal document, and sold to a wealthy patron to use as a status symbol. Digital art offers endless creative possibilities with no limits in duplication. This emphasizes the creative process and the idea, and de-emphasizes the preciousness of the original, physical product. What can we classify as the "original," anyway, in digital art? Surely, it's not the file itself, which is simply a collection of ones and zeros describing and encoding the creative decisions by the artist. Is it the image we see on screen? Is it a physical print made from the artwork? None of these possibilities offers a satisfying and definitive answer. In the end we're only left with a creative process that is filled with expressive potential—with no "original" and no limitations in duplication. There is a lot to be excited about while making it hard to be an elitist!

Core #5 by Qian Li. Starting *physical*, ending *digital*. The artist creates her works by painting on rice paper, scanning the images into a computer, adding elements that are shot from a digital camera, and then layering and shaping the elements in Photoshop. Qian Li prints her works in extremely limited editions, varying from a single copy to a maximum of six. You can see more of the artist's work in chapter nine. COPYRIGHT © QIAN LI

How does an artist make money creating digital images? The jury is still out. My own personal solution is to make a limited edition. I limit prints of my digital artwork to an edition of twenty-five prints that are signed and numbered. This comes from the tradition of printmaking, the revolutionary technology of earlier times. I have a feeling that there are better and more natural solutions out there, too. I'm just too mired in the old way of thinking to see them yet.

To say that digital art is in its infancy is a drastic understatement. There is little consensus, or consistent information, about making it. Currently, digital art is comparable to television in the 1950s, and we haven't created *I Love Lucy* yet. Formats, products, and categories have yet to be fully defined. We have yet to truly begin to grasp the enormous creative potential in this unprecedented synthesis of information. As with all new mediums, progress in the development of digital art is hampered by preconceptions made as a result of previous limitations. These limitations no longer apply, but changing perception is hard to do. Usually, it occurs in fits and bursts, built on one discovery after another by pioneering individuals, and later refined in subtlety and nuance by those of a more careful and less entrepreneurial nature.

Reason Four: Eliminate the Middleman

Creating and distributing art yourself is far easier and more possible than ever before. Nowadays, commercially successful digital artwork, design, and video that has been produced in home studios is commonplace. The odds may still be against the little guy, but they have been drastically equalized by digital technology. Also worth noting is that you no longer have to live in a centralized location to be a viable artist with digital art and digital transfer of information. It is possible for artists that have never met to collaborate, in real time if need be, from opposite sides of the world.

Reason Five: No Limitations

When digital cameras came onto the market and one-megapixel cameras were an expensive luxury, I often heard repeated the "fact" that digital cameras could *never* contain the nuances of traditional photography, because they could never approach the full range of information captured by film. Fast forward a few years. There is still debate about the exact amount of megapixels needed to equal the amount of information in 35 mm or large format traditional photography, but it is clear that high-end digital cameras are now, or soon will be, able to record a greater tonal range than traditional photography. Processing power increases exponentially every year. A technological limitation may seem to be an inherent limitation in the medium; but for practical purposes, all technological limitations are only temporary, and will be eliminated by an increase in processing power—matched by the constant development of better programs that bring elements closer and closer to the ideals of human perception. If you think digital photographs still don't look as nice as traditional film photography, you may be right, but what do you think digital photographs could look like when they record twice as

A video still from *Lucid Lunch* by Megan Ehrhart. Her independently produced animated films and sculptural works are exhibited in galleries, film festivals, and art museums all over the world. You can see more of Megan's work in chapter ten. Copyright © Megan Ehrhart

much information as traditional film? What do you think they'll look like with twenty to forty years of constant improvements in the A/D converters based on human perception?

Digital video is a newer technology. It takes a large amount of processing power and hard drive space to work with high-definition video. Generally, 35 mm movie film looks much better than video. It's also much, much more expensive. Using video can mean the difference between being able to make a movie or not. It also doesn't involve processing with poisonous chemicals that end up in rivers and oceans. High-definition video cameras are already looking pretty good, and are quickly becoming affordable to the average consumer.

Processing power will increase unimaginably, and hard drives will drastically increase in capacity. The price of technological equipment will continue to fall. People will work every day to improve the look of video, day after day, year after year. Technological and perceptual limitations in digital art are temporary. Don't assume a temporary limitation is an inherent one.

Myths and Misconceptions

As with any new idea, there are a lot of fears and misconceptions about digital art. I recently listened to a panel of abstract expressionist painters talk about digital art and why it is not "real" art. They referred to digital art as cold, mechanical, and taking the human element out of the process. I immediately pictured a panel of artists, fifty years ago, patiently, logically, and with good intent, explaining why abstract expressionism isn't real art, and how it was undermining true artists. Art-making, to me, is the act of using the elements of the visual language toward the goal of expressing a quality or emotion. Craft is the technical mastery of the process.

If you accept my definition, any tool or medium could be used to create successful art. It depends not on what tool you work with, but on what you do with it. Digital art is a tool, and an exceptionally good one, with a full range of expressive possi-

Fear of a digital planet!

bilities, from mechanical to quite organic, from hyper-fast to meditatively slow. Beware of any philosophy of art that includes an explanation of how the art somebody else likes is real art, and the art you are excited by is not real art. Convincing you to do work that you are less interested in can only result in less interesting art. Follow your interests. Do what you are passionate about. This is your voice. Honor it. Practice it. Refine it. Don't be talked out of it. There are much more efficient ways to make money doing things you don't want to do. Never lose sight of why you wanted to make art in the first place.

Is Painting Dead?

Some people who are excited by new media and have seen digital art featured prominently in important shows have proclaimed that painting is dead. Applying physical paint to a surface is an inherently satisfying, primal experience that I cannot imagine ever being replaced. It's not an outmoded technology. It's a simple, direct process that works well and produces great results. I expect digital art and traditional art to exist side by side, and in some cases, to intermarry. If you love to paint, then paint! Follow your interests. People also tried to say painting was dead when photography was invented.

Painter Donna LoGrasso Howson in action. COPYRIGHT © DONNA LOGRASSO HOWSON

About This Book

This book focuses on a mere portion of the vast spectrum of possibilities in digital art: two-dimensional fine art created with the help of Photoshop. It offers specific instruction within the perspective of a larger context of possibilities. *Digital Art Revolution* is a book that teaches digital art from a true fine art perspective. This is not a book that teaches readers to process photos in order to mimic various styles from art history. This is a book that familiarizes readers with the fundaments of the visual language and then shows them how to apply these principals to digital art. It demonstrates the possibilities in the medium and guides readers toward developing their own unique voice. Rather than imitating art history and the great, unique artists that made it, this book will encourage artists to explore the possibilities of digital art and *make* art history. The book not only offers "how," but just as important, "why." All instruction is placed within the larger context of understanding the visual language and using it for expressive purposes. Photoshop is a great digital-painting program and arguably the best photo-editing program in the world! We'll talk about the value of synthesizing these techniques at the beginning of chapter two. This book should give you a working knowledge of Photoshop and put this instruction in a perspective that encourages you to develop your own unique voice in doing so.

Above: *Fire Nation* by John Spofford. Photoshop is an amazing painting program—it's arguably the best photo editor in the world—but it is Photoshop's ability to synthesize materials from a combination of different sources that offers the greatest expressive possibilitites. COPYRIGHT © JOHN SPOFFORD

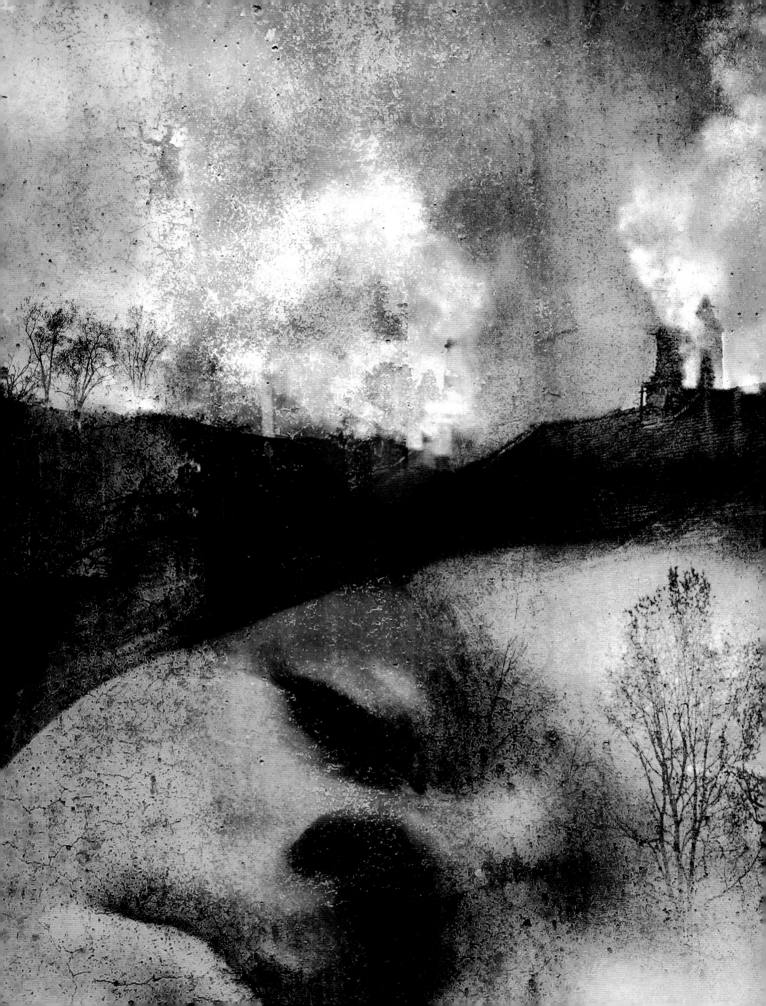

UNDERSTANDING THE VISUAL LANGUAGE

The principles of design and visual communication have been refined and developed for thousands of years in service of artistic expression. These principles must be understood in order to make outstanding digital art. This chapter is a crash course on the principles of the visual language. Any one of these principles could support an entire book by itself, and yet it's remarkable how easily they can be explained and understood when reduced to their bare essentials. Before we devote the rest of the book to learning specific ways in which we can create digital art in Photoshop, we'll first need to learn how artists use this universal language to communicate a quality or feeling that resonates with the viewer—in addition to producing something unique and personal. We'll even look at a few outstanding examples of traditional art to help us get the basics down. We will also address the principles of design as they apply to two-dimensional art, which include drawing, painting, and digital art. Even so-called 3D digital art creates the illusion of depth. If it is printed on a flat surface or viewed on a screen, it is still two-dimensional.

The word *design,* in its most general sense, means "on purpose." To do something by design is to do something purposefully. A successful design, then, is a design in which every element works to support the whole composition. A great teacher of mine used to tell us to "never be afraid to get rid of the best part of your painting." What she meant was this: you may, for example, have painted the best hand that you ever painted. It's so good that you want to show everyone in the world what a great hand you painted. However, if the hand does not work to support the general composition, if it doesn't work within the overall design, then it needs to be eliminated—no matter how good it is. Every part of your composition has to work to support the whole. This does not mean that you have to have a concrete plan in advance (although you might want to). If you do have a plan, it still doesn't mean that you are required to stick to it without variation. What it does mean, though, is that by the time you're done, everything should be there for a reason. Each individual element must work to support the whole composition. How do you know what "works" and what doesn't? While there are infinite variations in human expression using the elements of visual design, they are all based on some universal constants, often related to our physical environment.

This wonderful digital composition, *Muse for Hire,* by artist Myriam Lozada-Jarvis, is not meant to be realistic. It is essentially a well-considered placement of overlapping shapes. Our method of processing visual information is so pervasive and powerful, however, that we can immediately translate these shapes into an environment containing ground, sky, and elements supported by the ground in various levels of depth. The visual language is based on the human perception of physical reality. COPYRIGHT © MYRIAM LOZADA-JARVIS

Composition

The concept of figure/ground refers broadly to the way we process and perceive visual information. We search for edges and make shapes out of them, determine depth to separate the foreground (objects) from the background (negative space), and use this information to help us decide where we need to focus our attention. This unconscious process helps us to assess and understand our immediate environment. When we process visual information, therefore, we generally organize the information according to analogous physical laws and characteristics. In order to understand this concept and its importance, let's look at figure/ground in a more literal sense. A horizontal line implies ground, the horizon. It implies stability and stillness. A vertical line, or shape on top of the horizontal line, can be regarded as a figure, in the most general sense. It is perceived as an element that has weight and which is supported by the horizontal line.

The fact that we "read" elements in a composition in reference to physical reality is significant. Elements appear to exert gravity and have visual weight. Diagonal lines are the least stable, and can be used to create a sense of motion or excitement. Diagonals are also great for moving you through a piece and directing your attention to an important part of the composition. People, often despite appearances, seek balance. People intuitively find a balanced composition more pleasing and complete. Visual weight determines balance in a composition. A simple way to understand this is to think of your picture plane (your paper or canvas) precariously balanced on a triangle. If the composition is heavier on the right or the left, the painting will tip over. Smaller elements near the top of a composition can balance out larger elements near the bottom. This is how objects work in real life, too. Darker elements usually appear to have more visual weight than lighter elements.

The easiest way to achieve balance is to create a symmetrical composition. This is a composition that is the same on both sides. If the composition is the same on both sides, it could be thought of as very stable and predictable. An asymmetrical composition is different on either side. It achieves balance by arranging elements so that they counter-balance each other in a more complex arrangement. It is much easier to create the feeling of movement in an asymmetrical composition.

BALANCED

BALANCED

BALANCED

NOT BALANCED

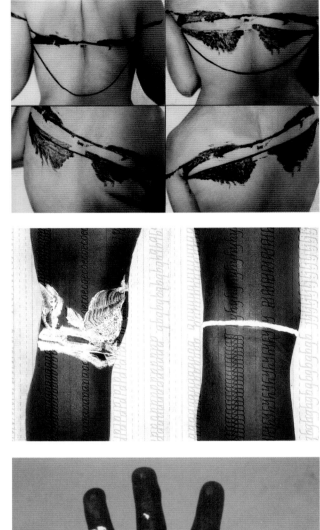

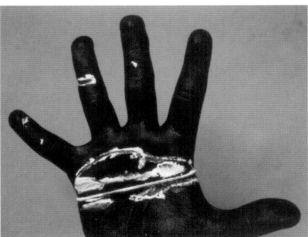

Line

Line has an immediate and direct effect on our emotional reaction to a composition. Jagged, vigorous, bold lines that collide in an aggressive manor evoke quite a different feeling than do soft, curving, delicate lines with harmonious, upward movement.

A drawing that uses line to convey or capture the movement and general proportion of an object is called a gesture drawing. A gesture drawing, as the name implies, is usually done quickly and spontaneously.

Line can be used to define shapes. A contour drawing uses lines in a slow, deliberate effort to record the outlines and interior shapes of forms. Often the two methods of drawing are used together. You can first use gesture drawing to map out an effective composition and give it a sense of life and vitality, and then go over it with contour drawing to add observational detail, nuance, clarity, and structure. Digital drawing is much easier to do using a drawing tablet and digital pen. We'll talk about tablets in chapters two and six.

CONTOUR DRAWING

Top: *Knee Script*; middle: *White Back*; bottom: *Palms Black* (detail) by Kaethe Kauffman. Expressive line quality is a big part of Kaethe's drawing process. Here, she uses a string dipped in wet paint to paint onto the model. The lines have a vigorous, organic quality that creates a feeling of motion in the still image, documented with photography, and then modified in Photoshop. Kaethe uses Photoshop to adjust value and color, and for layering other motifs and images into her work. Student calligraphy from the 1800s was incorporated into *Knee Script*.

GESTURE DRAWING

Shape

Shapes are the building blocks of design. It is extremely useful to think of compositions in terms of their general shapes and how they relate to each other. It is possible for works of very different styles, with completely different subject matters, to nonetheless have very similar compositions.

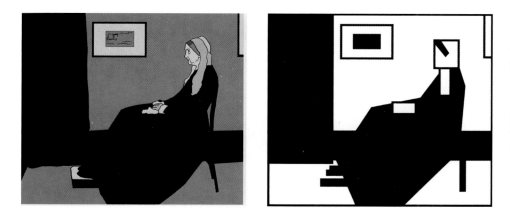

Left: A simplified drawing based on *Arrangement in Grey and Black No. 1, or the Artist's Mother* by James Abbott McNeill Whistler, oil on canvas, 1871.

Right: The composition, further simplified into its essential shapes. A strong, balanced arrangement of visual weight.

Mathematically precise shapes, such as a perfect circle or rectangle, are known as **geometric shapes.** Shapes with less uniform or predictable curves, such as those found in nature, are known as **organic shapes.** Objects themselves are referred to as **positive space.** The space between objects is called **negative space.** All are of equal importance and work together to make a successful composition, like the pieces of a puzzle.

Klimtich by Bradley Wester. The artist uses common stationery-store labels, stickers, and burst signs and redraws them as vector-based images that can be printed at any size. Bradley's works are excellent examples of how an artist rearranges shape and form to create balance and movement within a composition. Examples of Bradley's distinctive work can also be found in chapter eight.
COPYRIGHT © BRADLEY WESTER

Mr. Exploding Head by Jack Pabis. The fiery figure forms a strong implied triangle in this nearly symmetrical composition, a photographic composite created in Photoshop. COPYRIGHT © JACK PABIS

Different elements can be placed in a way that creates an **implied** shape. These implied shapes can be used to direct your eye and attention to an important part of the composition. Remember, diagonal lines imply movement! Many compositions arrange elements to create at least one giant implied triangle that acts like a big arrow directing you to your focal point. Once you know to look for this, you'll be amazed at how frequently this occurs in the masterpieces of art.

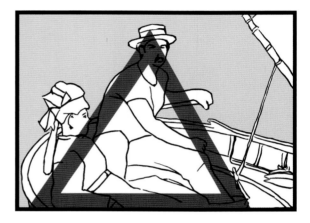

An implied triangle. Composition based on *Boating* by Edouard Manet, 1874.

Two-dimensional, or **2D objects,** contain shape, but no volume. **Volume** is a three-dimensional element of design. Sculpture and ceramics are examples of **3D** art that contains *actual* depth and volume. The *illusion* of depth can be created in two-dimensional images by shading in a manner that records the changes in relative darkness as light falls over an object. Which brings us to …

Value

Value is the range of possible lightness and darkness in your work, from pure white to pure black. Being able to see and render values accurately is an important tool in being able to draw and paint in a believable manner. Gradations of value create the illusion of depth. Objects are rarely pure white or pure black in physical reality. They are likely to be somewhere in between these extremes.

Light falls over an object in space, creating variations in value.

Diabolique by Davida Kidd. The limited, almost monochromatic color palette places adds emphasis on value and contributes to the distinctiveness of the piece. These seamlessly composited Photoshop images involve doll bits, real body parts, and "photographic" painting. You can see more examples of the artist's work at the beginning of chapter four.
COPYRIGHT © DAVIDA KIDD

Contrast in value is used to create **focal points** in design. A light figure on a dark background, or a dark figure on a light background, can clarify and direct attention to a focal point in your design. The distribution of dark and light areas throughout a composition must be considered in creating balance of visual weight in a composition. Value influences the mood or feeling of a design. A dark, somber portrait of a person in deep shadow certainly conveys a different feeling than a portrait of the same person in a brightly lit environment.

Francisco de Goya (Spanish, 1746–1828). *The Little Prisoner*. Etching. 26.2 x 17.7 cm. The Cleveland Museum of Art. Gift of Louise S. Richards, 2005.280. Strong mood created by contrast in value and an agitated, expressive line quality that is appropriate for the subject matter.

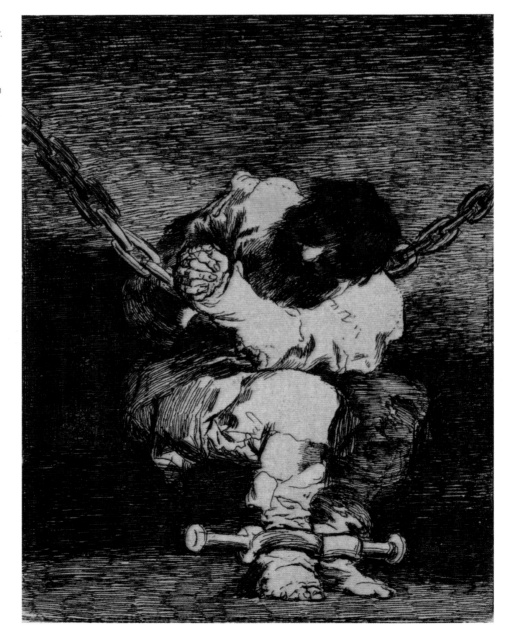

Color

Hue is the color itself, such as red, green, yellow-orange, and so on. **Chroma** is the intensity, or vividness, of a color. The lightness or darkness of a color, as we know, is value. In traditional color theory, the **primary** colors of physical paint (subtractive color) paint are considered to be red, blue, and yellow. Primary colors are the colors from which all other colors are created. **Secondary** colors are colors mixed from equal parts of any two primary colors. Red and blue make violet. Blue and yellow make green. Yellow and red make orange. **Tertiary** colors are made of equal blends between a primary and a secondary color. Blue and green make blue-green, for example. There are infinite possible variations of color.

There is a strong movement in recent years to consider cyan, magenta, and yellow (CMY) to be the primary colors in subtractive color, because this system allows for greater accuracy in the mixing of color. Red, green, and blue (RGB) are the primary colors in light (additive color) and in digital art.

Warm colors like red, yellow, and orange appear to come forward in space. Warm colors are more likely to appear vibrant, aggressive, or agitating. Cool colors—blues and greens—can appear to recede in space. Being the most abundant colors in nature, they tend to be soothing, passive, and contemplative. This knowledge can be used toward clarity and emotional effect in design. Try limiting your color palette. Think of the colors in your work as themes.

Use major themes that are dominant in the composition, and minor themes that add a spark here and there for excitement or visual interest. Repetition of color throughout the composition anchors things together and gives stability and purpose to your work. Variations on the themes add tension and interest in your designs. Colors that are similar in hue are **analogous** colors. **Monochromatic** color is a single color with variations in value.

Complementary colors are colors that contain none of the color of their complements. Red and green are complementary colors, for instance, because green is made up of blue and yellow, but contains no red. Complementary colors are very vibrant and jarring when placed next to each other. There are several ways to select or create colors in Photoshop. They'll be covered in detail in chapter six during our introduction to digital painting.

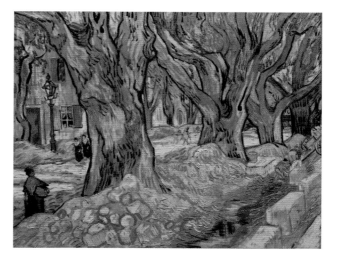

Vincent van Gogh (Dutch, 1853-1890). *Large Plane Trees*, 1889. Oil on canvas, 73.4 x 91.8 cm. The Cleveland Museum of Art. Gift of the Hanna Fund, 1947.09. A limited palette. Colors reoccur in different parts of the work as visual themes. Many prominent colors can be found in both the background and the foreground objects, unifying the entire composition.

Getting Alive by Howard Ganz. Formal relationships between vibrant colors figure prominently in this digital painting. Howard is a digital pioneer who wrote one of the first digital painting software programs.
COPYRIGHT © HOWARD GANZ

Complementary Colors are vibrant and jarring when placed next to each other.

Space

In art, such as drawing, painting, and digital art, our works have two dimensions: length and width. The third dimension is depth. There are several visual clues we use every day to judge the distance, or depth, of an object. The illusion of depth can be created in two-dimensional art by mimicking the way objects appear in real life when they recede into three-dimensional space.

No. 56 by Sally Grizzell Larson. Sally's collages were made from a wide variety of found images, which were manipulated and integrated using Photoshop. These photo-based works incorporate a lush, painterly use of light and atmospheric perspective to convey a sense of depth. More images by the artist can be found in chapter five. COPYRIGHT © SALLY GRIZZELL LARSON

Here are some basic methods you can use to create the illusion of space in a two-dimensional work:

◆ **OVERLAPPING ELEMENTS:** When one object partially covers another object, we feel certain that it is in front of that object.

◆ **VARIATION IN SIZE:** When we have two similar objects in which one is large and the other is small, we perceive the larger object as closer to us. Size is also a big factor in **linear perspective**.

To understand linear perspective, picture a box in front of you. The side that is parallel to our point of view appears flat, but parallel lines that recede in space appear to grow closer and closer together. If uninterrupted, these lines converge until they meet at a point on the horizon known as the **vanishing point.** Vanishing-point perspective is one of the few aspects of art that involves an exact formula with predictable results. Mastering linear perspective enables you to create believable environments from your imagination. It also makes it easier to correct inaccuracies in observation while drawing.

◆ **ATMOSPHERIC PERSPECTIVE:** Things that are closer have more detail and sharper focus. They have more vivid colors. They have darker darks and lighter highlights (a greater range of value). Things that are further back lose saturation in color. They lose the extremes of value, and become blurrier. Even artists that work in very abstract styles use the human perception of atmospheric perspective to separate and clarify elements in their work.

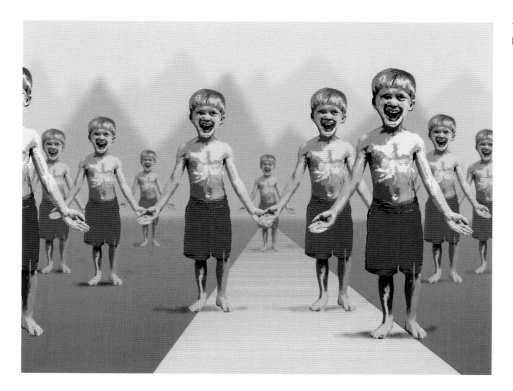

Things get smaller, blurrier, and less vivid as they recede in space.

Texture and Pattern

Texture is the surface quality of an object, rough or smooth. It's what an object feels like or looks like it would feel like. There can be actual textures, such as the texture of paint applied thickly, or the illusion of texture in a flat two-dimensional work. The textures you create in digital art will probably fall into the second category. **Pattern** is any uniform, repeated motif of visual elements. These patterns can be geometric or organic. Often the repetition of a texture or pattern, with variation, is a secondary theme in a composition. Like seasoning in cooking, it adds a little spice and variety to the design. Repetition of a texture or pattern can add structure and stability to a design as well.

PAINT TEXTURE

Corpus Callosum by Matthew Hamon. Photographic images are used as textural elements in this mixed media work, assembled in Photoshop. See chapter nine for more works by this artist.
COPYRIGHT © MATTHEW HAMON

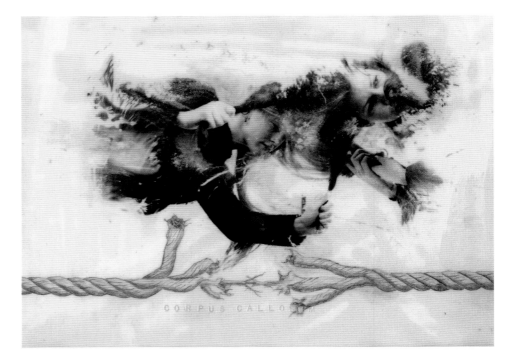

The Sum Is Greater Than Its Parts

Individual elements placed near each other are perceived to relate to each other, and create a different effect than the elements would individually. Things near each other are perceived as a group. An object separated from a group of similar objects by a large amount of negative space conveys isolation.

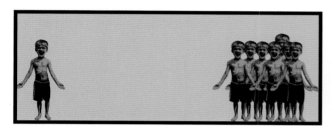

Isolation. Placement of objects can have emotional meaning.

Objects can direct the eye to an important part of the composition because of their placement in relationship to other objects. Things can appear to recede or come forward in space because of their color and value relative to the other colors and values in the picture. This is the secret to understanding the visual language. Nothing is perceived as an individual element that stands alone. Visual meaning is derived from the *relationships* between the elements in a composition. It can be used to communicate a quality or feeling that is discernable to the viewer, even while remaining unique to the artist.

Hula Hula Gal by Mark Mothersbaugh. What kind of feeling or quality is evoked by this symmetrical composition? Humorous? Unsettling? Somewhere in between? A skilled artist creates something unique while communicating something universal. Chapter five contains more images by this artist. COPYRIGHT © MARK MOTHERSBAUGH

CHAPTER TWO

MEET PHOTOSHOP

In the previous chapter we learned about the elements of the visual language and how to apply them for expressive purposes. In the exercises in this book, these visual elements will be created or manipulated using Adobe Photoshop. This chapter contains an overview of the Photoshop interface as it pertains to the projects in this book. The capabilities found within Photoshop will be your tools for personal expression, and they offer a vast array of creative possibilities. Once you understand the basics, you will face the enviable task of using your imagination in developing unique and individual ways to apply these powerful tools. Although other programs are referenced where appropriate, this book centers firmly on Photoshop as a tool for the creation of digital art. The principles discussed in the book are universal and apply broadly. Although I could easily include twenty programs and make twenty volumes of material, we have to start somewhere; and out of all those "somewheres," I believe that Photoshop is the best place. It is a pixel-based program that manipulates elements in an intuitive way.

Many Photoshop techniques are performed in a manner that is similar to the way we would manipulate physical materials: grabbing, stretching, drawing, painting. Photoshop is capable of subtlety, nuance, and organic quality.

It is quite possible to use Photoshop and a drawing tablet to paint in a traditional Renaissance style, using the "thicks and thins" of a paint brush. You can create an underpainting and use semitransparent "glazes" of color to build tones gradually. Photoshop, is also, of course, an amazing photo-editing program, capable of manipulating photographic material in endless ways with great efficiency. Many programs do one or the other, but it is the ability to draw, paint, manipulate photos and other materials, and, most important, combine them into something new and cohesive that makes Photoshop the ideal choice for this book.

Why Photoshop?

Photoshop is part of the wonderful Adobe creative suite. There is overlap among these programs in layout and functionality. Learning the tools of Photoshop will give you a head start on mastering any Adobe creative program. It is also an industry standard in multiple industries. If you were to go into an office that had anything to do with fine art, illustration, graphic design, printing, animation, filmmaking, gaming, or photography, you would most likely find Photoshop there.

If you'd like to "try before you buy," you can get a fully functional thirty-day trial version of Photoshop as a free download (see Resources on page 248). It's a very large file, so make sure you are downloading it using a speedy and reliable Internet connection. Adobe also offers a free online version of Photoshop, with limited capabilities and free gallery space, called Photoshop Express (see Resources on page 248). Adobe also sells a simplified and affordable consumer program called Photoshop Elements, which is sometimes offered as part of a free software bundle when you purchase certain scanners, drawing tablets, or digital cameras. Each of these options offers an inexpensive way to test the waters, but if you are relatively committed to creating art on a computer, there's no substitute for purchasing the genuine article. Adobe Photoshop is an indispensable tool for virtually every form of digital art.

Make sure you install Photoshop before you install the software drivers for your scanner, drawing tablet, digital camera, or any similar peripheral if you want them available in Photoshop. Free and updated drivers are generally available on the websites of their manufacturers.

A Pixel-based Program

If you were to magnify a pixel-based image sufficiently, photographic or drawn, you would see that it is made up of lots and lots of tiny squares. Each one of these squares, called a **pixel,** can only be one color and one value. Remember, value refers to the darkness or lightness of a color. If there are enough pixels in the image at the size we are viewing it, we perceive the image to be continuous and complete. If there are not enough pixels in the image at the size we are viewing it, the edges will start to appear jagged, as you can see the individual pixels that form the image.

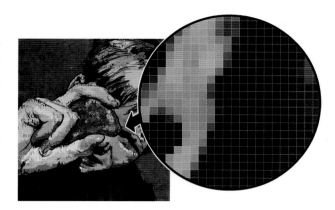

Pixel-based images are made of tiny squares (or rectangles), each of them a single color and value.

PIXEL VS VECTOR

Some programs, such as Photoshop's sister program Adobe Illustrator, are vector programs. Vector-based programs use a description language to draw or paint. Rather than being constructed of pixels, the image is made with geometric descriptions. When you select a tool, draw a vector shape, and then assign it a color and other characteristics, the software essentially translates this to: "This shape is a square, it's 6 inches in height, it's blue, etc." Because it is a description language, vector art creates comparatively small files. It is also resolution independent. This means that it can be enlarged to any size without losing any clarity. Vector drawing is ideal for flat colors, crisp lines and shapes, and smooth, uniform blending between colors.

Although I've seen interesting and beautiful vector art in galleries, particularly on the west coast, vector programs have limited application in fine arts. If your style and interests are suited to smooth, flat shapes, colors, and gradients, you would be best served by a vector software application. However, if you want the fullest range of possibilities in your digital artwork, such as grit, messiness, and nuance with a photographic or painterly quality, you will want a pixel-based program—the best and most versatile of which is Photoshop.

Pixel and vector art can be combined in the same document. You can import pixel-based images, such as photographs, into vector-based Illustrator. Photoshop has simple vector drawing tools and can import vector images. In Photoshop type is created as a vector image on a separate vector layer, so it stays crisp and clear at any size, and remains fully editable as well.

A vector image by Wendy Knapp. COPYRIGHT © WENDY KNAPP

Resolution

Unless we specify otherwise, when we refer to resolution in this book, we are discussing the **image resolution** of a pixel-based document. This is the resolution of the actual file, or in other words the artwork you are creating. People are often confused between the terms describing image resolution and the resolution of creative tools like printers, scanners, and monitors. Image resolution is measured in **PPI** or **pixels per inch**. The amount of pixels per inch at 100% of print or viewing size determines how clear your image will be. 300 PPI is good for printing. 72 PPI is standard for the Web. This is separate from **printer resolution.** (Ink-jet printer resolution is measured in **DPI, dots per inch**, or how many tiny dots of ink, per inch, make up the printed image.) It is also separate from **monitor resolution,** which describes the size and quantity of the dots of light that make up the image on the screen and affects your viewing clarity (and judgment!) but does *not* affect the actual image quality.

Opening a Document

This book observes the standard method of describing basic menu actions in software applications. If you wanted to open a document, you would access the appropriate file by going to **FILE > OPEN**. This means going to the **Menu Bar** at the top of Photoshop, clicking and holding on the word "File" in the menu, choosing "Open" from the submenu that pops up, and locating the appropriate file. I'm going to open a file called curry_back.jpg. It's located in a folder called BookArt, which I placed on my desktop. I navigate to the folder, click on the image, and hit "Open" at the bottom of the dialogue box. The image appears.

Opening a document from the Menu Bar.

Opening the document curry_back.jpg.

Orienting the Image

When we open our image, we may notice that it is on its side and needs to be rotated to its proper orientation. To rotate an entire document, such as a photograph, go to **IMAGE** > **IMAGE ROTATION** and choose an appropriate setting. If an image is on its left side, as in our example, select **IMAGE** > **IMAGE ROTATION** > **90° CW** (clockwise) to move the image into its proper orientation. If you wanted to type in a specific degree of rotation for an image, select **IMAGE** > **IMAGE** > **IMAGE ROTATION** > **ARBITRARY**. If you wanted to create a mirror image of your document, select **IMAGE** > **IMAGE ROTATION** > **FLIP CANVAS HORIZONTAL**.

Here, the rotated image is properly oriented.

IMAGE › IMAGE ROTATION › 90° CW (clockwise) moves our image into its proper orientation.

Saving Your Work: The .psd Format

Once you make changes to a document, you have to save the file in order to preserve the changes. *Don't forget to save frequently.* Even reliable, well-maintained computers crash occasionally, and you will lose work if it is not saved. When your creative work is going well and you are experiencing the state of heightened focus and interest, it's difficult and counterintuitive to interrupt your state of "flow" and save your document. However, when your work is going well and productively, this is exactly when you least want to lose work that may be difficult or impossible to reproduce.

41

To save changes made to a file, go to **FILE** > **SAVE**. Experimentation and risk are part of the creative process. By definition, some of your risks may not pay off. If you have made unsuccessful changes to a file, you may want to use **FILE** > **REVERT** to return your file to the state it was in the last time you saved it.

Photoshop's native file format is **.psd**. Unless your image is already in Photoshop format, go to **FILE** > **SAVE AS** > **PHOTOSHOP** (.psd) after you open it. This ensures that your complex and unique Photoshop information is properly preserved. When you want to save a document in another format, complete your work in Photoshop format first and go to **SAVE**, then **SAVE AS**, which makes a copy in whatever new format you have chosen, preserving your original Photoshop file.

To save our image in Photoshop's .psd format, go to **FILE > SAVE AS**.

The image that we rotated earlier, curry_back.jpg, is a **JPEG** file. JPEG (.jpg) is a very common image format. It is the format used for many consumer cameras. It is also the standard for photographic images on the Internet. Heavy image compression creates a small file size but also reduces the quality of the image. JPEG compression is very efficient. You can produce a great looking JPEG image with a very small file size. Each time you alter and resave a JPEG, however, it recompresses the image and gets rid of more information. If you do this a few times, the loss of quality can be quite significant. It's amazing how many creative people continually alter and resave JPEG files and then wonder why their images look so bad. In order to save your document in the Photoshop format go to **FILE** > **SAVE AS** >**.PSD.** Always do your work in this native Photoshop format. Save, then Save a Copy as a JPEG only at the end of your work in Photoshop, if it is needed. JPEGs can be opened just about anywhere. You can open them and view them over and over with no loss of quality. Just don't make changes and resave them . . . seriously.

Even if your image is already in the .psd format, you may find it advantageous to use **FILE** > **SAVE AS** to make a copy of your file with a different file name. This creates a new file, leaving your original file untouched in its last saved state. You may want to do this in order to experiment and create variations of a file that can be modified independently.

Curry_back.jpg is now curry_back.psd.

OTHER COMMON FILE FORMATS

Below are some other common file formats:

◆ **PDF (.pdf):** A PDF file (named for Adobe's Portable Document Format) can be opened on virtually any modern computer. A PDF file can have lossless compression and great quality, or it can also utilize **"lossy"** compression in order to reduce file size, depending on the settings you choose. It is a good format for multipage documents.

◆ **TIFF (.tif):** The TIFF format (named for Tagged Image File Format) uses lossless compression. This means you can alter and resave a TIFF file with no loss of quality. The TIFF format can also function as a container for other forms of compression, such as JPEG, so pay attention to the details of settings. It is a good format for copies of both pixel and vector art.

◆ **EPS (.eps):** A PostScript file (named for Encapsulated PostScript) is formatting language that describes how a document should print or be displayed on a monitor. It is ideal for type and vector images.

◆ **GIF (.gif):** A GIF file (named for Graphics Interchange Format) is a compressed format often used for Internet images containing large, flat areas of color.

◆ **PNG (.png):** A PNG file (named for Portable Network Graphics) is a newer format that uses very efficient data compression. Like a .gif file, it is ideal for Internet images containing large, flat areas of color; however, it may not display properly on very old browsers.

◆ **RAW FORMAT OR CAMERA RAW:** Photoshop can work with unformatted data from digital cameras that are capable of recording data in RAW format. This lack of processing allows for greater control over the image. Some people refer to a raw image file as a digital negative, which is an apt metaphor. The raw format can also be used to combine multiple exposures of the same image to produce a super-sharp mega-image with tremendous quality and tremendous file size. Many manufacturers use their own proprietary format for storing this raw data. As universal standards are implemented and processing power and storage capacity increase, expect this "non" format to obtain increasingly greater prominence.

Color Modes

Color modes are models for managing colors. Each **color mode** has a predetermined range of colors and method of color management appropriate to a specific use. If I go to **IMAGE > MODE**, I can see that curry_back.psd is in the **RGB** color mode, because it has a check mark next to RGB in the pull-down menu. This is good! Unless you have specific circumstances that require another mode, use RGB color mode for the projects in this book. Named for red, green, and blue, the primary colors in additive color (light)—as opposed to red, blue, and yellow, the primary colors for subtractive color (paint). RGB is the desired mode for monitors, TV, and ink-jet printing.

OTHER COLOR MODES IN PHOTOSHOP

Below are some of the other common color modes you will encounter:

Four-color images are printed in cyan, magenta, yellow, and black that are printed with one color on top of another.

◆ **CMYK:** The format for commercial four-color printing used for magazines, books, and other mass-market printed material is CMYK. If you are preparing a document for commercial printing with color separations (four-color printing), use CMYK. Four-color images are printed as tiny half-tone dots of cyan, magenta, yellow, and black. Each color is printed on top of the previous color in careful registration. If the dots are small enough, they will appear to form continues tones of a color image.

◆ **GRAYSCALE:** This mode is the format for black and white photos or other images with gray tonal values. This format contains no color information.

◆ **BITMAP:** This mode reduces each pixel to either solid black or solid white. There are no grays or intermediate tones. Bitmap is useful for scanned typography or ink line drawings. You have to convert bitmap to grayscale in order to use the image adjustment tools in Photoshop.

The other color modes on the menu are specialized modes that are unlikely to be used for the exercises in this book. **Indexed Color** utilizes only the 256 Internet-safe colors, ensuring accurate colors on websites. Many people prepare Web images in the RGB color space, and it works just fine. **Lab Color** is a specialized color space for advanced color and value manipulation, sometimes used by professional photographers. **Multichannel** mode and **Duotone** mode are used to set up images for specialized commercial printing with a limited number of colors.

The Photoshop Layout

Okay! We've opened a JPEG image, rotated it to its proper orientation, saved it in the Photoshop (.psd) format, and made sure that it's in the proper color mode. We know how get an image properly prepared before working on it. Now let's review the basic components of the program and how they function. We want to understand how things are organized in Photoshop in order to make it easier to utilize all the amazing art-making tools this software has to offer.

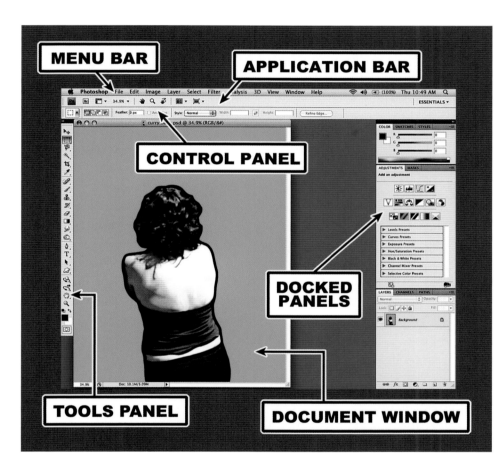

The basic components of the Photoshop environment.

Photoshop is a complex, multifaceted program, but it is designed in a very intuitive way. Once you understand the basic principles of its organization, you may find that you are able to anticipate how other, more specific functions will be performed. Things that seem like they *should* operate a certain way generally *do* operate that way. This is a good indication that Photoshop is a well-designed, user-friendly program.

Tabbed documents in the Document Window.

Arranging multiple document windows with the Arrange Documents menu.

THE DOCUMENT WINDOW

This is the window containing the actual image you are working on. All other visible panels contain tools to manipulate the image found in the document window. Multiple images can be opened simultaneously and viewed and organized in various ways.

Documents can also be organized and viewed in several different ways. They can all be opened within a single document window as tabs. If you open a new document in a window that already contains at least one document, your new document will appear in the document window, and every open document will have its own tab at the top of the window. Each tab contains the file name. Clicking on the tab selects the document that will be seen in the document window. You can drag a tab to the right or left to change its order. You can drag a tab away from the other tabs in order to have the image float in its own separate window. If more than one document window is open, you can drag a document into the tabs to have it become another tab within that document window. If your document window is too small to show all the tabs, you'll see a double arrow ⟩⟩ at the right side of the tabs. Clicking and holding on these arrows will pull up a menu containing all the documents in the window. Selecting one of these documents makes it visible in the document window.

In the **Application Bar,** there is a small icon with three windows in a rectangle, the **Arrange Documents icon** (see image at left). Clicking on this icon reveals a menu with options that allow multiple document windows to be viewed in various arrangements. You can select **"Float All in Windows"** from the menu next to the Arrange Documents icon to place all documents in free-floating windows. The icon to the right, **Screen Mode**, can be used to allow you to view your current document in isolation, with or without tools, panels, and menu bars.

THE MENU BAR

The **Menu Bar** is located at top of the screen. Various functions can be accessed by clicking and holding the menu items. Click and hold on **"View,"** for instance, and a pop-up sub-menu appears, with options associated with different aspects of how you view the contents of your document, including what elements are visible and how closely you are looking at them.

Many Photoshop functions have keyboard shortcuts for quick access. In the Menu Bar menus, commands that have keyboard equivalents have them written after the menu commands. Many menu functions can also be performed by using tools, panels, and various other methods.

THE APPLICATION BAR

In the Mac OS, the **Application Bar** is directly under the Menu Bar. In Windows, it's to the right of the Menu Bar. You can use the Application Bar to access files via Adobe Bridge (see page 51) to navigate through your documents and determine how they are viewed. The viewing and navigation tools found within the Application Bar can also be accessed through the **Tools Panel.** One of these tools is the **Rotate View tool** . When you click on this tool, you can click, hold, and drag on the image to determine your viewing orientation. When we're drawing on a piece of paper, we might turn it sideways to make it easier to work within a certain area. The Rotate View tool allows us to do this in Photoshop. It does not rotate the actual document and should not be confused with **IMAGE > IMAGE ROTATION** that we used earlier to rotate our document to its proper orientation.

THE CONTROL PANEL

The **Control Panel** is found near the top, underneath the Menu Bar and (in Mac OS) underneath the Application Bar as well. The Control Panel, also known as the **Options Bar**, contains options associated with the currently selected tool. The menu options are specific to whichever tool is selected and change when a new tool is chosen.

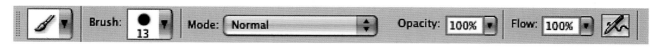

The Control Panel, also called the Options Bar, offers choices specific to the tool that is currently selected.

DOCKED PANELS

Many functions in Photoshop are accessed in **Panels.** These panels, for convenient access, can be docked, floating, collapsed, or tabbed in combination with other panels. You can place a panel into a group of tabbed panels by dragging its tab onto any tab within a group. You can drag a panel by its tab to separate it from a group and make it free-floating. You can expand or collapse panel groups by clicking in the dark gray bar on top. You can grab a docked panel group on its edge to drag it and change its size. In the upper right corner of the Application Bar you'll see a word with an arrow next to it, which is the **Workplace Switcher.** By default, this will say **"Essentials."** If you click and hold the arrow next to this word, you can access workspaces with panel arrangements designed for various tasks. You can save your own workspace and corresponding panel arrangement by selecting **SAVE WORKSPACE** from this menu and giving your workspace a name. To view a panel, go to **WINDOW**>(name of panel) in the Menu Bar. Choosing the same panel again in the Window menu makes it disappear.

Photoshop Panels are accessed under the Window menu.

THE TOOLS PANEL

The Tools Panel is, by default, aligned with the upper left corner of the screen. All components of the Photoshop interface can be moved customizable. Holding your mouse over a tool momentarily will cause a **"Tool-tip"** to pop up, which tells you the title/function of each tool. To enable or disable this feature, Mac users should go to **PHOTOSHOP > PREFERENCES > INTERFACE** and check or uncheck **"Show Tool Tips."** Windows users should go to **EDIT > PREFERENCES > INTERFACE**. Tools with little triangles in the lower right corner have other tool choices available. Click and hold on one of these tools to see the other tool choices and variations.

Holding your mouse over a tool will cause a "Tool-tip" to pop up.

THE HISTORY PANEL

The **History Panel** is likely to be one of the features of Photoshop that you will use the most. If you wish to undo multiple actions, you can return to a previous state in your document's history by clicking on one of these states, listed in chronological order, in the History Panel. If this panel is not visible, you can access it by going to **WINDOW > HISTORY**. If there is a check mark next to the word **"History"** in this pull-down menu, it should be accessible somewhere on your screen.

Tools with little triangles in the lower right corner have other tool choices available underneath.

By default, Photoshop remembers the last twenty actions taken. In Photoshop's preferences you can change these settings to include more previous states, but doing so can greatly increase the amount of memory and available hard drive space needed to process an image efficiently. You can click on the little **Camera icon** at the bottom of the panel to create a snapshot of a selected state that will be remembered as long as the document is open, even if it is not among the twenty most recent actions.

It's also possible to use the History Panel to revert only *part* of a document to a previous state. Let's say you're working on a photographic portrait and you are happy with improvements made to skin tones and overall value, but these changes have made the eyes, in particular, lose some detail. In this particular area only your actions were not beneficial. If you wish to revert the eye area to a previous state, you can do so by clicking on the square to the left of any state in the History Panel, then selecting the **History Brush tool** in the Tools Panel and painting in the area(s) you wish to revert to a previous state. When you close a document, Photoshop will not save the previous states of history.

Undo your recent actions with the History Panel.

GETTING A CLOSER LOOK

It's often desirable to change the magnification of a document. You can "zoom in" on a certain area of your image in order to more clearly view details in your work and then "zoom out" to view the work in context. Photoshop offers multiple tools for changing image magnification.

The Zoom tool 🔍 in the Tools Panel (and the Application Bar) can be used to zoom in on an area by clicking on it. Hold the Alt/Option key (or select the magnifying glass icon with the "minus" symbol on the left side of the Control Panel) to zoom out. You can also click-and-drag the Zoom tool to select an area to fill the screen. When the Zoom tool is selected, clicking "Fit Screen" in the Control Panel is a quick way to view your entire document at the largest possible size on your monitor. When the Zoom tool is selected you can select "Zoom All Windows" in the Control Panel to change the magnification of multiple documents windows simultaneously. Options for magnification are available under the **View** menu as well.

Zoom tool options. Clicking "Fit Screen" lets you view your entire image at maximum size.

Photoshop has a specialized panel for image magnification, the **Navigator Panel.** Adjust the slider at the bottom of the panel to zoom in or out. Drag the red square in the image area over a specific area to magnify it.

When your document is magnified so that you can't see the entire image, you can select the **Hand tool** ✋, which shares a space with the Rotate View tool in the Tools Panel, and then click, hold, and drag to change the area you are viewing in the Document Window. When the Hand tool is selected, you can select **"Scroll All Windows"** in the Control Panel to scroll through the viewing areas of all open document windows simultaneously.

The Hand tool does not actually move objects in your document. It only changes what you are looking at. The **Move tool** ➤ is used to actually move the elements in your document. When this tool is selected, just click on any unlocked element and drag.

The Navigator Panel allows you to quickly view a specific area and change the degree of magnification within a document.

Adobe Bridge

What if you're not sure what image you want to open? What if, for instance, you had a whole folder full of photographs you had taken on a specific occasion and wanted to look through them and select just a few of them to work with? Photoshop has a convenient tool to assist you with this task.

Adobe Bridge offers a convenient way to view and organize your images.

Adobe Bridge is a separate software application that comes free with Photoshop and other Adobe creative applications. It is installed by default when you install Photoshop. Adobe Bridge can display images and content inside any folder to which you navigate. You can adjust the viewing size of the images using a slider located in the lower right-hand corner of the application window. You can change the method of viewing your image by choosing another option, such as "**Filmstrip**" at the top on the panel. Adobe Bridge can also be used to organize groups of photos and facilitate batch processing of multiple images. I find the application very helpful in viewing artwork and selecting a consistent group of images to submit to a gallery. Adobe Bridge can be accessed from inside Photoshop and other programs in the Adobe Creative Suite by going to **FILE > BROWSE** or clicking on the **Bridge icon** Br in the Application Bar.

Drawing Tablet and Pen

Many of the projects discussed in the early chapters of this book can be done with a mouse. When it comes to drawing and painting, however, it's very difficult to do a good job without using a **drawing tablet** (also known as a **graphics tablet**) and a pressure-sensitive **pen** (**stylus**). I strongly encourage you to get one, practice with it until you are comfortable, and use it on the projects in this book whenever appropriate, especially in later chapters. There is more information on drawing tablets in chapter six.

Wanna Make Something of It?

Okay. We've talked about digital art and its revolutionary potential. We've learned how to use the visual language for communication and self-expression. We've been introduced to Photoshop and learned how to gain access to many of the important art tools we will be using to create the projects in this book. Now we're ready to start making things! At the end of each chapter there are project assignments that summarize the concepts we learned. I suggest doing these assignments. It's all academic until you get behind the wheel. Sit down, explore, struggle, refine, and make some art!

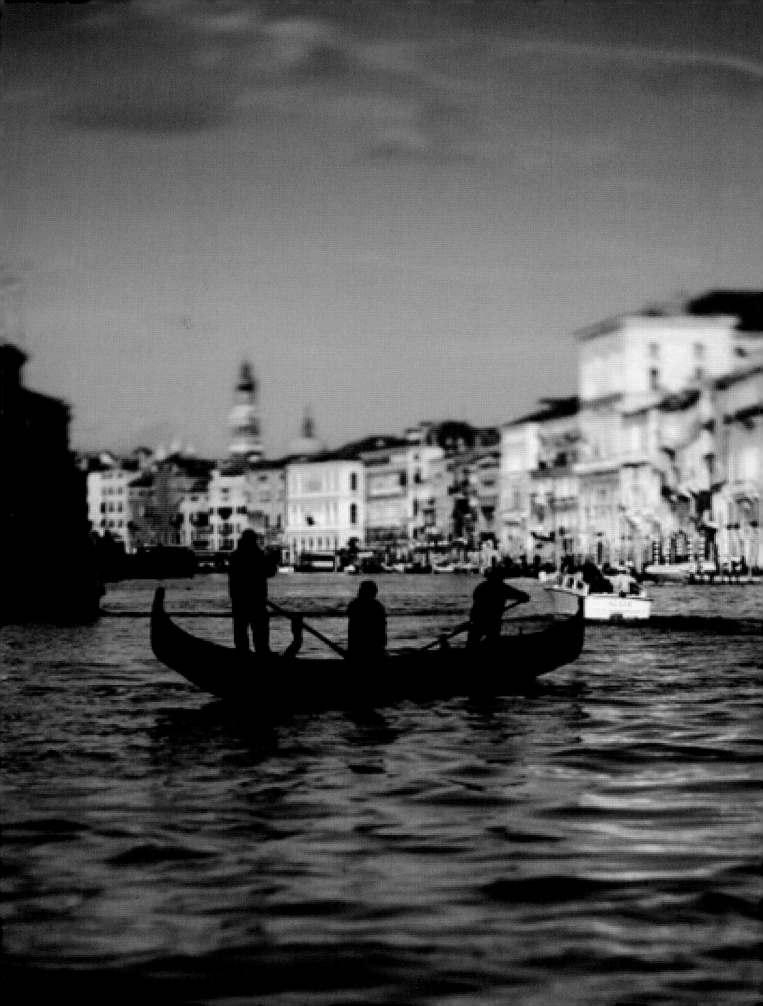

PHOTO BASICS

Simple enhancement of photographic images is a good way to begin our work. Instruction in this chapter involves modifying the color and value of an entire image, or individual elements, for clarity and visual interest. This chapter will address the use of atmospheric perspective to convey a sense of depth and to further clarify an image. We'll learn about using the retouching tools in Photoshop, which can be used to de-emphasize human imperfections, of course, but they can also be used to remove extraneous elements in order to improve and clarify a composition. As in chapter two, we will learn how to use many of the fundamental tools of Photoshop and how to exercise creative judgment in their use. You'll continue to use these tools in more complex and creative projects later in the book.

CHAPTER THREE

Many great photographers achieve spectacular results by using advanced camera settings in addition to traditional darkroom techniques. If you're not one of them, I suggest taking a standard, clear digital photograph with a full range of tonal information and then modifying the image in Photoshop later. If you have a good, accurate image to work with, you can experiment and push the image in any number of directions until you get exactly the effect you're looking for. Once you have taken the pictures and opened them in Photoshop, let's take a look at some of the basic things we can do to enhance images. In the following short exercise we'll learn how to improve the composition of an image.

The Nesting, photo by Stephen John Phillips. Don't try this at home! The image was created using in-camera and darkroom techniques to push the photo in a distinctive direction—a sepia tone was applied to the black-and-white image. If you're not an expert photographer like Stephen, capture the basic information in the camera and then experiment in Photoshop so that you can retrace your steps if your changes don't create the desired effect.

It is often useful to crop a photo in order to improve a composition or remove an unwanted area from an image. In this first exercise I'll crop the image on the right to emphasize the figures in relation to the monolithic icon behind them.

① Make the Selection

I can perform this action by selecting the **Crop tool** ⌗ from the Tools Panel. With this tool selected, I click, hold, and drag a selection to create the approximate position of my crop. By default, a gray tone will appear in the areas outside my selection. This helps me visualize what the cropped image will look like. You can refine your crop area by clicking and dragging one of the little white squares found on the corners and center of each side of your selection.

② Accept the Selection

Once you are comfortable with your crop, click on the check mark ✔ in the upper right area of the Control Panel in order to complete the crop.

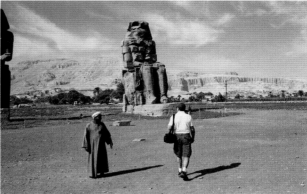

Images can be cropped to enhance a composition or change its emphasis. Above is the original photo.

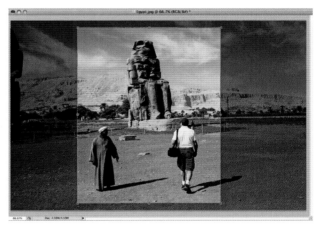

The Crop tool is used to create the approximate position of your crop.

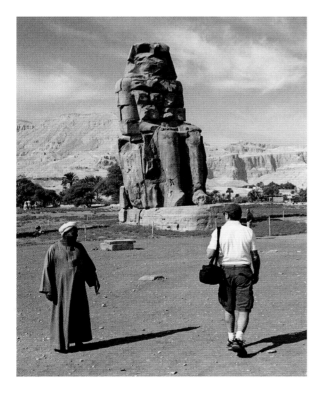

The cropped image, with its new composition.

Enhancing Value and Color

Many photographic images can benefit from adjustments to their value and color in order to improve clarity, accuracy, or visual interest. Photoshop offers a variety of effective methods to enhance, or modify, the value and color of an image.

Dakota by Steven Parke. Before. COPYRIGHT © STEVEN PARKE

The final image after using Photoshop image adjustments.

Jump by David Spatz. Before. COPYRIGHT © DAVID SPATZ

The final image. Adjusting the value (dark to light) within an image can affect color as well. The artist made only value adjustments on this photo, but creating a full and accurate range of values also improved the color of this photo.

AVOID USING "AUTO" ADJUSTMENTS WHEN LEARNING

Photoshop has tools for adjusting value and color automatically. Under the Image menu, you'll see **IMAGE > AUTO TONE, IMAGE > AUTO CONTRAST,** and **IMAGE > AUTO COLOR.** I recommend that you do not use these tools when familiarizing yourself with image adjustments in Photoshop. With practice and careful judgment, you will achieve the best results by making manual changes and then observing, reacting, and refining your changes. Learn to rely on what you see. Additionally, this book is about creating artwork that is unique and personally expressive. In later projects, as you modify your colors and values in support of your compositional ideas, "auto" image adjustments will become less than useless.

Tools for making changes in value and color, as well as the ability to create some specialized effects, are found within the **Adjustments Panel.** If you don't see the panel, you can access it by going to **WINDOW > ADJUSTMENTS.** Avoid the presets in this panel for now. Let's practice using our judgment. These image adjustments are nondestructive. This means that Photoshop remembers the original state of your image. Any changes you make to value and color can be modified or deleted later.

It's possible to make destructive (permanent) changes to value and color by going to **IMAGE > ADJUSTMENTS** in the Menu Bar and accessing the appropriate panel. There are also additional options found under **IMAGE > ADJUSTMENTS** that are not found within the Adjustments Panel.

The Adjustments Panel is used to make changes to value and color.

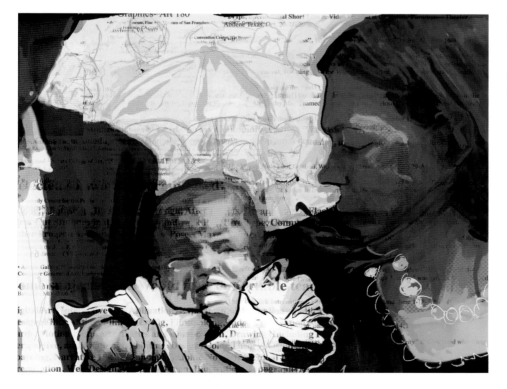

Every End a Beginning by the author. Photoshop couldn't possibly auto-correct the color in this image! An artist must learn to use his or her judgment when adjusting value and color.

IMPROVING A PHOTO WITH BASIC IMAGE ADJUSTMENTS

In this exercise, I'll go through the process of adjusting the value and color of an image with the goal of making it clearer and more visually pleasing. In the original photo below, we have an image of a little guy at the beach. Although the basic range of value and color information is there (with no highlights washed out or detail lost in shadow), it's a little faded, lacks contrast, lacks color saturation, and is perhaps a bit too purple in general hue. It's a nice snapshot, but it could be improved using some basic image adjustment tools in Photoshop.

Remember, as you make changes in a photo, use your eyeballs and your brains! When you move a slider look at what you see, and then react to it. Your judgment will improve with practice and familiarity with the tools. Err on the side of caution! Exaggerated image adjustments create an unnatural appearance. By making ill-considered image adjustments, it's possible to lose information in tone, color, and/or image detail. Extreme settings in image adjustment can quickly become special effects. This might be perfect as a starting point for a creative project; but if your goal is to improve a standard photographic image, however, exercise restraint when you move those sliders! Generally speaking, it's best to adjust the value first and then make changes in color, since color can be affected by modifications in value.

We'll adjust the value and color of this image to make it more visually appealing.

❶ Adjust the Value

Let's use the **Levels Panel** to adjust the tonal range of the image, from dark to light. Click on the **Levels icon** 📊 in the Adjustments Panel.

In the Levels Panel you will see a graph representing the range of value in an image. The three little triangles under the graph represent dark, mid-range, and light values. If you see an area on the left, or right side, of the graph that contains no information at all, you could try moving the "dark" or "light" **value slider** to the area where the information on the graph begins. I move the left triangle (representing the dark areas) to the right until it is at the left edge of the "mountain" of value information in our graph. I then move it back and forth until I see improvement in the dark values of the image but that no detail is lost in the shadows. I move the triangle on the right (representing the lightest values) to the left until I reach the approximate area where value information began on the graph. I then move it around until I improve the highlight values without causing the bright areas to "wash out" and lose detail.

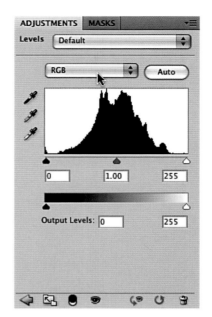

The Levels Panel graph describes the range of information in our original photo from dark (on the left) to light (on the right).

Then I move the middle triangle, representing the middle values in tone. I move it back and forth, observe the results, and end up moving it slightly to the left to open up the mid-range values in order to compensate for my changes to the dark and light sliders. The mid-range value slider can significantly modify the clarity and detail of the tonal range. Sometimes, you may not need to adjust the dark or light value sliders much at all. The **output slider**, at the bottom of the panel, is used to limit the possible value range of the entire image, thus reducing contrast. I leave this untouched.

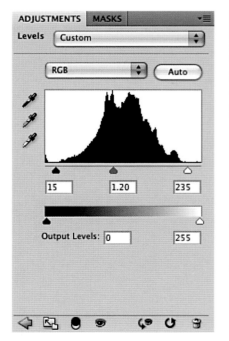

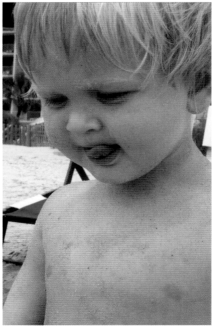

Left: Adjustments are made to the Levels Panel in order to improve the range of value (tonal range) in our image.

Right: The image, after adjusting the value.

NOTE: The Curves Panel is another option for adjusting the value range of an image. In this panel you adjust the tonal value by altering the shape, or position, of the diagonal line crossing the graph in the panel. Photoshop professionals often swear by the Curves Panel as the best method for value adjustment because of the amount of control and detail it offers. I find that beginners can find these options overwhelming, and are more likely to inadvertently lose tonal information or make bad decisions. If you are an artist that uses photography heavily, I would encourage you to investigate the Curves Panel once you are fully confident and have practiced image adjustments.

Photoshop makes the adjustments on a separate **Adjustment Layer.** Photoshop enables elements, or information, to be placed on individual layers so that they can be manipulated separately. You can access the **Layers Panel** by going to **WINDOW › LAYERS.** Inside the Layers Panel, there is an **eye icon** to the left of each layer. Click on the "eyeball" next to your Levels Adjustment Layer to make the layer invisible and to see the image as it was before you made the changes. Toggle the eye on and off to do a before-and-after comparison whenever you perform any image adjustment. Did you make the image better or worse? If you improved the image adequately, proceed to the next step. If you made it worse instead of better, double-click on the layer and then readjust the settings in the Adjustment Panel or simply drag the Adjustment Layer to the trash can at the bottom of the Layers Panel to delete it and start over. We'll cover layers in greater depth in the next chapter. Once you have made an image adjustment, you can return to the main Adjustments Panel by clicking on the arrow located in the lower left of the panel.

The Layers Panel. Click on the "eyeball" to the left of your Levels Adjustment layer to make your changes invisible and to do a before-and-after comparison to make sure you improved the image.

2 Adjust the Color

Now we're ready to adjust the color of the image. To do this we'll go to the Adjustments Panel and click on the **hue/saturation icon** to access the corresponding settings.

In the **Hue/Saturation Panel,** the **hue slider** adjusts the color of an image. Moving this slider slightly to the right or left can adjust the color temperature to make it either more natural or more appealing. The image we're working on had a slightly purple tint to it, so I push the hue slider to the right to correct the general color temperature of the image, until the skin tones looked more natural.

The **saturation slider** controls color intensity. I move it slightly to the right to make the colors in the image more vibrant and intense. Moving it to the left reduces color intensity, and moving it all the way to the left results in a black and white image.

The **lightness slider** affects the overall value of the image. Since we have already addressed value changes in step 1, we'll leave this slider unchanged. Make sure that **"Master"** is selected in the pull-down menu at the top of the panel to affect all colors.

Within the Hue/Saturation Panel you can also adjust colors individually by selecting them from the pull-down menu instead of **"Master."** The **Color Balance Panel** is a separate panel that uses sliders to individually adjust the levels of red, green, and blue—the primary colors in additive color (light). Adjusting individual color channels allows for

more control and versatility, but also has more potential to create unnatural or undesirable changes if you are a beginner.

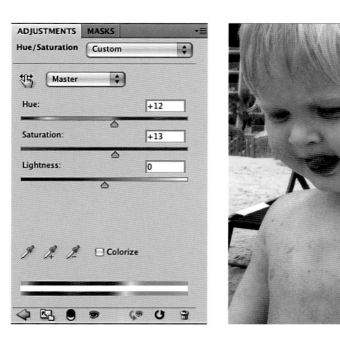

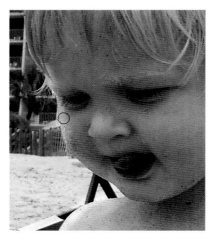

Left: The Hue/Saturation Panel. I push the hue slider to the right to correct the color temperature of the image. I also boost (color) saturation by slightly moving the saturation slider to the right.

Right: The image with color temperature and saturation adjusted.

③ Use the Dodge, Burn, and Sponge Tools

The **Sponge tool** can alter the color intensity of an area when you click, hold, and drag over it when this tool is selected. You can choose **"Mode: Saturate"** to increase color intensity or **"Mode: Desaturate,"** to lessen it. You can adjust the size and type of brush within the Control Panel. In the image below, I use the Sponge tool to saturate the color of the background. This works against the idea of atmospheric perspective, where color intensity would decrease with distance. In this case, however, I felt it was appropriate. Higher color intensity in the background helps to unify the image and create greater visual interest as a counterpoint to the large areas of flesh color. I also use the Sponge tool to desaturate the mouth slightly because it was beginning to look unnatural.

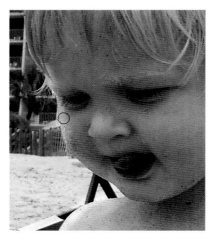

You can use the Dodge, Burn, and Sponge tools (respectively) to lighten, darken, or change the color saturation of specific areas. Here, the Sponge tool is used to saturate colors in the background, and the Dodge tool to emphasize highlight areas.

When selected, the **Dodge tool** lightens specific areas when you drag over them. In the Control Panel, **"Range"** determines which value range is most affected by your use of the Dodge tool. **"Exposure"** determines the degree of the effect. I choose **"Range: Highlights"** and **"Exposure: 28%"** and paint over the left side of the face and body to exaggerate the highlight. Using a relatively small number as the setting for "Exposure" helps make the changes less drastic.

The **Burn tool** has the opposite effect. It darkens any area upon which you use it. The Burn tool offers the same modification choices as the Dodge tool. I feel the contrast in the image is now sufficient and therefore do not use the Burn tool. I now judge the image to be finished. The changes are subtle enough to appear natural, and the photo is significantly improved.

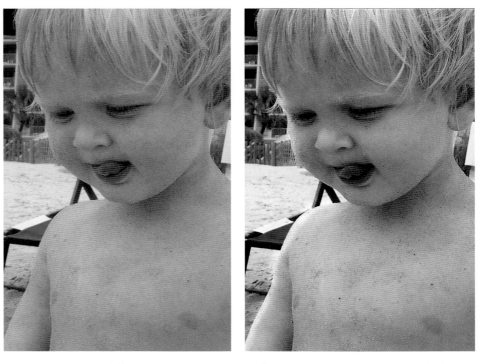

The original image.

Our finished image, with all of our color and value changes.

CONVERTING A COLOR PHOTO INTO A BLACK-AND-WHITE PHOTO

In this exercise, we'll take a color photo and convert it into black and white using two methods.

1 Method 1: Desaturate the Image

The simplest way to convert a color image to black and white is to use **IMAGE › ADJUSTMENT › DESATURATE.** The color information disappears, and you will have a black-and-white image. As you can see in the image on the lower right, simply desaturating the image looks okay, but not spectacular. Differences in color help to define objects against a background, even if the value of the objects is similar. When you get rid of color information, however, a lack of value contrast between elements can transform a good color photo into a mediocre black-and-white photo. Fortunately, Photoshop has other methods for creating black-and-white images that offer greater control over the process. In the second method, on the next page, we'll adjust the individual color channels to improve the overall image instead of simply desaturating it.

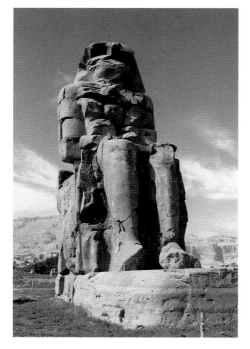

The original photo is a strong source for creating a black-and-white image.

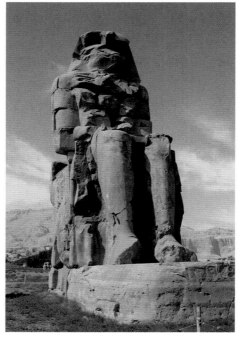

IMAGE › ADJUSTMENT › DESATURATE is used to make this black-and-white image. The result is okay, but it could use further adjustments in value.

NOTE: The Channel Mixer Palette 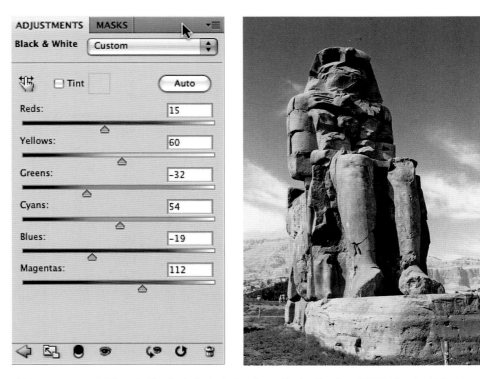 has individual color sliders that are determined by the color mode you are currently using. This panel is often used to convert a color image to black and white by selecting the "monochrome" box and then adjusting the individual sliders. It has several useful presets.

Method 2: Adjust Value Range in the Black & White Panel

Within the Adjustments Panel, you can select **"Black & White"** to access a greater variety of options in the creation of a black-and-white image. The Black & White Panel has sliders representing the value information found within specific colors. You can use these sliders to emphasize or de-emphasize the value range within a specific color. You can take advantage of these expanded options to create a richer, more appealing black-and-white image. I make subtle changes to our photo and carefully observe each area of the image once I make the changes. Adjusting individual color channels can create complex interactions, even when dealing only with tonal information. Using the Black & White Panel, I'm able to achieve a much more dramatic effect.

This image was created by adjusting the individual color channels using the Black & White Panel, which allows for more control over the final image. This image was created using the settings on the left.

Selection Masking

Specific areas of a composition can be selected so that only those areas are affected by an action taken in Photoshop. Once you have created a selection mask, if you were to adjust the levels, for instance, only the selected parts of the image would be altered. You could also delete this part of the image, enlarge it, fill it with color, copy and paste it, duplicate it, resize it, process it through a filter, or drag it onto another Photoshop document. Being able to select and independently manipulate individual areas of a composition gives you tremendous control over the completed image.

Top: *Carwash 1*; middle: *Carwash 2*; bottom: *Carwash 3* by Susan Greenspan. Susan took these photos and refined their value and color in Photoshop using the Image Adjustment tools we just learned. These images of a carwash are both painterly and accurately descriptive photographic images. Copyright © Susan Greenspan

WORKING WITH SELECTION MASKS

In this exercise we'll create a selection mask and use it to isolate a figure from its background and then modify each of them independently. The project is based on the idea of atmospheric perspective. Objects in the distance become blurrier. They lose their extremes in value (highest highlights and darkest shadows). They lose their color intensity. These are visual clues we use to judge distance and make sense of what we see. We can use this concept of atmospheric perspective to visually separate a foreground subject from its background and clarify the image. This idea can improve a photo where the figure is in front of a busy background that could detract from the focal point of the composition. Try the following exercise, but don't use this on every photo. We're learning techniques, not gimmicks!

❶ Use a Selection Mask to Crop the Image

You can create rectangular selections using the **Rectangular Marquee tool.** You can create elliptical (oval) selections using the **Elliptical Marquee tool.** Holding down the Shift key while dragging with these tools will create a perfect square or a perfect circle. You can select a single row of pixels across a document by clicking on an area with the **Single Row Marquee tool** (horizontally) and the **Single Column Marquee tool** (vertically). You may not use the Single Row and Single Column tools all the time (or ever!), but I've seen some specialized creative uses for these tools such as filling them to create a hairline rule, stretching the pixels in the selections to create stripes or patterns, and using them to define precise edges for a selection.

The Marquee Selection tools.

Since we are exploring selection tools, let's use a selection created by the Rectangular Marquee tool as an alternative method to crop the photo. Click, drag, and release the mouse button to create a selection for the crop area. When any selection is completed, you'll see a distinct border around the selected area consisting of animated dashes. When the selection is complete, go to **IMAGE > CROP** to crop the photo to your selected area.

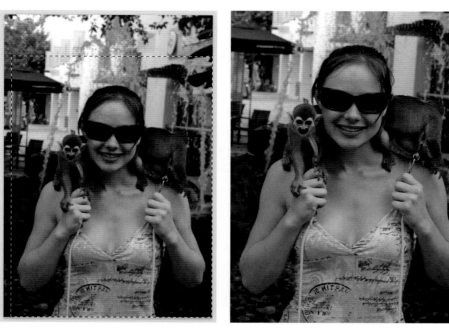

Making a selection using the Rectangular Marquee tool.

Using the selection mask to crop the photo.

② Mask the Figure

Our next step is to create a selection mask around the figure so that we can isolate it and modify it independently from its background. The selection of complex and organic shapes within an image can be made using the **Lasso tools**. There are three Lasso tools. Click and hold on the Lasso tool that is visible in the Tools Panel to view and select any one of them. They are:

◆ **LASSO TOOL:** Makes a selection by drawing. This works well with a tablet and pen.

◆ **POLYGONAL LASSO TOOL:** Makes a selection by clicking and dragging. This works well with the mouse, but you may need to refine your edges when you are done.

◆ **MAGNETIC LASSO TOOL:** Clings to edges as you drag the mouse over an area. You can click to add a point manually, which helps to define sharp corners. This tool works best with clearly defined edges.

The Lasso Selection tools.

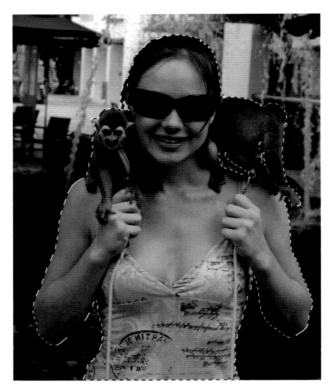

The Polygonal Lasso tool is used to create a selection mask around the figure.

Using the Subtract from Selection option to remove unwanted areas from our initial selection.

Since the Polygonal Lasso tool works well with a mouse, I'll use it to create a simple mask around the figure. I click, go to a nearby point along the edge, and click again to create a line between the points. I make small areas between clicks to avoid creating a mask with obvious geometric edges. All Lasso selections are completed by reconnecting the end of your selection mask to the point where it began, forming a complete shape. A hollow circle will appear to the lower right of your cursor in the document window when you are near your beginning point, making it easier to find. I will need to find the beginning in order to close (and thus complete) the selection.

When using the Polygonal Lasso, hit the Delete key to get rid of your last "click" point. You can do this multiple times in order to retrace several steps. If you become confused and want to start over, you can delete your partially completed selection area by hitting the Escape key. Even if the mask is not perfect, complete the mask by connecting the end to the point where it began. In the next step, we'll learn how to refine and improve a selection mask.

③ Improve the Selection Mask

When a **Selection tool** is chosen in the Tools Panel, you'll see four connected squares on the left side of the Control Panel. If you hold your mouse over each square, you will see that from left to right these squares correspond to:

◆ **NEW SELECTION:** Creates a new mask each time you draw a selection shape, deselecting any previously selected areas.

◆ **ADD TO SELECTION:** Adds to a previously selected area. You can select multiple areas, and each will be added to your selection without deselecting previously selected areas.

◆ **SUBTRACT FROM SELECTION:** Enables you to deselect specific areas of a previous selection, leaving the remaining areas selected.

◆ **INTERSECT WITH SELECTION:** Allows you to draw selections where the only the area of overlap (or intersection) will remain selected.

If your mask is not perfect, use **Add to Selection** to select additional areas that you may have missed in your initial selection. Complete the selection, and this area will be added to your mask. Use **Subtract from Selection** to select areas that were accidentally selected in your initial selection. Complete the selection to subtract these areas from your initial mask. I use both options several times to clean up my selection mask for the image.

Clicking on "**Refine Edge**" ⬭ Refine Edge... in the Control Panel opens up a panel that allows you to smooth or blur the edges of a mask, as well as expand or shrink it. **Feather** creates blurred or "fuzzy" edges around the borders of a mask. You can control the extremity of these effects with the individual sliders. You can preview your selection in multiple ways by clicking on one of the five icons toward the bottom of the panel and viewing the results before you commit.

When I use the **Refine Edge Panel** to preview our selection mask, I can see that it can benefit by smoothing the edges, feathering (softening) them a bit, and expanding the edges of the mask—enlarging it very slightly. Once I have made the necessary adjustments, I hit **"OK"** to refine the edges of my selection mask.

NOTE: Refine Edge can also be accessed in the **Masks Panel**, which is located in a tab behind the Adjustments Panel by default. You can also create a mask in the Masks Panel by selecting "**Color Range**" and using the **Eyedropper tools** to sample, add to, or subtract from the colors selected. Adjusting the **fuzziness slider** determines how close to the sampled color(s) your pixels must be in order to be selected. The Masks Panel can also be used to adjust the density (opacity) of a mask, or "feather," a selection from inside the Masks Panel.

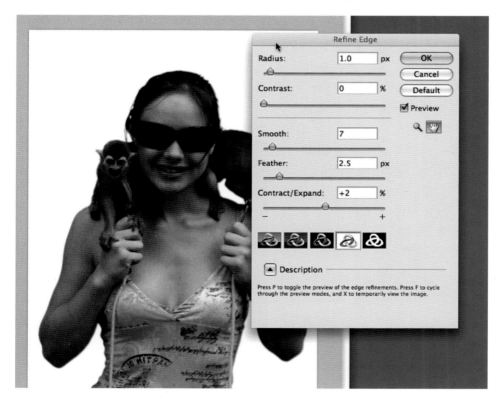

Using the Refine Edge Panel to fine tune the selection mask.

④ Enhance the Value and Color of the Selected Figure

The creation of a complex mask might represent a considerable investment in time and effort. To save my selection for later use, I go to **SELECT › SELECTION,** name it, and click **"OK"**. My selection will be found in the Channels Panel. If I wish to make it reappear later, I'll use **SELECT › LOAD SELECTION,** choose my selection under **"Channel"** and click **"OK."** Now I'm ready to make image adjustments to the figure.

The Levels Adjustment Layer, with a layer mask thumbnail.

When I have made my selection, I choose **"Levels"** from the Adjustments Panel. I see a selection mask attached to the Levels Adjustment Layer in the Layers Panel, indicating that only the area within my mask will be affected by changes. Now we adjust the levels, with the goal of clarifying the tone and strengthening the contrast in the selected figure.

Left: Adjusting the levels within the selected figure.

Right: The image, after using levels to strengthen value and contrast within the figure.

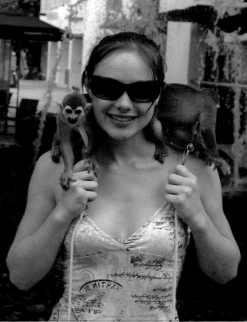

Next, I go to the Adjustments Panel again and select **"Vibrance."** The **Vibrance Panel** allows you to boost the saturation only in those colors that are lacking color intensity. It can boost the general color intensity of our selected area without oversaturating the skin tones and making them unnatural.

The Vibrance Adjustment Layer clipped to the Layer Mask.

Before I go to the next adjustment, however, there's one other thing I need to do. By default, any image adjustments will affect all layers below them. It's possible to create a clipping layer that "clips" a mask to a specific layer so that the mask only affects the layer directly beneath it. I click on the **clip to layer icon** ●, the third from the left at the bottom of the Adjustments Panel, in order to clip my Vibrance Adjustment Layer to the layer below it so that only my masked area (the figure) is affected by my changes. With the Adjustment Layer clipped to my selection mask, I boost the vibrance quite a bit, and saturation only a little.

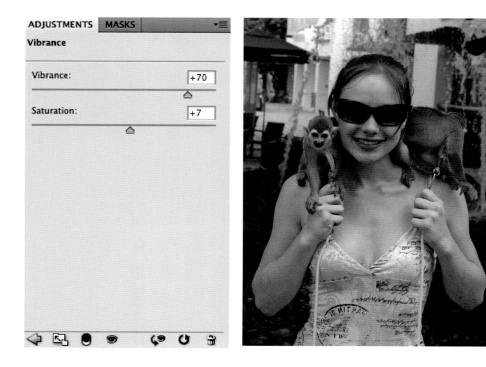

Left: The settings used to modify the image in the Vibrance Panel in order to boost color intensity within the selected figure.

Right: The image after boosting color intensity within the Vibrance Panel.

Sharpen the figure with Unsharp Mask.

5 Sharpen the Figure

Next, I sharpen the foreground image. I go to **SELECT › LOAD SELECTION** and choose my figure mask, which I saved earlier. With this selection active, I make sure the original image layer is selected (as opposed to an Adjustment Layer) by clicking on it in the Layers Panel. I go to **FILTER › SHARPEN › UNSHARP MASK**. This filter sharpens the edges in an image. I adjust the sliders to achieve the desired degree of sharpness. The **amount slider** increases or decreases the contrast in the sharpened edges. The **radius slider** widens or reduces the edge area that is sharpened. The **threshold slider** determines the amount of contrast needed to consider something an "edge." Moving this slider to the right can soften the sharpening effect. I was able to sharpen the image considerably, but generally speaking, exercise restraint and sharpen an image only slightly. Too much sharpening will give the image an unnatural appearance.

6 Use Value and Color to De-emphasize the Background

Now we're ready to start working on the background. We don't have to create a new mask. We can select the background with **SELECT › INVERSE**. This command selects the exact opposite of the previously selected areas of your image.

Select Inverse to select the background instead of the foreground.

Now, with our inverted selection active, I can select **BRIGHTNESS/CONTRAST** in the Adjustments Panel and decrease the contrast and brightness of the background.

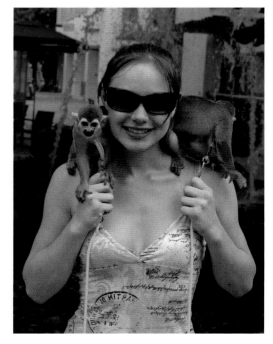

Left: Decreasing value contrast in the background area with the Brightness/Contrast Panel.

Right: The image, with lower contrast in the background.

Next I click on Hue/Saturation. Again, I make sure to click on the clip to layer icon at the bottom of the Adjustments Panel to clip my new Adjustment Layer to the masked layer below it so that only the background will be affected. I decrease the saturation (color intensity) within the background selection.

Left: Using Hue/Saturation to reduce color intensity in the background.

Right: The image, with a desaturated background color.

7 Blur the Background

I will now blur the selected background area, slightly but noticeably. I load my selection mask one more time, make sure that my image layer is selected in the Layers Panel and then go to **FILTER › BLUR › GAUSSIAN BLUR.** I adjust the radius slider to noticeably blur the background of our image.

Blurring the background with Gaussian Blur.

Remember, it's easy to make image adjustments too extreme, causing an image to appear unnatural. This effect will become more noticeable when the image is printed. Be subtle. Make adjustments until they look right, and then lessen them slightly.

Left: The original photo.

Right: The finished image, with blur applied to the background.

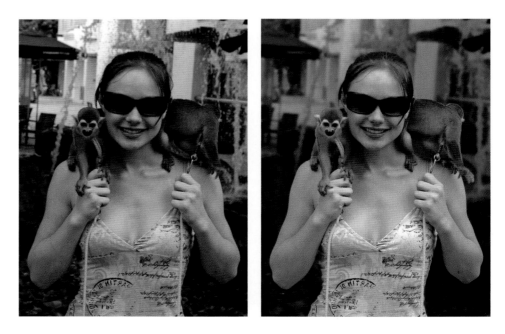

The Magic Wand and Quick Selection Tools

The **Magic Wand tool** can be used to instantly create a mask based on similarity of color and value. If you wish to select an area of solid, uniform color, for instance, the Magic Wand tool will save a lot of time and effort. Simply click on an area that contains similar pixels. The more nuance and variation in your image, the less helpful the Magic Wand tool will be. Adjusting the "Tolerance" in the Control Panel determines how similar the pixels need to be in order to be selected. Selecting **"Contiguous"** will only select pixels that are touching each other.

The **Quick Selection tool** selects areas when you click, hold, and drag over them. This tool also functions best with well-defined areas of similar color and value. However, you may find that you are able to use it to make selections that are not possible to make with the Magic Wand tool.

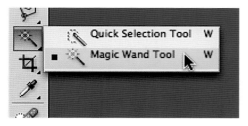

The Magic Wand tool and Quick Selection tool.

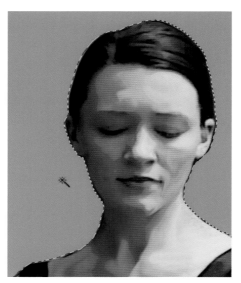

Sneak Preview! The Magic Wand tool was used to select a solid green color in this painterly image from exercise 2 in chapter eight.

QUICK MASK MODE

In **Quick Mask Mode,** selection masks can be made by painting them in with the Brush tool. This can have the advantage of creating a mask with more natural, organic edges. If you paint the edges with a small blurry brush (not too blurry!) it will create a natural blending effect. If you paint with a semitransparent brush in Quick Mask Mode, you can create semitransparent areas in your selection. This is useful for masking wisps of hair or other ephemeral elements, as well as for achieving specialized effects. The lower the Opacity setting, the more transparent the area will be when you paint in the selection. I'll use the Quick Mask Mode to create a selection mask around a figure in the next exercise.

5 CREATING A SELECTION MASK IN THE QUICK MASK MODE

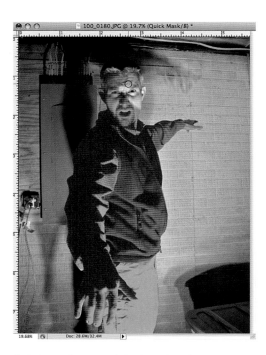

Painting a selection with Quick Mask Mode. We'll see this gentleman again in the next chapter.

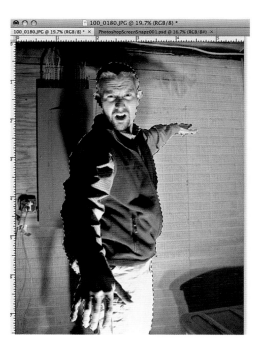

Once you exit the Quick Mask Mode, your painted area becomes a selection mask.

Before we begin, I first make sure that my foreground and background colors at the bottom of the Tools Panel are black and white, respectively. There is a little symbol of overlapping black and white squares directly above the big overlapping squares that define the foreground and background colors. Clicking on this little default foreground and background color icon will cause the foreground color to revert to black and the background color to revert to white.

❶ Paint in the Selection

I double-click on the **edit in quick mask mode icon** 🔲 at the bottom area of the Tools Panel and choose **"Color Indicates: Selected Areas."** I click once more on the edit in quick mask mode icon to activate Quick Mask Mode. I select the Brush tool in the Tools Panel. I begin painting in the area containing the figure. By default, the selection area will be indicated with semitransparent red. If you paint with black as your foreground color, you add to your red mask by painting. If you select white as your foreground color and paint with it in Quick Mask Mode, it will erase from your selection. You can adjust brush transparency using the opacity slider in the Control Panel. I paint with full 100% opacity. I use a large non-blurry brush to block in the majority of the mask and then switch to a small, slightly blurry brush, zoom in, and go around the edges of my selection.

❷ Exit Quick Mask Mode Icon

When I complete my selection, I click again on the quick mask icon at the bottom of the Tools Panel to take me out of Quick Mask Mode. When I do this, my painted area turns into the familiar selection mask. Quick Mask Mode can be combined with other selection tools when creating a mask.

Photo Retouching

Since photography was invented, people have altered photographs to remove unwanted details from an otherwise appealing image. Here are some Photoshop tools you can use to perform these retouching functions.

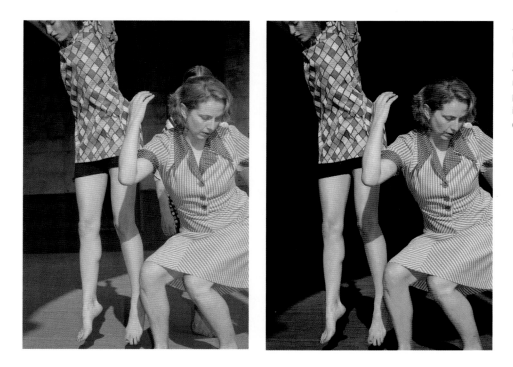

Last Tango in Pumphouse by Ken Hopson. In addition to noticeable enhancements in value and color, Ken used Photoshop's retouching tools to get rid of the person in the background because it detracted from the composition.
COPYRIGHT © KEN HOPSON

RED EYE TOOL

Flash photography can cause the pupil of the eye to acquire a demonic red color. Select the **Red Eye tool** in the Tools Panel, click on the red area, and watch it disappear. This tool generally works really well.

Select the Red Eye tool and click on the pupil to correct the color.

Foreground and Background colors are located near the bottom of the Tools Panel.

Selecting a new color in the Color Picker.

THE BRUSH TOOL

The **Brush tool** is not specifically a retouching tool itself, but when you select it in the Tools Panel, you will see choices in the Control Panel that are the same as the options available for many of the retouching tools. Click and hold on the arrow to the right of the word "brush" in the Control Panel. You will see a pop-up menu offering several brush presets that should include non-blurry brushes, blurry brushes, and brushes that paint with specialized textures or patterns. The slider at the top of the panel, labeled **Master Diameter**, adjusts the brush size.

Your current foreground and background colors are indicated by icons located near the bottom of the Tools Panel. By default, the foreground color will be black, and the background color for your document will be white. When you paint with the Brush tool, you paint with the currently selected foreground color. To change this color, double-click on the foreground color in the Tools Panel to access the **Color Picker**.

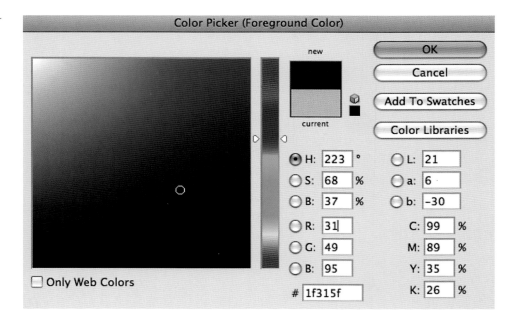

Within this panel, click on an area in the little rainbow **color slider** to select the general color. Move your cursor around in the big rectangular color field on the left to refine the value and hue. You can see your new color, compared to your previous foreground color, in the upper right area of the palette, under the word "new." Click **"OK"** and begin painting with your new color.

There are other ways to make, save, and select colors in Photoshop. We'll cover them when we discuss digital painting in chapter six.

SPOT HEALING BRUSH TOOL

The **Spot Healing Brush tool** 🖌️ has the Band-Aid–looking icon with the little rounded shape behind it. To eliminate a small blemish on a surface, select this tool and click, or click-and-drag, over the area. It will "heal" the blemish and blend the area into the surrounding pixels. You can adjust the brush size in the Control Panel to enlarge or reduce the area you are affecting when you drag across it. If you don't achieve the desired results the first time, you can undo and try it again, or use it more than once to further blend an area. Retouching complex surface textures can be accomplished by using some of the following Photoshop tools that "paint" with the actual texture from a selected area of the photo.

A blemish healed with the Spot Healing Brush tool. Just draw over the blemish and watch it disappear!

THE CLONE STAMP TOOL AND THE HEALING BRUSH TOOL

The **Clone Stamp tool** 🖈 "paints" with an area sampled from your actual image. Pick an area of the image you'd like to use as a source, go to the area, and hold down the Alt/Option key. Your cursor will change to a circle with cross hairs. Release the Alt/Option key. Click and drag the mouse in the area you wish to retouch. You will be "painting" with the part of the image you have selected. The Clone Stamp shows you a preview of your cloned image before you begin to paint, making it easy to line up edges properly.

The original photo. We'll use the Clone Stamp tool and the Healing Brush tool to paint in the trunk so that it appears to be in front of the green pole.

The **Healing Brush tool** operates similarly to the Clone Stamp tool. The difference is that the Healing Brush tool attempts to blend the edges of the "painted" area with the surrounding pixels. I used both of these tools to paint a trunk on the elephant in the images below. I had to sample the image several times in various locations to complete my trunk.

Left: Holding the Alt/Option key and clicking on a target area as your clone source to paint in the image.

Right: Painting with the cloned image.

The completed image.

THE PATCH TOOL

The **Patch tool** ⬦ creates a selection and uses it to "patch" an unwanted area. Select the Patch tool and drag a selection to another part of the image. Depending on whether **"Source"** or **"Destination"** has been selected in the Control Panel, one area will replace the other, and Photoshop attempts to automatically blend the seams of your selection.

You can also create a selection mask using any of the selection tools and then use the Patch tool with the selection. In the image on the lower left, I created a mask around the pile of clothing. I selected the Patch tool, chose **"Source"** in the Control Panel, and dragged my selection so that the items were replaced by the pristine sand to its right.

The Patch tool was used to remove an unwanted element from the photo.

The final image.

USING LIQUIFY FOR RETOUCHING

Liquify is such a powerful feature that it has its own image window and unique tool set. As its name implies, Liquify treats pixels as if they were wet paint, allowing you to move them freely around the canvas. We'll cover some of the more expressive possibilities of the Liquify environment in chapter five. For photo retouching, it is often used for lifting chins, tucking tummies, and reducing thighs. Be cautious when doing this to your personal photos. It's easy to get rid of a loved one's distinctive characteristics in service of a nonexistent ideal. (Notice how often celebrities on magazine covers don't even have pores on their skin!)

To access the Liquify environment, go to **FILTER > LIQUIFY**. I'm going to perform a chin lift on the photo below. I select the **Forward Warp tool** . It's the first tool in the **Liquify Panel**. I adjust the brush size to create a giant brush to click and drag the entire body part to its new location. The brush should be only slightly smaller than the entire area you are modifying. Take a tummy and drag it, for example. Instant diet! This process will require some practice, as well as some trial and error in selecting the ideal bush size. If you are not happy with the results, hit **"Undo"** and try again. If you've done a lot of work and you're only pleased with some of it, paint over the unsuccessful area with the **Reconstruct tool** , the second tool from the top, and it will be restored to its pre-liquified state.

Pay attention to how your alterations affect the background of your image. It may be advisable to mask or separate a figure from its background before using Liquify. The background may also require additional retouching.

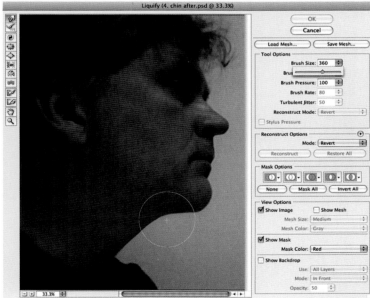

A chin lift using the Forward Warp tool in the Liquify
Panel. Be subtle to be convincing.

PROJECT:
Enhancing a
Photographic Portrait

Use any, or all techniques covered in this chapter to make significant enhancements to a photographic image. Improve its tone and color. Use selection tools to mask the foreground so that it can be manipulated separately from its background. Use retouching tools as needed to remove unwanted items from the image. Crop the image to make a more compelling composition. Save the document as a Photoshop file and print the completed image at an appropriate printer resolution. We'll end this chapter with an example from one of my students.

BEFORE

AFTER

Brandon Mercer, Continuing Studies, Cleveland Institute of Art. Brandon cropped the photo only slightly, causing the red drapery to function as a compositional framing element for the figure. He boosted the contrast and color saturation to a point where the objects became solid shapes with little variation in color and value, placing an emphasis on formal design. COPYRIGHT © BRANDON MERCER

Dall'acqua alla terra (Capricorn) is a beautiful example of photographic compositing by artist Giovanni Auriemma. Even though it's surreal in appearance, the consistency of light, shadows, and reflections lends believability to the scene. A limited color palette also helps to unify the composition. COPYRIGHT © GIOVANNI AURIEMMA

COMPOSITING:
THE ILLUSION OF REALITY

Compositing refers to an image created by assembling various elements from different sources and combining them into a single, unified composition. In this chapter we will work with photos from different sources and then alter and combine them into a single, consistent image that appears to be a realistic environment. It will appear as if we are viewing a photograph of a scene that is actually occurring. Regardless of whether or not (1) the photo appears within a surreal or everyday environment or (2) the subject is mundane or far-fetched, the final image should create the impression that you are viewing a moment in time captured by a camera. Careful use of selection masking, layers, image adjustment, and retouching tools will be paramount in maintaining the illusion.

In our modern era, when political and economic turmoil is a constant topic of media attention, I began to think a lot about conformity and the mob mentality that enables large groups of people to make bad decisions and propagate them based on the premise of safety in numbers. In the exercise in this chapter I will create a science fiction metaphor for this kind of group thinking. My idea is to construct a sort of body-snatchers image in which people have been robbed of independent thought after coming in contact with a mysterious glowing rock. Let's imagine that this image will be part of a series of works in a gallery exhibition that addresses this concept in various ways, thus making our intentions clear.

Plug In by Davida Kidd. This work involves a lot of Photoshop compositing of doll bits and real body parts, both of which the artist sets up and photographs herself. COPYRIGHT © DAVIDA KIDD

CREATING A COMPOSITE IMAGE

I took photographs of people specifically for this exercise, but they were taken in various places and under various conditions. Therefore, they will need to be modified in numerous ways in order to look like they belong in the same "world." We'll assemble these pictures, combine them with a few other images, and go through the process of making a composite environment. When compositing, it is important to remember to work with high-resolution images that are at least 100% of the size you need, whenever possible.

① Create a New File for the Composite Image

When beginning a project, create a new (blank) .psd file at 300 PPI at 100% of your desired document size. You could even make it a higher resolution, in case you decide to present the work in a larger format later. Starting with a blank document with the proper resolution prevents you from inadvertently dragging images on top of an existing low-resolution image. If you do this, any high-resolution images you drag into this document will be reduced to its low-resolution, and the image will be diminished in quality. It's a bad feeling to put a lot of work into a composite image, wonder why it doesn't look so great, and then discover your artwork is 1 x 1.5 inches at 72 PPI because you dragged everything on top of an image of this size. I've seen it happen.

For this exercise, I created a document that is 31.5 x 20 inches at 300 PPI. As multiple layers were added to the document, the file size became so huge that it was slow to process and hard to work with. It was worth it in this case, however, because I had taken photos with a 10 megapixel camera and then created this large document in order to incorporate the largest figures at 100% of their original (high) resolution. You may wish to start with a much smaller document if processing power and storage space are issues.

I create the new document by going to **FILE > NEW.** In the panel that pops up, to the right of the word **Preset** I choose **"Custom."** Next to **"Width,"** I select inches as my unit of measurement and type in **"31.5."** Next to height, I type **"20."** I choose **"RGB"** for the color mode, since this will be a gallery image that will be printed on a photo printer or displayed on a screen. Next to background contents, I choose **"White."** If you will be using the same document settings frequently and there is no existing preset for them, you can create a new preset by clicking on **"Save preset"** in the panel and giving it a name.

② Drag New Elements into the Composition

Keeping elements on separate layers allows them to be manipulated or repositioned without affecting the elements on other layers. This is essential for fine-tuning a composition. It enables an artist to create sophisticated, convincing composite images from multiple photographic sources. In your Photoshop document you can create as many layers as needed to isolate and organize elements. The background layer, by default, will be filled with white. All other layers are invisible (transparent) except for the elements placed into

LAYERS

Normal | Opacity: 100%

Lock: | Fill: 100%

👁 | chad legs
👁 | chad
👁 | julie chad shadow
👁 | bill
👁 | striped shirt

The Layers Panel. A layer must be selected in order to modify its contents.

The landscape photo that will be used as the background for our image.

them. To view the **Layers Panel,** if it is not already visible, go to **WINDOW > LAYERS.** Mastering Photoshop layers will be a crucial skill in virtually *every* project in this book. We'll look at some additional features of the Layers Panel in later chapters and how to apply them to specific projects where these features will be of great use.

When images are placed on individual layers, their edges can be defined and modified without affecting the surrounding areas. Make sure objects in your composite images have natural-looking edges and that nothing in the image is cut off. If a figure is missing a part, you need to create it or find a natural-looking way to hide it. Make sure significant elements are on separate layers for optimal control. Unnatural masking will definitely spoil the illusion of reality.

When using a selection tool, check **"Anti-alias"** in the Control Panel. This creates some semitransparent pixels around the edges, which could produce an edge with a more natural appearance. The Rectangular Marquee tool does not allow anti-aliased as an option.

As mentioned in chapter three, clicking the eye icon located to the left of each layer causes the elements in that layer to become invisible. They cannot be seen and they will not print, but they will still exist. Clicking on this icon again restores the layer visibility. Sometimes it is helpful to make certain layers invisible while you modify other layers that would otherwise be partially obscured by them.

In this exercise it will be necessary to have several source documents open at the same time in order to combine parts from various documents and modify them into a composite image. You can use the selection tools to isolate a specific element and drag it onto another open document. Once the element is selected, make sure part of both document windows are visible and use the Move tool to drag the element from one document to the other. This procedure makes a copy of the selected element in the new document and leaves your original document unaltered.

The photo I will use for my background for our composite image was taken in the American southwest. We'll place this photo into our new document and then scale and stretch the photo, modify its value and color, replace the sky, and modify the light source.

I drag this entire background image from its current document window into our newly created empty document. Dragging an image into a document automatically creates a new layer for it. You can lock a layer to prevent accidental changes by selecting the layer and then clicking on the **lock all icon** (with the picture of the lock) near the top of the Layers Panel. The neighboring icon choices lock only certain aspects of a layer: position, transparency, and ability to use paint tools on the layer.

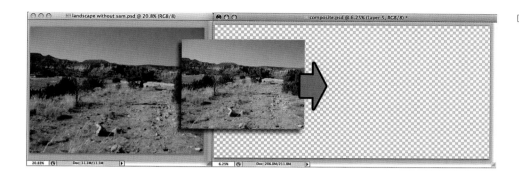

Dragging the landscape.

It's possible to scale, rotate, and distort an individual object, rather than the entire document. This can be a selected element on a layer containing many elements, or an element isolated on its own layer, which does not need a selection mask. In order to transform elements in a layer, the layer must be currently selected in the Layers Panel.

Individual elements can be rotated, resized, and otherwise modified using the options found under **EDIT ›TRANSFORM**.

③ Resize Individual Objects

Once the background image is dragged into the new document, I go to **EDIT › TRANS-FORM › SCALE** to resize my image. An image can be rescaled by grabbing and dragging one of the white squares that appears at the corner, or middle, of the bounding box. To keep your proportions the same, grab a corner and hold the Shift key as you drag. I hold the Shift key when rescaling the figures momentarily so that they are not squashed or stretched. When scaling the background, however, I will *not* hold down the Shift key, because I want to stretch the image horizontally to conform to our panoramic composition.

When the Move tool is active, you can select **"Show Transform Controls"** in the Control Panel. This makes the transform controls active at all times for the selected layer. This could be convenient when scaling multiple objects, but you may find yourself inadvertently scaling an object when you are trying to move it, especially if you have zoomed out to view the entire composition.

Once I rescale the object, I click on the **"Check"** symbol located at the right side of the Control Panel to commit to the new size. I could click the **"No"** symbol to reject the changes. Once I hit the check mark, Photoshop redraws the pixels to reflect the new size I have chosen.

Using **EDIT › TRANSFORM › SCALE** to stretch our image to fill the document.

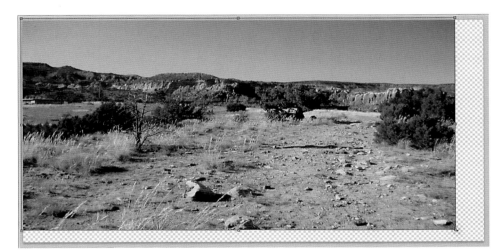

NOTE: Although it's not applicable to this project, it's worth noting that Photoshop has a **Content-Aware** scaling feature that allows a background to be stretched (within reason) without distorting the figures within the background. This feature can be accessed by going to **EDIT > CONTENT AWARE SCALE**.

If you are enlarging an element in your document, it may appear severely pixelated until you hit the check mark and the new pixels are added to the image. Photoshop does a pretty good job with modest enlargement of images, but there's no substitute for starting with the largest, highest resolution images possible—especially for key foreground elements in your composite image. In this case, the background will be enlarged slightly. Since it will be modified significantly, it shouldn't matter too much in this case. Again, I make sure that all the figures have sufficient resolution so that none of them will have to be enlarged in our image.

4 Create a Smart Object

If you reduce an image in size, Photoshop gets rid of pixels to redraw the image. Your image quality will be diminished if you later tried to scale it back to its initial size. You can get around this limitation by converting your image layer to a **Smart Object** before resizing it. Go to **LAYER > SMART OBJECTS > CONVERT TO SMART OBJECT.** When an element has been converted to a smart object, it preserves the element in its original state, and any reduction in scale would be a nondestructive instance that refers to the original file. Smart Objects can be used to scale or rotate objects or process them with filters. These filters will show up in your Layers Panel as nondestructive **Smart Filters.** When I drag each figure into the composition, I'll convert it to a Smart Object before reducing the size of the figure. This enables me to change the sizes of each figure several times without losing any pixels while I rearrange my composition. Many important compositing tools such as the Dodge and Burn tools, the Eraser tool, and the Blur tool will not work with Smart Objects, so I will eventually use **LAYER > RASTERIZE > SMART OBJECT** to convert each of my Smart Object into pixels once I have fine-tuned the scale.

5 Placing a Figure into the Composition

Okay, now it's time to place our first figure into our composition. I use the Lasso tool to draw a rough selection mask around my figure, leaving some of the background around the figure to be cleaned up later using a nondestructive **Layer Mask.** Once this approximate selection is made, I drag the image into our composite document and convert it to a Smart Object. I then scale it, making it slightly smaller.

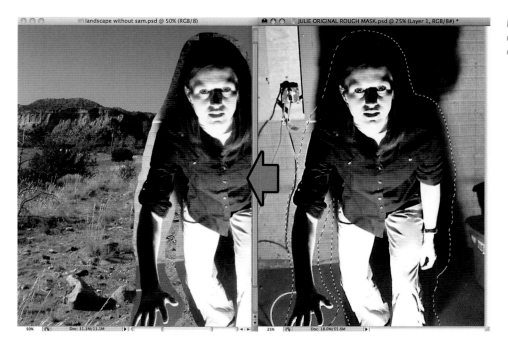

Making a rough selection and dragging our first figure into the composition.

A layer mask as seen in the Layers Panel.

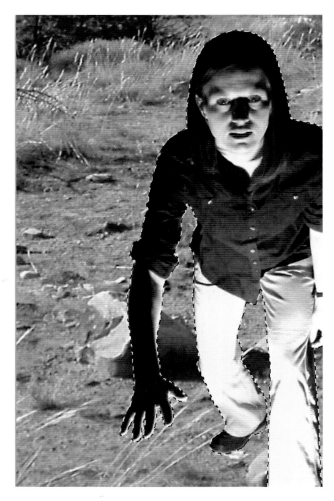

I make a careful selection around the figure. If you click on the Pixel Mask button in the Masks Panel, the area outside the mask becomes invisible on the selected layer.

6 Create a Layer Mask

Once I have established a rough scale and position for the figure, I make a careful selection mask around the figure, adding to, subtracting from, and refining my selection until it is perfect. Once the selection is made, I go to the Masks Panel (**WINDOW > MASKS**) and click on the **add a pixel mask icon**. Anything outside of the selected area should disappear. My Layer Mask appears as a second rectangle within my layer in the Layers Panel. I can make a Layer Mask invisible (deactivated) by holding the Shift key and clicking on the rectangle.

This will create a nondestructive mask. I can undo my masking at any time by clicking and dragging the rectangle to the trash in my Layers Panel. To edit my selection later, I can click on the Layer Mask rectangle in my layer within the Layers Panel to make it active. When the Layer Mask is active, I can use the Brush tool to adjust my mask. I can add to the mask by painting it with black. I can subtract from it by painting with white. Painting it with gray will create semitransparent areas.

7 Adjust the Color and Value of the Figures

I use the Adjustment Panel to boost the contrast in the figure and to push the saturation a little beyond what it would be in real life. Each time I make an image adjustment to a layer, I click on the clip to layer icon in the Adjustments Panel so that the other layers are not affected by my changes.

With each subsequent figure that we place in the composition, I will be using our first figure and our background as reference points when adjusting value and color. All the elements in the composition must have consistent and appropriate value and color in order to look like they belong in the world we are creating. Use the image adjustment tools. Look at the value range (dark to light) within each element in your composition. Match the highlights and midtones in the objects. Observe the darkest shadow areas in each of the elements and make sure they are consistent. If elements are supposed to occupy similar areas in space, and one element has dark, rich shadow areas and another is washed out and anemic in its darkest areas, it is an immediate visual clue that they have been taken from different sources. Match contrast among elements as well. Harsher

light creates higher contrast and more drastic value transitions. Softer light creates a more subtle transition with greater midrange value information.

Observe the color cast of each element. Natural light tends to create a warmer (orange) color-cast where as artificial light can create a cooler (blue) color-cast. Many other variations such as weather conditions, type of lighting, reflective surfaces, and multiple or unusual light sources can affect the general color temperature of an element. Decide what kind of lighting is appropriate for the environment you are creating and alter the color of each element so that it appears consistent within your image.

Match the color intensity of each element as well. If your environment has bright, vivid colors, its elements should have bright, vivid colors as well. If the colors appear washed out and faded, all the elements should appear so as well. Compare specific colors among the elements. For example, if one element has yellow in it, do the neighboring elements have a similar color intensity in their yellow areas? If they are more intense or more faded in the similar yellow areas, adjust those areas until they match.

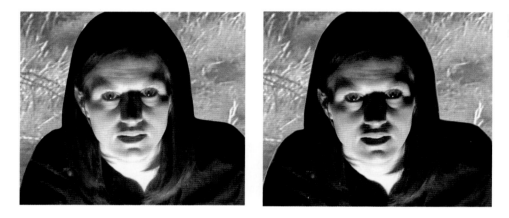

Before and after examples of adjusting value and color.

I next take a picture of a rock, open it, select the rock, and drag it into our picture. This small rock will play the roll of a big rock.

At this point, we have dragged three elements into our composition. This means that three new layers have been created, which can each be manipulated independently. In order to make a change to the elements in a specific layer, you must click on that layer in the Layers Panel to select it for manipulation. When the Move tool is selected in the Tools Panel, you can click the **"Auto-Select"** box in the Control Panel. When Auto-Select is activated, the Move tool will select a layer automatically when you click on a specific, visible element on the layer.

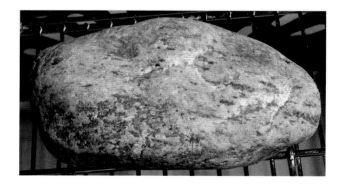

The next element for our composition, a rock.

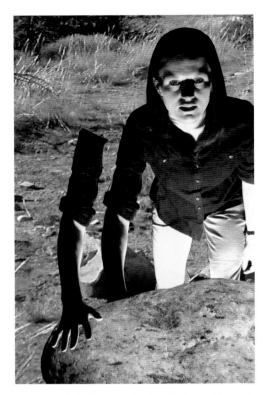

Layer order. A duplicate arm is placed in front of the rock while the original figure remains behind it.

Change the Layer Order

In the Layers Panel, multiple layers are stacked from top to bottom, which determine how they are viewed in your document. If you have more than one layer in your document, the layer at the top of the Layers Panel is the layer on "top" of the other layers in your document, and each subsequent layer below it represents one more level "down" in the layer order. The layer order determines which element is in front of the other. You can change the order of layers by grabbing a layer in the Layers Panel and dragging it to a new position.

The **Background Layer** is, by default, the bottom layer in your Layers Panel, and is locked in position. If you wish to change its layer order, you must first change the name of the background layer by double-clicking on the name in the Layers Panel. You may wish to rename other layers to describe their contents, which will make elements easier to find. You can also change a layer name by going to **LAYER > LAYER PROPERTIES.**

In the composition I want the figure to be positioned behind the rock. At the same time, I want the figure's arm to be in front of the rock, as if she were touching it. A single layer cannot simultaneously be behind and in front of another layer. We can solve this problem by selecting the arm, choosing the layer containing the figure in the Layers Panel, and then going to **LAYER > NEW > LAYER VIA COPY** to make a copy of the arm. Since I have created a selection mask, only the selected elements will be copied from the layer. I drag the layer containing the duplicate arm so that it is in front of the layer containing the rock.

LAYER > NEW > LAYER VIA COPY will remove a selected area from one layer and place it in a new layer. You can also **EDIT > COPY** or **EDIT > CUT** a selected element from a layer and then **EDIT > PASTE** into any other selected layer, including a new (blank) layer.

Our composition so far: the background is stretched and scaled, the figure is sized and placed into position, her value and color have been adjusted, our rock is in place, and the figure's hand has been duplicated onto a new layer in front of the rock.

9 Use Layer Styles

Next I select the layer containing the rock and use Hue/Saturation in the Adjustment Panel to give the rock a greenish hue. In addition to the greenish color, I also want to give our meteoric rock an unearthly glow. I'll use one of Photoshop's **Layer Styles** to do this. Layer Styles are nondestructive effects that can be assigned to individual layers. They can include drop shadows and outlines (strokes) around objects.

I use **LAYER > LAYER STYLE > OUTER GLOW** to achieve our desired effect. In this panel I select a green color and adjust the spread, size, and opacity (reducing opacity makes elements semitransparent) until I create a subtle glow around the rock. As the composition progresses, I'll use other techniques to help the ground and figures reflect this glow.

Our rock, made green (using Hue/Saturation) and glowing (using the Outer Glow Layer Style).

In the Layers Panel, you can click the eye icon next to a Layer Style to render it invisible. You can double-click on the name of the Layer Style to edit the effect. You can delete a Layer Style by dragging it to the trash in the Layers Panel.

Our Layer Style, visible in the Layers Panel.

Next, I drag the second figure into our composition. I move his layer in the Layers Panel, so it is behind the layers containing the female figure and rock but above the layer containing our landscape. I convert him into a Smart Object and scale the figure to an approximate size. I use the Adjustment Panel to change the value and color of the figure, making sure to clip my Adjustment Layer to the layer containing the new figure. This time, I have to compare the color and value of this new figure to the other figure in the composition when making decisions.

A before and after of our second figure. I matched the value and color from the first figure.

The male's hand, duplicated, scaled, rotated, and painted on with the Clone Stamp tool in order to rest on the female's shoulder.

⑩ Rotate Individual Objects

The male figure's hand will be on the shoulder of the female character, as he tries to warn her not to touch the rock. I'll select and duplicate the hand using the same method I used to duplicate the arm of the female figure in step 8. The male's hand also has to be scaled down and rotated. To rotate the hand, I go to **EDIT › TRANSFORM › ROTATE.** I place my cursor outside of a corner point of the selection. The cursor turns into a curved, double-sided arrow. I drag to rotate the image. If **"Show Transform Controls"** is selected, the Move tool will automatically change into a curved arrow if placed in the proper position.

When you are rotating objects, holding the Shift key while rotating makes the rotation "stick" at logical positions such as 180 degrees. Alternately, you could just select one of the choices at the bottom of the **TRANSFORM** sub-menu. **EDIT › TRANSFORM › ROTATE 180°** turns your image upside down, for instance.

My figures are properly scaled and positioned in relation to each other. I'll now use **LAYER › RASTERIZE › SMART OBJECT** to convert the original figure layers into pixels. This will be necessary in order to perform the following steps in this exercise.

⑪ Retouch Elements

Once my layers are rasterized, I use the Clone Stamp and Brush tools to retouch the thumb area to make it look natural as it comes in contact with the shoulder.

Once this figure has been placed into position and adjusted in color and value, I select the layer containing the landscape and adjust its color and value. I darken the landscape and boost the contrast and color saturation to match our figures and enhance the mood of the piece.

Our figures in place and the background darkened.

⑫ Construct a Figure from Multiple Sources, If Necessary

At this point, as you might have noticed, the male figure doesn't have legs. The image I liked best was a close shot, and his legs were not visible. I select his legs from another shot, drag them over, scale them, and place them in the proper order within the layers. I adjust their color and value to match the torso. I also darken the middle values in the pants so they will contrast with the lighter color of the pants on the female figure. Since the female figure is covering the area where the legs meet the torso, no retouching is necessary.

Legs for our male figure are darkened to contrast with the female figure.

⑬ Use the Eraser Tool to Reveal Multiple Layers

Eventually, I'll try to give the skin tones of every figure a greenish tint when I adjust the color. Right now, in the female figure in the foreground, I want a particularly noticeable green reflection on the skin tones, since she is directly above the glowing rock. In order to do this I duplicate the layer containing the woman using **LAYER › NEW › LAYER VIA COPY.** With this duplicate layer, I use Hue/Saturation to give the image a greenish tint, as I did with the rock.

I then select the **Eraser tool** and reduce the hardness in the Control Panel to make a blurry eraser. I reduce the opacity to 14% to create a very transparent eraser that will gradually erase an area when going over it several times. I erase away at parts of the green layer, revealing the normal flesh tones of the original copy below it in places, but leaving the green glow in desired areas.

Left: Making a duplicate layer.

Middle: Making the duplicate layer green and partially erasing the duplicate layer with a semitransparent eraser to reveal parts of the original layer below.

Right: The finished result, reflecting the greenish glow of the rock.

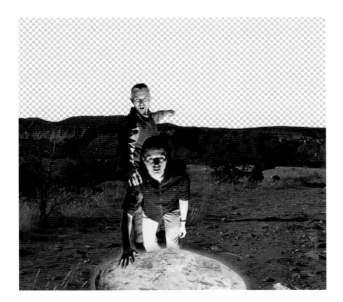

Here, we see our progress so far: the male figure's legs, a shadow under the hand on the rock, and the sky removed, waiting for a replacement.

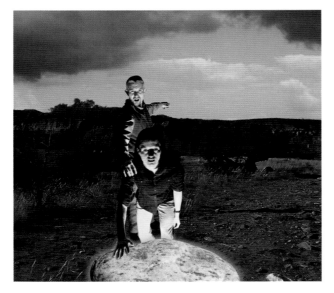

The new sky on its own layer behind the landscape.

The other two Eraser tools are the **Background Eraser tool** , and the **Magic Eraser tool** . The Background Eraser tool makes pixels transparent along the image's edges and is designed specifically to clean up and blend images that have been removed from their original backgrounds. Toward the end of this exercise in step 23, I'll use the Background Eraser tool to help make the edges of the figures look more natural where necessary. The Magic Eraser tool erases areas of similar color and value by clicking on them. Like the Magic Wand tool, it works best with clearly defined areas with very similar pixels.

Next, I decide to replace the plain blue sky with a more dramatic cloud-filled sky. I select the current sky and hit the Delete key to get rid of it. The gray-and white-checkered areas that appear in the image indicate that this area is transparent. This pattern will not print. The checkered areas are there so that you can tell the difference between an area that is transparent and an area that is solid white. I also use the Burn tool on the rock to create a subtle shadow underneath the hand on top of it.

14 Replace the Sky

I drag a new sky photo into the image and place it below the layer containing the landscape. I then adjust its color and contrast to appear more dramatic.

15 Change the Light Source

A light source refers to the direction from where light is coming in the image you are constructing. The light source in your environment will determine how light reflects on an object, where the highlights are created, and where the shadows fall. The position of light and shadow, as well as the quality of light, should be consistent among all elements. Decide where the light is coming from. Identify existing light sources. Highlights and shadows should all be consistent with the light source.

When you are choosing elements to use in your composite image, try to select images with consistent light sources, as it will make your job easier. In this exercise we have an unusual primary light source, the glowing rock. This will define where the light and shadows should be in every figure that is placed into the composition. In order to make this glow believable, the ground needs to reflect this light as well.

In our original snapshot of the southwestern desert, the sun is starting to set and the lighting clearly comes from the left, casting shadows to the right of objects. The image is so stark and empty, however, that it won't be too hard to change the perception of where the light is coming from in the scene.

I use **FILTER > RENDER > LIGHTING EFFECTS** to create an artificial light source on the landscape layer, with the light emanating from the area containing the rock. In the **Lighting Effects Panel** I select **"Style: Default"** and **"Light Type: Omni"** as a useful place to start exploring. In the preview window I move the center point to change the source of the light. I grab the squares on the oval surrounding the center point and stretch them to further influence the character of the light. I use the sliders in the panel to adjust the intensity of the light and specific reflective properties of the image.

NOTE: Many environments, especially indoor environments, can have multiple light sources. Each of these sources generates light and creates shadow to varying degrees and needs to be taken into consideration.

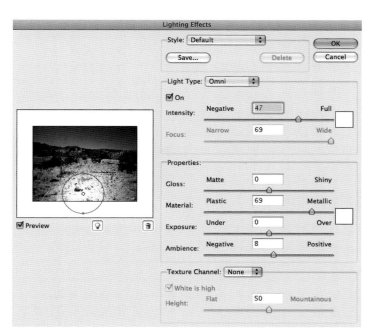

Adjusting the lighting with **FILTER > RENDER > LIGHTING EFFECTS**.

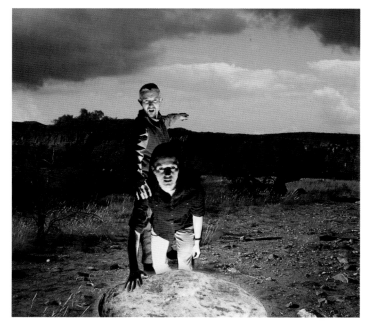

The landscape, modified to reflect our light source.

After applying the lighting effects, I use the retouching tools and the Brush tool to make sure that shadows and highlights are on the correct side of rocks and trees, to be consistent with our light source.

Little rocks, cloned and painted to reflect the light from the big rock.

16 Make a New (Blank) Layer

Before I begin to paint changes into the landscape, I create a new, blank layer. To create a new layer, I go to the Layers Panel and click on the **create a new layer icon** at the bottom of the Layers Panel. You can also create a new layer from the Menu Bar by going to **LAYER > NEW > LAYER.** Creating a separate layer for my changes allows me to modify or delete these changes later without affecting my original image. To get rid of an unwanted layer and its contents, go to the Layers Panel and click on the **delete layer icon** at the bottom of the Layers Panel. You can also delete a layer from the Menu Bar by going to **LAYER > DELETE > LAYER.** When using a retouching tool such as the Clone Stamp in this new layer, I make sure that **"Sample All Layers"** is selected.

17 Make a Rough Composition

Scaling each figure using **EDIT > TRANSFORM > SCALE.**

Now that we have some our most crucial elements working well, it's time to start dragging in the other figures and thinking about their approximate size and placement. For all of these figures, I use the Polygonal Lasso tool to create a very rough outline around the figures and drag them, one by one, into my composition. Each time I do this, a new layer is automatically created for the figure. Since I'm not sure of the exact size and location of each figure, it's very important that I select the layer containing each figure and go to **LAYER > SMART OBJECTS > CONVERT TO SMART OBJECT.** so that I can tweak the size of each figure several times without losing any pixels. Once I convert these images into Smart Objects, I create a more careful selection around each figure. I then go to the Masks Panel and click on the select the pixel mask icon to create a nondestructive mask. I use the Move tool to drag elements around the page and scale them until I see a pleasing composition.

All the figures assembled into an approximate composition.

18 Add Light and Shadow with the Dodge and Burn Tools

Every figure will require proper adjustment of color and value. In addition, each figure has specific, unique qualities that need to be modified. In the figure below, I remove a corporate logo from the T-shirt. I also use the Burn tool and the Brush tool to add shadow areas in the leg and face and to reflect areas where the figure in front of the male is blocking the light. Finally, I use the Dodge tool with a giant brush size and low exposure setting (about 20%) to create a highlight spot on the shirt that is consistent with the highlight spot on the other figures.

Left: The logo is removed from the shirt.

Middle: Shadows are added to the leg and face.

Right: A light source is added to the shirt with the Dodge tool.

The figure below didn't have the dramatic shadows that many of the other figures had. I use the Burn tool to create the shadow areas and then use the Brush tool with a very tiny, almost transparent (7% opacity) brush to blend the shadows and modify the skin tones. A light touch and low opacity is crucial here!

Shadows added with the Burn tool and then blended with the Brush tool.

Although I had the foresight to light the figures from below when I took the pictures, many of the photos had shadows on the wrong sides of their faces when I eventually placed them into the composition. In the case of the figure below, I take advantage of these wrong shadows and place the figure behind another figure, positioned so that the shadows on the face and legs will appear to be caused by the figure in front of her.

I took advantage of the existing shadows when placing this figure into the composition.

In other cases when a shadow was on the wrong side of a figure, I go to **EDIT › TRANS-FORM › FLIP HORIZONTAL** to create a mirror image of the person and place the shadows on the correct side of the figure. In the figure below, I flip the figure and severely alter the color and value. This figure is farther back in space, and I have to fade the darkest values in the figure to match the faded shadows within the landscape. I match the highlights of the skin to the muted highlights visible on the rocks. I clone and paint in bushes in front of the figure. I also use Liquify to modify the happy expression on our actor's face.

Here, I created a mirror image of the figure with **EDIT › TRANSFORM › FLIP HORIZONTAL** to place the shadows in the correct place. I then faded the color and value to match the landscape, modified the facial expression, and cloned bushes around the feet.

⑲ Use Atmospheric Perspective

Things in the same "space" should have the same degree of sharpness. The illusion is spoiled if one figure is sharp and one is blurry within the same part of the picture plane. It's important to have consistency among those elements that occupy a similar position, or space, within your composition. Objects that are further back in the depth of your picture plane, however, must reflect changes in atmospheric perspective in order to look right. As discussed in previous chapters, when elements recede in space they are reduced in size and they lose their darkest values, their lightest highlights, their color intensity, and their sharpness. In short, they become smaller, grayer, and blurrier.

I reduce the color saturation and contrast in value to make the elements appear to recede in space. With the exception of our original female figure touching the rock, I use **FILTER › BLUR › GAUSSIAN BLUR** to apply a slight blur to every figure in order to make them consistent with their surroundings. I adjust the radius slider to the desired degree of blurriness for each figure.

Figures in the distance are blurred and desaturated. The smallest figure was partially erased to show that the tree is in front of him.

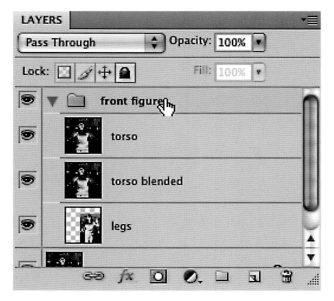

A Layer Group in the Layers Panel.

In the picture to the left, you can see that the tiny figures in the distance are very blurry and lack extremes in color and value. In the layer containing the smallest figure, I use a tiny, blurry eraser to erase into it to reveal the tree. The tree is on a layer beneath him, but erasing this area of the figure makes the tree appear to be in front of him.

🔟 Link and Group Layers

It's possible for complex images to contain dozens of independent layers, as is the case with our current image. Therefore, it is sometimes useful to select multiple layers at the same time so that they can be moved, rescaled, or distorted as a group. Multiple layers can be selected by holding down the Shift key and selecting adjoining layers in the Layers Panel. When the layers are selected, you can click the **link layers icon** 🔗 on the bottom left of the Layers Panel to link, or unlink, the layers.

A few of the figures were assembled from multiple parts. In these cases, I click on the **create a new group icon** 🗀 at the bottom of the Layers Panel in order to create a **Layer Group** that will contain all the parts of a figure. This makes it easier to move them as a single element and makes your layers more clearly organized. I give each Layer Group a descriptive name using the same methods we used in step 8 for naming a single layer. The Layer Group has a **folder icon**. I drag the layers to place them inside this group folder and then drag them to change the layer order within a group if necessary. You can also create a Layer Group by holding down the Shift key, selecting multiple layers, and going to **LAYER › GROUP LAYERS.** Click on the triangle on the left of Layer Group in the Layers Panel to hide or reveal the individual layers within the group. To **ungroup** layers, select the Layer Group and go to **LAYER › UNGROUP LAYERS.** To remove individual layers from a group simply drag the layers out of the group folder.

21 Merge Layers

Sometimes it's useful to consolidate some, or all, the layers in a document so that they can be fully manipulated as a single new layer. Options include:

◆ **LAYER › MERGE DOWN:** Merges the selected layer with the layer directly below it.

◆ **LAYER › MERGE VISIBLE:** Merges all layers that are currently visible. If you merge layers that have other nonvisible layers in-between, the layer order can be affected, since the nonvisible layer can no longer be in-between elements in the newly merged layer.

◆ **LAYER › FLATTEN:** Flattens all the layers in a document into a single layer.

◆ **LAYER › MERGE GROUP:** Merges all the layers in the selected group into a single layer. If you select a Layer Group in the Layers Panel, this option will become available.

In the figure below, I use the top half of the figure from one photo and combine it with a set of legs from another photo. Each of these photos had been selected and dragged onto a separate layer in our composition. I select the top layer of our figure, the torso layer, and use **LAYER › MERGE DOWN** to merge this layer with the layer below it, containing the legs. These layers become a single layer. I then use retouching tools to blend the seam where the pieces met.

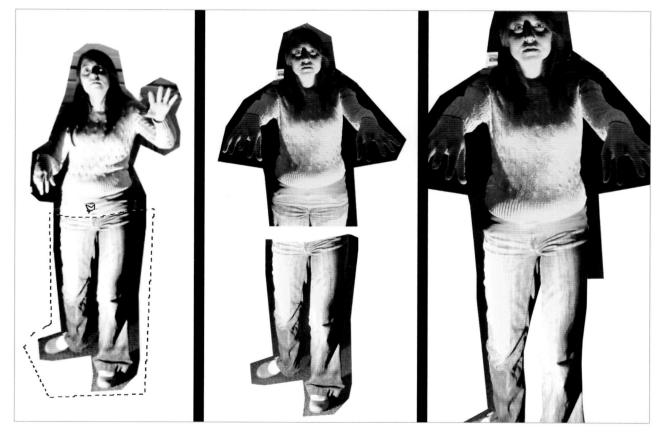

Two halves put together.

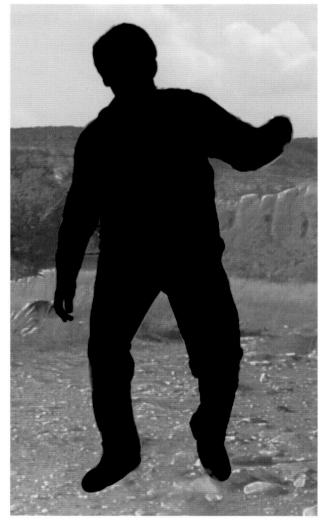

A rough silhouette painted over the figure on a new, blank layer. We'll use this to create a shadow.

㉒ Create Shadows

If you are placing elements into a background they may need appropriate shadows to convince us that they are in our new environment. If there is an element casting a shadow in a photo you are using as part of your background environment, you can use it as reference to create other shadows that match. Since our main light source is unusual and completely manufactured, we'll be constructing our shadows from scratch. Shadows are essentially silhouettes of an object, distorted by the angle of the light source. We'll use this fact as the basis for creating a believable shadow for the complex shape of each figure.

Each figure is on its own individual layer in my document. I select the layer containing a person and then hit the new layer icon at the bottom of the Layers Panel. This creates a layer directly above the layer containing the figure. I will draw a shadow on this new layer. I begin by selecting the Brush tool, choosing a standard, non-blurry brush, and painting over the entire figure, creating a silhouette. Be careful not to accidentally draw your shadow on the layer containing the actual figure, or you will draw over your actual photo and ruin it. We will blur and distort this shadow image, so the silhouette does not have to be exact or detailed. Just quickly brush in a general solid shape over the figure. Alternately, you could create a mask around the figure using any combination of selection tools and use **EDIT > FILL** to create the silhouette on your new blank layer. Once you have created the silhouette, drag the layer in the Layers Panel so that it is now behind the layer that contains the figure.

With this silhouette layer still selected, I go to **EDIT > TRANSFORM > DISTORT** and grab each corner of my selection to stretch it to conform to the shape, size, and direction appropriate for the light source. I try to make sure the shadow is connected to the element in an appropriate way. Since it is a standing figure with two feet on the ground, the shadow will connect at the feet. If the shadow doesn't quite meet up with the feet correctly, or needs other corrections, I simply use the Brush tool to paint into it.

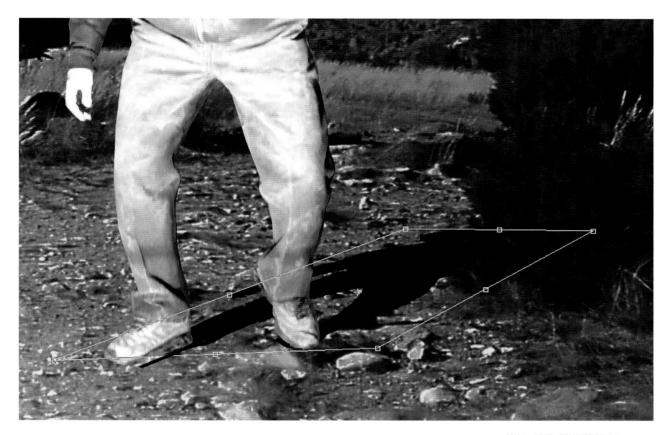

Using **EDIT › TRANSFORM › DISTORT** to pull the shadow into position.

When the shadow has taken on an appropriate shape, I deselect it before taking further steps, using **SELECT › DESELECT**. Next, I go to **FILTER › BLUR › GAUSSIAN BLUR** to blur the edges of the shadows to a degree that is convincing and consistent with the other shadows. In order to let the background elements show through underneath a shadow, I adjust the opacity of the shadow layer. I do this by selecting the layer in the Layers Panel and then accessing the opacity slider by clicking on the arrow to the right of the word **"Opacity"** at the top of the Layers Panel. Moving this slider to the left makes the layer semitransparent. I clone a few rocks, place then into my shadows, and darken them with the Burn tool. I select the Eraser tool and use a small semitransparent eraser to erase into the edges of the shadows to reflect the areas where the grass and other materials would cause the edges to be irregular.

There were places where my shadow would curve in real life, such as where part of the shadow falls over a bush rather than a flat surface. In these places, I simply reshape the portions of the shadows by painting and erasing. I then magnify everything, look everything over, and correct any flaws in the details. As mentioned previously, I use the Magic Eraser to clean up edges.

Using the Blur tool and the Background Eraser to clean up edges.

23 Refine Edges with the Blur Tool

Using the **Blur tool** in the Tools Panel to carefully go over the edges, just once or twice, can sometimes help to make the edges of objects appear more natural when their background has been erased. Once the shadows are created, I do this to each figure to refine edges as needed.

I then zoom out, view the piece as a whole, and make final adjustments in color, value, and sharpness. I repeat this process two or three times, come back to the composition with fresh eyes, and then conclude that the work is finished.

The final piece, containing dozens of layers.

Putting Things into (Linear) Perspective

As we discussed in chapter two, parallel lines that recede in space appear to converge, or grow closer together, as they move toward the horizon. If an element that recedes in space were to continue all the way to the horizon line, it would connect to it at a point called the **vanishing point.** Objects parallel to the viewer do not converge; only objects that are going away from the viewer in space do. If more than one visible side of an element is receding in space, each side would have a vanishing point.

Speaking of which, there is a Photoshop environment called **Vanishing Point** that is used for working with linear perspective. Like Liquify, Vanishing Point has its own environment and tools. Within Vanishing Point, the artist constructs three-dimensional grids that correspond to various surfaces in perspective. These grids can be used to place objects into perspective inside the Vanishing Point environment. They can be saved onto their own layer in the normal Photoshop environment and used as **perspective guides** when utilizing other methods of bringing images into perspective. They can even serve as the basis for the creation of complex 3D environments and can be exported for use with other 3D software.

Within by Jessica Maloney. Jessica's process is based largely in photography and scanned textures. She takes her own photographs, brings them into Photoshop, and combines them with scanned surfaces. Gritty textures, simplification of shapes, and flattened use of space are all strong visual characteristics of this work. COPYRIGHT © JESSICA MALONEY

CREATING A MURAL WITH VANISHING POINT

For this exercise I will take a painting and place it into the perspective of a wall in a room setting, as if it were a mural painted on the wall.

Fried Eggs by Laura Sherrill Ligon. The original images we'll use to make a wall mural using Vanishing Point. COPYRIGHT © LAURA SHERRILL LIGON

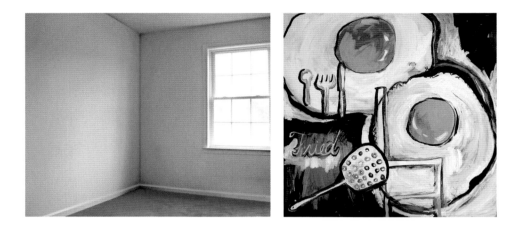

① Select an Image

Before using Vanishing Point, you need to make a few preliminary preparations. In Photoshop, open the document containing the image you'd like to place in perspective. Use **SELECT > ALL** to select this entire document. You can also use a keyboard shortcut, which is Cmd+A on a Mac (the Command key with the Apple on it) or Ctrl+A on a PC. We'll have to use keyboard shortcuts to paste the texture inside Vanishing Point, so let's also use the keyboard shortcut to copy your selected texture, Cmd+C/Ctrl+C. Now open the document to which you will apply the perspective grid. In our case, it's the image of the room setting. Before opening Vanishing Point, create a new blank layer in the Layers Panel on which your perspective work will be placed.

NOTE: You can create multiple grids in Vanishing Point that correspond to other perspective planes in an image. Make sure the Create Plane tool is selected for each plane. Hold down the Alt/Option key, grab the point in the center of the appropriate edge, and drag to create a new grid for each surface. Adjust surfaces with the **Edit Plane tool** as needed. If "Allow Multi-surface Operations" is selected from the menu options, you will find that your image placed into perspective will also wrap around any other perspective planes you have created.

② Apply Vanishing Point

Go to **FILTER > VANISHING POINT.** Inside the Vanishing Point environment the **Create Plane tool** should already be selected. With this tool selected, click on the four corner points of a surface (in our case the left wall) and a perspective grid should appear over the area. If the grid is blue, it means you have created an accurate perspective grid that Vanishing Point can work with. If it is yellow or red, try again. You can grab and drag a corner point to refine the edges.

③ Paste the Copied Image

Now, paste in the image of the painting we have copied to the clipboard. You must use the keyboard command to do so. Press Cmd+V/Ctrl+V. The painting should appear. Drag this image into the grid and watch it conform to this perspective. In the upper left hand corner of the Vanishing Point environment, next to its Tools Panel, you'll see a small triangle. Click and hold on this icon to reveal menu options. If **"Clip Operations to Surface Edges"** is selected, your pasted image will be cropped to the edges of the grid. This option is selected in our example. You can resize or rotate the painting using the **Transform tool** in Vanishing Point. You can paint or clone images inside the environment as well. When you are happy with results, hit **"OK."**

Now, let's save the grid you have created as a reference layer in Photoshop. In the normal Photoshop environment, create another new layer in the Layers Panel. Open Vanishing Point again. Within the menu beneath the triangle in the upper left, select **"Render Grids to Photoshop"** and hit **"OK."** Your blue grid should now appear in a separate layer in the Layers Panel.

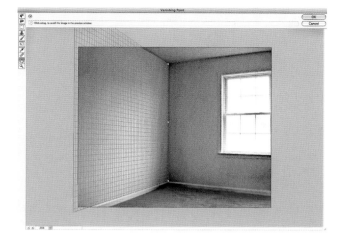

Creating a perspective grid in Vanishing Point.

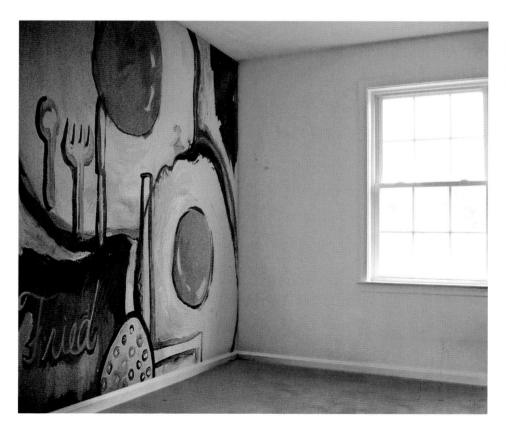

The "mural" image copied and pasted into the perspective grid in Vanishing Point. It was further modified using Image Adjustment tools.

Other Methods for Creating Perspective

As an artist it's also beneficial to understand the principals of linear perspective and to be able to observe their effects in an environment. If you have a fair understanding of the concept, you may find it easier to directly stretch a basic object to match the perspective of an environment. You will find the following useful commands for manually putting objects into perspective under **EDIT > TRANSFORM**.

◆ **EDIT › TRANSFORM › PERSPECTIVE:** Emulates basic one-point perspective. When you move one corner, it moves the neighboring corner (horizontal or vertical) at the same time.

◆ **EDIT › TRANSFORM › SKEW:** Slants the bounding box by stretching a corner point.

◆ **EDIT › TRANSFORM › DISTORT:** Is my preference for complex shapes in two-point perspective. Grab each corner and stretch (distort) the image into its approximate desired position. Refine the positioning until you have created believable perspective.

◆ **EDIT › FREE TRANSFORM:** Can scale or rotate an object, depending on where the cursor is placed. Holding the Cmd or Ctrl key while dragging a corner distorts the image. You can also access Free Transform from the selection menu **SELECTION > TRANSFORM SELECTION.**

You must click on the **"check"** symbol in the Control Panel so that Photoshop can redraw the pixels once you have used any **EDIT > TRANSFORM** command.

Guarding Eve by Davida Kidd. Here is another work by Davida in which we can see her signature doll bits. She also fine draws in Photoshop using the Brush tool to create reflections in multiple layers. COPYRIGHT © DAVIDA KIDD

Zipper Eyes by Jack Pabis is a convincing and visually consistent composite of photographic images created in Photoshop. COPYRIGHT © JACK PABIS

USING EDIT > TRANSFORM TO CREATE PERSPECTIVE

In the images below, I use **EDIT > TRANSFORM > DISTORT** to grab each corner of the painted image to stretch it and have it conform to the perspective of the book. Once I have the image in position, I adjust the tone and color and blur the edges of the painting with the Blur tool to help make the image convincing.

Using **EDIT >TRANSFORM > DISTORT** to place the painting into the perspective of a book cover.

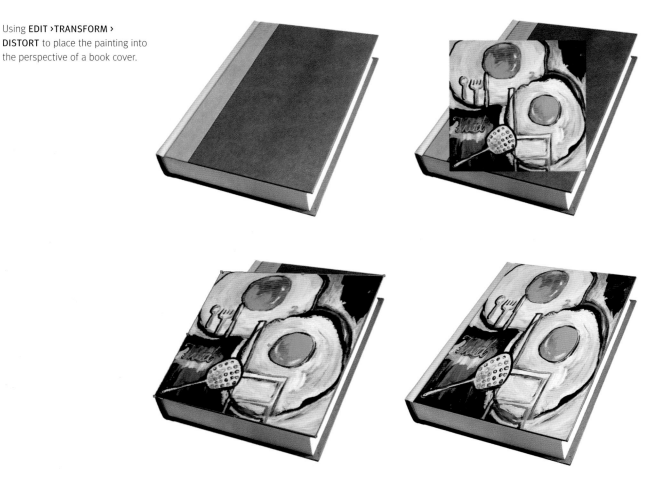

There are an endless amount of additional possibilities, advanced techniques, and individual approaches to realistic compositing. Many entire books have been written just to cover certain approaches to realistic compositing.

PROJECT:
Create a World

Composite a convincingly realistic image using photographic elements from at least five different sources. Whether the scene is mundane or fantastic, your goal is to transform these individual pieces into a believable environment. Address all technical considerations to create a convincing environment. Position the elements to create an interesting, balanced composition. Use colors as themes that add consistency to your work. Think about what mood you want to create and use light and shadow in an appropriate manner. You are in charge of the little digital world you are creating. Every part of your work should be purposeful, appropriate, and function in service of the work as a whole! To the right are some of my students' solutions to this project.

Top: Nicole Cooke, Cleveland Institute of Art. Multiple images of the artist were taken and integrated with the dinosaur statue. Although Nicole still had to adjust value, color, contrast, and focus, she made things easier on herself by posing for each image with the actual statue so that the light source was consistent among them.
COPYRIGHT © NICOLE COOKE

Bottom: Josh Dryden, Cleveland Institute of Art. Josh placed his face into the space helmet and made it semitransparent to integrate it with exterior reflections. All the elements were given a consistent reddish hue. The photo of the astronaut was flipped to place the light source on the correct side. In addition, shadows were created from Mount Rushmore.
COPYRIGHT © JOSH DRYDEN

EXPRESSIVE NONREALISTIC PHOTO ART

Visual artists have a long history of distorting, or changing, an image's elements for expressive effect and compositional clarity. Even the most realistically representational artists are likely to modify what they see in front of them, both for compositional purposes and to emphasize qualities they wish to convey in the work. Many visual artists distort elements in more extreme ways. They abandon the illusion of external reality in favor of creating something that reflects a more personal, subjective inner reality. Individual elements can be distorted, stretched, and manipulated. Colors can be exaggerated, changed, or de-emphasized in a way that is appropriate to the ideas in the work. Elements can be made more sharp and angular, or be manipulated into soft, curving shapes. When experienced artists create such a work, they use compositional themes in the treatment of elements. Establishing consistency in the way similar elements are treated within a composition makes us feel like these elements belong there.

With digital images, everything is paint. Using the vast array of tools available in Photoshop, photographic materials can be altered to appear as if they are no longer merely representations of reality but rather elements of personal expression that are distinctive and consistent in treatment and evocative of a certain emotion or quality that is discernable to the viewer. The instruction in this chapter focuses on photographic images, or pieces of images. Rather than an attempt at creating the illusion of reality, successful completion of these projects involves using the elements of design for expressive effect. Elements should be modified in a way that supports the overall mood, quality, or emotional timbre of the piece, with consistent visual themes among the elements.

When creating your work, choose appropriate visual themes and repeat them to build structure. Use variations on the themes to create greater visual interest. Elements should be similar enough to look like they belong in the work but different enough to offer something visually unexpected. Using only photographic images you can create a work where every part is well considered and works to support the piece as a whole. You can create something that only you, with your unique point of view, could make.

Top: *No. 5*; bottom: *No. 6* by Sally Grizzell Larson. Photoshop is used to create lush landscapes from composited photos and textures. COPYRIGHT © SALLY GRIZZELL LARSON

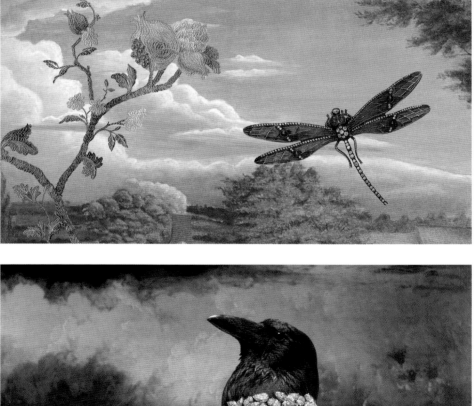

Visual Themes

Let's say you are creating a visual image with a general feeling of weariness and despair. In this composition, your figures are all rendered entirely in a muted, yellowish color. The composition is arranged to create diagonals that collide in opposing directions. The figures have extreme high contrast in value and they are stretched in an angular manner so they appear fragile and emaciated. The figures are placed on a background that is essentially red but also has tiny sparks of yellow in places, which helps to unify the background with the figures. If I asked you, "What are your visual themes?", you could answer by saying, "All of the figures are dull yellow, have high contrast, and are placed against a red background. The red background also has little sparks of yellowish color that are used in the figures. The figures are stretched and distorted in a specific manner, appropriate to the subject."

Yellow figures, stretched, red background—this is easy to understand, right? If this is a new way of thinking for you and you feel uncertain about how you might go about modifying photographic elements to create specific visual themes, I recommend simplifying things until you have incredibly *blatant* and *clear* visual themes in order to understand the process. The image below is a specific application of the visual themes I just described above. The exercise in this chapter will demonstrate how Photoshop techniques can be used to modify and combine photographic images to create a decidedly nonrealistic artwork.

Distinctive visual themes. Yellow figures, stretched, and a red background. We'll see how I created this image in exercise 1, which illustrates the different concepts and tools associated with modifying photographic images for expressive purposes.

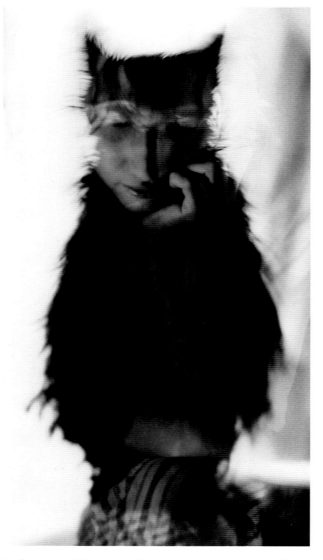

Catface by Jack Pabis. A dreamlike image, created in Photoshop. This work was created from two photos taken by the artist. One photo was of a woman; the other was of a wet cat that had just come in from the rain and was sitting on the edge of the couch. These images were placed on different layers. Jack adjusted the size of the "cat" layer so that the eyes matched up. He then adjusted the opacity so that both images were visible. Jack selectively erased some of the cat layer so that the image of the woman became more prominent in some areas.

Although it may be quite helpful to have the subject matter relate to the visual themes within a composition, it's possible to create a body of consistent works using specific visual themes, regardless of the specific subject matter of each work.

I've urged you to select a few simple, clear visual themes in order to make the concept of visual themes understandable. Once you are comfortable with the concept, there's certainly room for more sophisticated and subtle visual themes. You can have several visual themes in the same composition working together. Two very different visual treatments could be unified in your composition by including "transitional" elements that have aspects of both visual themes. Often, successful compositions will have a main theme with secondary themes as accents.

If you are uncertain where to begin, however, I urge you to limit yourself to a few simple, direct visual themes within the treatment of the elements. Treat every element consistently where it is logical to do so. Once you feel comfortable with the basic concept of visual themes, you can add more nuance and subtlety to your work. Look at the work of successful artists, digital and otherwise. Ask yourself, "What is it that makes this particular artist's work distinctive and recognizable?"

It may be helpful to write a list of your visual themes. If you cannnot clearly state what your themes are, you may not have any. Write about the subject as well. What is the image about? How do you feel about the subject as it is represented in your image? What would you like to communicate? Finally, use your imagination! What could you do to photographic elements to support the quality you wish to convey using the Photoshop tools that we have covered so far?

EXPRESSIVE PHOTO ART

Let's look at some specific ways to establish consistent visual themes and manipulate photographic images for expressive effect. You may use any, or all, of these methods, where appropriate, when you create your composition. You can also invent your own.

❶ Create a New Document

As I did in the previous chapter, I begin my project by creating a new, blank document. I created my document for this project at 11 x 14 inches at 300 PPI.

I posed for a photo for this project in a slumped over, defeated posture. I open this file. My figure has already been separated from its original background. However, before I place the figure into our new document, I'll do several things to exaggerate the slumped posture and further modify the figure.

❷ Distort the Image for Emotional Effect

Elements in your composition can be warped, stretched, and distorted. They can be made to be short and stout or visually strong and immobile. They can be made to be gaunt and angular, rounded, and friendly, or curving and graceful. Facial expressions can be made to be grotesque, desperate, silly, cute, playful, resolved, or any other possible quality that can be associated with the human face. Figures can be warped to appear to tower over everything; they can be tilted forward aggressively, or be made to shrink backward in fear. They can be leaning toward each other in affection, or away from each other in repulsion. They can all lean in the same direction to indicate speed or movement with purpose.

There are a variety of methods you can use to distort elements within Photoshop. Many commands found under **EDIT › TRANSFORM** can be used to contort elements for expressive effect. You can use **EDIT › TRANSFORM › DISTORT** to click, hold, and drag a corner to distort a selected element, for instance. In this exercise, I select our figure and use **EDIT › TRANSFORM › SCALE,** dragging the image without holding the Shift key in order to stretch it.

Me, posing for this exercise.

Using **EDIT › TRANSFORM › SCALE** to stretch the figure.

③ Use Liquify to Enhance the Distortion

We were introduced to the Liquify environment in chapter three. **FILTER › LIQUIFY** offers a variety of valuable tools for distorting elements toward expressive effect. Below is a description of these tools:

◆ **FORWARD WARP TOOL:** Enables you to move photographic pixels as if they were wet paint. Use a very large brush size to distort or move whole areas of your image. Use a small brush to change the character of details. This is a good tool for creating soft, curvy distortions.

◆ **RECONSTRUCT TOOL:** Reverts any area to its pre-liquified state when you paint over it. This is sort of like an **undo** Brush.

◆ **TWIRL CLOCKWISE TOOL:** Can swirl an image area in a circular manner when you click and hold on the area. Brush size determines the area to be twirled. Hold the Alt/ Option key to reverse the direction of the twirl.

◆ **PUCKER TOOL:** Shrinks a portion of the image when you click and hold on an area.

◆ **BLOAT TOOL:** Enlarges a portion of the image in the same manner. The brush size will determine the affected area.

◆ **PUSH LEFT TOOL:** Moves pixels to the left when you drag the tool up, or right if you drag down. Drag a circular motion clockwise to enlarge an area, counter-clockwise to shrink an area.

◆ **MIRROR TOOL:** Mirrors the pixels to the left of the area you drag.

◆ **TURBULENCE TOOL:** Distorts pixels in a smooth and uniform manner.

◆ **FREEZE MASK TOOL:** Prevents a specific area from being altered in Liquify when you paint over the area using this tool.

◆ **THAW MASK TOOL:** "Unfreezes" an area previously selected by the Freeze Mask tool.

In the Liquify Environment I select the Forward Warp tool, the first tool in the Liquify Panel. Under Tool Options, on the right side of the panel, I adjust the brush size to create a giant brush. My brush size is over 1,000 pixels! I use the giant brush to click, hold, and drag the head and shoulders in a curved arc to exaggerate the defeated posture of the figure. This is a trial-and-error procedure. If I don't get it right the first time, I can hit **EDIT › UNDO**, adjust the brush size if necessary, and try it again. I can use the Reconstruct tool at any time to paint over an area and undo any changes I have made to it.

Next, I decide to enlarge the hands to make them appear heavy, increasing the pathos of our figure. I select the Bloat tool in Liquify. I select a large brush size and click and hold on each hand to enlarge it. Again, I use trial and error, hit **EDIT › UNDO**, and try it again as necessary.

Using **FILTER›LIQUIFY** and selecting the Forward Warp tool to exaggerate the slumped posture of the figure.

Using the Bloat tool in Liquify to enlarge the hands.

④ Decide on Color Themes

Your colors are themes. A color that occurs in your work is a visual idea. If a color is random and doesn't occur anywhere else in the composition, it is likely to be a visual idea that goes nowhere. Your work will suffer with too many random visual ideas. Pick color themes and stick with them. If a color is prominent in one element, find ways to bring a little of it into other elements and parts of the composition. If one element has a blue-green color and another has a more violet blue, adjust the colors to be more similar, unless there is a visual reason not to.

Many masterworks were created using very few colors. In many cases, we are not likely to even notice this limited color palette unless we stop and analyze the work. It doesn't take too many colors in a work for us to perceive it as a "full color" image. Select a few colors that reoccur throughout the composition and use variations of only these colors. This is a good foundation for consistency in design. The combination of colors that you use and how they are used in the composition should be selected to help the viewer

feel what you want him or her to feel. Are garish, abrasive colors appropriate? Maybe the general feeling of your work is best represented by muted earth tones. A combination of contrasting colors could be appropriate; perhaps a cool blue color throughout the general composition, with tiny sparks of a warm color in various places. Choose a set of colors to work with, appropriate to your desired effect, and stick with them exclusively.

As we know, one of the components of color is value. You can create low-contrast faded images, or boost the contrast for dark saturated shadow areas and exaggerated highlights by using Brightness/Contrast in the Adjustments Panel. You can also use Hue/Saturation in the Adjustments Panel to modify color. Should you exaggerate the color saturation? Should you (partially or totally) desaturate the color of elements? Should you push the general hue of an image in an unexpected direction? In the Hue/Saturation Panel, clicking on the **"Colorize"** box reduces the image to various values of a single color. Use any of the other image adjustment options in creative ways. Working with the concepts involved in this chapter, you don't have to be subtle. *Experiment!* Push the sliders to extreme positions, observe the results, and allow them to inspire potential directions.

You can use **IMAGE > ADJUSTMENTS > REPLACE COLOR** to select a color range and modify it. Use the Eyedropper tool at the top of the Replace Color Panel to sample the color you'd like to replace. The sampled color will appear in the upper right hand corner. The **Fuzziness slider** affects how closely a color must resemble the sample in order to be changed. The more the Fuzziness slider is pushed to the right, the greater the area that is affected by your changes.

Adjust the sliders at the bottom to alter the Hue, Saturation, or Lightness of the selected color range. You can also click on the color square above the word **"Result"** to access the Color Picker and simply pick a replacement color or sample another color from your image. You can add or subtract from the selected color range by using the other Eyedropper tools, **"Add to Sample"** (+) or **"Subtract from Sample"** (-). You can use this panel to make colors consistent with your visual themes or to replace specific colors with unusual, expressive hues.

You can select a foreground color and use the **Color Replacement tool** ✏️, to replace the general color of an area by painting into it. Various settings in the Options Menu can limit the colors that are changed by your painting or change the way they are affected.

For this exercise, I've decided to use red, yellow, and black as the predominant color themes. The colors will be fairly muted, the figures will have high contrast in value, and we'll work to integrate these colors within all of the elements.

In the Adjustments Panel, I click on the brightness/contrast icon. The **Brightness/Contrast Panel** has only two sliders. One adjusts the overall brightness of an image; the other increases or reduces the contrast between the darkest and lightest areas in an image. These two sliders affect each other and often must both be moved before you can accurately determine the proper position for either of them. I boost the contrast significantly in the image and take down the brightness a bit. I go back to the Adjustment Panel, select Hue/Saturation, and push the hue toward yellow.

⑤ Copy a Layer

At this point, I decide that I wanted the figure to have long, ill-fitting pants. Shorts seemed too cheerful for our dejected figure. I select and copy the shorts to a new layer, using **LAYER ＞ NEW LAYER ＞ LAYER VIA COPY.** I then select and stretch the copies with **EDIT ＞ TRANSFORM ＞ SCALE** and use the Clone Stamp tool and the Healing Brush tool to complete the new long pants. I then use the Burn tool to continue the shadow area on the left leg. I also use the Clone Stamp tool to remove details from the shoes. There is no formula for completing the details of your artwork because the needs of every composition, and every unique stylistic approach, will be different. Once you become familiar with the tools, you'll be able to improvise according to your needs.

The hands have been enlarged using the Bloat tool. The contrast and hue have been modified in the Adjustment Panel. The shorts were copied onto a new layer, stretched, and painted with the Clone Stamp tool to make them into long pants. The Burn tool was used to continue the shadow on the left pant leg. The Clone Stamp tool was used to simplify the shoes.

Next, with the pants still on a separate layer, I use Brightness/Contrast to reduce the brightness significantly and give the pants a more somber tone. I then merge the pants layer with the figure layer with **LAYER ＞ MERGE DOWN** and use the Burn tool to darken the shoes.

I darkened the pants and shoes to give them a more somber tone.

⑥ Create a Background in a Blank Document

Now it's time to create a background for our work. You could easily create a background from multiple source images, but I selected a photograph I took of an abandoned gas station as the basis for our entire background. I drag the photo onto the blank document that was created in Step 1 and use **EDIT > TRANSFORM > ROTATE** to place the image at an uneasy angle.

Our background image rotated to an uneasy angle.

Next, I select the layer that contains our background image and make an exact copy of it using **LAYER > NEW LAYER > LAYER VIA COPY**. I'll do this again to make a *second* exact copy. Now click on the eye icon next to the layer containing our original background layer. It'll be invisible, but it'll be there in case we need it later.

Now I select the first duplicate layer in the Layers Panel. With this layer selected, I go to Hue/Saturation in the Adjustment Panel. In this panel, I click on the box next to the word **"Colorize"** to put a check mark in it. When Colorize is selected, the image will be reduced to variations in value within a single color. I move the hue slider until I get a sickly yellow-green color that is appropriate for our work. I move the saturation slider to the left to make the color less vivid.

Using "Colorize" in the Hue/Saturation Adjustment Panel makes an image into different shades of a single color. I made two copies of our background image. I made the first copy a dull yellow-green color.

I then select the second copy of the background image. This is the layer at the top of the Layers Panel. I use Colorize to make this image into a muted, but slightly more vibrant, red color.

I made the second copy of our background into a muted red color.

7 Use Layer Blending Modes

Next I create a new layer using the new layer icon at the bottom of the Layers Panel. I click on the Foreground Color in the Tools Panel and use the Color Picker to make a mustard yellow color. Making sure this new, empty layer is selected, I go to **EDIT › FILL**. When the dialogue box comes up, I make sure **"USE: FOREGROUND COLOR"** is selected, and hit **"OK."** This yellow color should fill the entire layer. Alternately, I could click on the **create new fill or adjustment layer icon** at the bottom of the Layers Panel to access a pop-up menu and select **"Solid Color"** from the top of the menu. The Color Picker will appear and you can select your color. I drag this color layer so it is below the two copies of the background image in the Layers Panel. Why I am doing this will become apparent once we begin learning about layer blending modes.

I created a new layer and used **EDIT › FILL** to fill it with a yellow color, which will be used in conjunction with Layer Blending Modes.

Accessing the Layer Modes menu from the Layers Panel.

LAYERS | **PATHS**

✓ Normal
Dissolve
Opacity: 100%
Fill: 100%

Darken
Multiply
Color Burn
Linear Burn
Darker Color

Lighten
Screen
Color Dodge
Linear Dodge (Add)
Lighter Color

Overlay
Soft Light
Hard Light
Vivid Light
Linear Light
Pin Light
Hard Mix

Difference
Exclusion

Hue
Saturation
Color
Luminosity

Layer blending modes affect the appearance of layers by changing the way that they interact with the layers beneath them. Any **mode** other than **"Normal"** will cause your layer to react with the images below it in a specialized way. Layer blending modes can be used not only to create subtle, realistic effects, but they also have limitless potential for creating distinctive, expressive visual images as well. Layer blending modes are grouped thematically within their pull-down menus. Some lighten, some darken, and some interact based on color or value.

Since layer blending modes react with the layers underneath them, when you change the mode of a selected layer, nothing will happen unless you have elements on the layers below them. Changes created by layer modes are *cumulative.* One layer may be set to a layer mode that darkens aspects of the previous layer, which may have a layer mode that creates a soft-light effect on the layer below it. The layer below it might use a layer mode that is set to multiply its image with that of the layer below it, etc. You can develop a basic familiarity with the effects of individual layer modes, but the possible combinations among multiple layers are infinite. Informed experimentation is required in order to achieve the best results.

In our project, the layer order for visible images is: (1) a yellow solid color fill on the bottom; (2) a yellow-colorized background layer in the middle; and (3) a red-colorized background layer on the top. We'll adjust the blending mode of various layers so that they will interact. When you select a layer, you can change its blending mode at the top of the Layers Panel. By default, it will say **"Normal."**

I select the yellow-colorized image and change its blending mode to **"Darken."** I select the red-colorized layer and change its layer mode to **"Darken"** as well. I leave the layer containing the solid yellow fill on **"Normal"** mode. If a layer's blending mode is set to **"Darken,"** it allows only darker colors to combine with the layer underneath it.

You can use Layer Blending Modes to make layers interact in various ways. Both image layers are in "Darken Mode." They are on top of the yellow fill layer, which remains in "Normal Mode." Compare this to the appearance of the red-colorized layer in normal mode earlier.

⑧ Add the Figures

Now I'm ready to drag our distorted figure into our file, which contains the background image. I do this four times. Each time I drag the figure into the file a new layer will automatically be added for this copy of the figure. Making sure the layer for each figure is selected, I take turns resizing them with **EDIT › TRANSFORM › SCALE.** This time, I hold the Shift key to keep my image in proportion. I could convert them into Smart Objects before scaling, as I did in exercise 1 in chapter four, but in this case I don't bother. Because I'm working with multiple copies of the same figure and taking a less realistic approach, I decide to live dangerously and make permanent changes. I can always delete some copies and drag over some more figures if I need to. I scale the figures so that they are reduced in size as they go backward in "space"—even though the goal is to create an interesting composition, not accurate perspective. I temporarily turn off the eye icons next to each layer except for the figure layers, and then merge the figures with **LAYER › MERGE VISIBLE.** I make all the background layers visible again, except for our original uncolored background image.

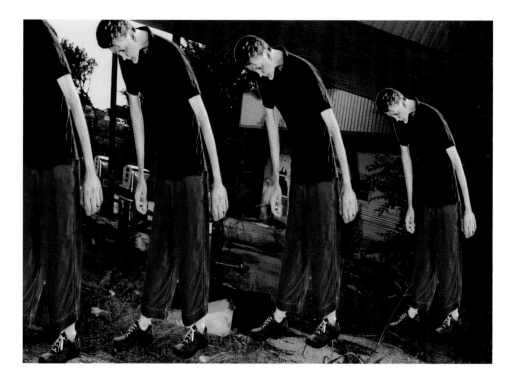

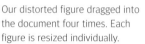

Our distorted figure dragged into the document four times. Each figure is resized individually.

Next, I want to continue our line of figures in the distance behind the other figures. I drag one more copy of our figure from its document into our current file. I scale it so that it is smaller than the others. I use **EDIT › TRANSFORM › FLIP HORIZONTAL** to make this figure face the opposite direction of the other figures. Now I drag the layer containing our new figure so that it is below the layer containing the other four figures. This time, I make three more copies of the figure by selecting the Move tool, holding down the Alt/Option key, and dragging the image to make a copy of it. These new images will be created on the same layer as the figure that I am copying, so I make sure to drag my copies clear of each other to keep them separate. Next, I make shadows for the figures. I make a new, blank layer and create an angular selection mask under each figure. I use the Eyedropper tool to

sample the (almost) black shirt color. I then go to **EDIT > FILL** to fill our selections with this color, creating our shadows. I drag the shadow layer so it is behind the layers containing the figures.

I reduce the contrast and adjust the hue/saturation of the background figures so that they don't detract from the foreground figures. I blur them (and their shadows) very slightly using **FILTER > BLUR > GAUSSIAN BLUR.**

New background figures are flipped in the opposite direction and duplicated. They are altered in hue and value and blurred slightly so that they won't detract from the foreground figures. "Cut-out" shadow shapes were then added.

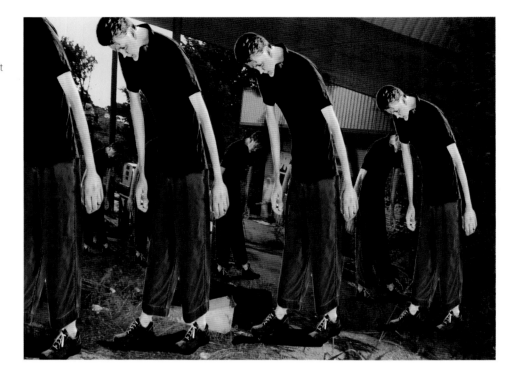

9 Add Texture

Photographic textures or patterns can be recurring design elements. In a composition, they can be cut out and used as independent objects or combined with other images. One method of combining textures with other elements is the use of layer blending modes. Another method is to reduce the opacity of a layer, making its contents semitransparent. Layer blending modes and Layer Opacity can be used together to achieve a desired effect.

Objects in individual layers can be made semitransparent so that other elements below can show through them in varying degrees. Nuance and subtlety can result from the layering of multiple semitransparent elements, one on top of the other. Combining this technique with the appropriate kind of distortion in shape can produce a dream-like quality. It's also possible to use transparency to add new characteristics to an element as surface textures.

To adjust the transparency of a layer, select the desired layer in the Layers Panel and adjust the opacity pop-up slider, found under the arrow to the right of the word "Opacity" near the top of the Layers Panel. You can also type in a value in the opacity text box. Layer transparency can be adjusted repeatedly as you add elements and fine-tune the relationships between them. I'm going to import an image texture and place it over our entire

Adjusting Layer Opacity in the Layers Panel.

composition. I'll use both layer blending modes and layer opacity to integrate the texture with our image. I open the photograph below of beach sand, drag it into our image, and resize it. This layer is on top, covering everything else.

A photograph of sand imported as a texture in our image.

I wanted a texture as part of our image to add visual interest and subtlety, as well as abstract it in a way that would contribute to the dismal, gritty appearance that is appropriate to our piece. You may try and then reject several textures or combinations of textures before finding something that works with your piece. I select the sand layer, change the mode to **"Difference"** and then change the opacity of this layer to **"27%."** If anything in the texture image detracted from the figures or other elements, I go over it with a semitransparent eraser to reduce its prominence.

I add to the texture by scribbling into various layers with a very tiny, semitransparent eraser. These lines react with the sand texture in **"Difference Mode."** At this point, I look at the piece and decide I'd like to distort the figures in a more dramatic fashion, and in a way that creates shapes that work in service of the composition. In order to complete the next step, I'll need to place all the figures on the same layer. First I use **FILE > SAVE** to preserve the document in its current state. Then I use **FILE > SAVE AS** to save a copy of my file under a new name. I click the eye icons next to the layers containing the buildings, the yellow fill, and the sand to make them invisible. Only the figures and their shadows are visible. I use **LAYER > MERGE VISIBLE** to place all visible elements on a single layer. Since I did a **SAVE AS** and renamed my file, my figures are preserved on individual layers on my original document.

The sand layer in "Difference" mode, reduced to 27% opacity. This transparent texture adds grit and helps contribute to the somber mood.

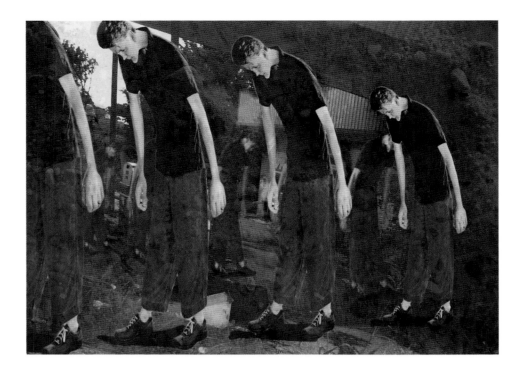

⑩ Distort the Figures Some More

Now I'm ready to further distort my figures. I'll use **EDIT > TRANSFORM > WARP** to do this. Using this command creates a grid. I click and drag points on the grid to distort individual portions of an element. We can use the Bezier handles connected to the outside corner points to distort with smooth curves. In the left side of the Control Panel, the pull-down menu next to the word **"Warp"** offers some preset methods of distortion that could serve as useful starting points for the manipulation of images.

Line textures are added with a semitransparent eraser. **EDIT > TRANSFORM > WARP** is used to further distort the figures and enhance the composition.

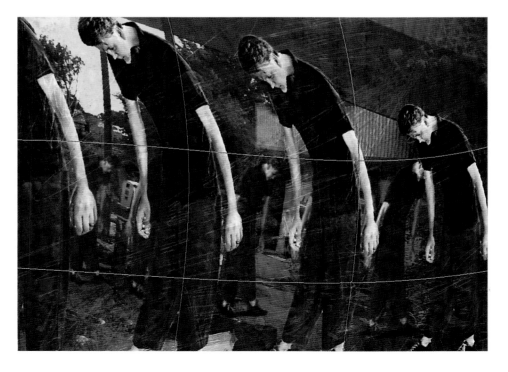

⑪ Add Finishing Touches

At this point, I sit back and assess our piece before adding finishing touches. What does it need? What parts work? What parts need to be further refined? The following are the final changes I make to the piece:

1. I crop the piece to improve the composition.
2. I decide that my suburban haircut doesn't fit in with the dismal world I'm creating. I use the Forward Warp tool in Liquify to drag some "hair" down from the forehead and then use the Blur tool to blend it into the background.
3. Even though I want a gloomy, murky image, I feel it could still benefit from greater clarity. I boost the general contrast and color saturation with image adjustments and then use the Burn tool to darken the upper right-hand corner of the composition in order to balance the visual weight.
4. I then create a selection mask around the middle section of the background. I create a new layer in front of all the other layers and fill it with the same yellow color I used to make the previous yellow fill. I make the yellow layer very transparent and then roughly erase around the background figures, trying to reveal some interesting little bits of color or texture by controlling where I erase. This yellow layer reduces the contrast in the background of the middle area, adding a sense of depth and clarifying the figures in the foreground.

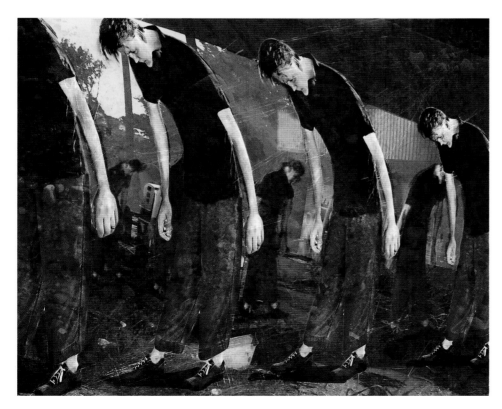

The completed piece, with finishing touches added. A new crop and a darker area in upper right corner improve the visual balance. A transparent yellow fill in the background clarifies the image. The hair is changed, and value and color have been adjusted a final time.

The Importance of Clarity for Compositional Interest

Think like a painter. You should be starting out with a blank canvas (new document). Anything can be there when the work is complete, but nothing has to be there. It's completely up to you. You can add elements, remove them, move them around, and change them repeatedly until everything works exactly like you want it to—in support of the overall design. This is freedom and responsibility. You have no excuse for anything being there unless you want it to. In your image, a person's shirt should not be blue because it was blue in the original photograph. It should be blue because that particular blue is a visual theme that reoccurs in various parts of your composition. Why? You would select it as a visual theme because it supports the emotion or general quality that is being conveyed by the piece.

Create an interesting composition with a balance of visual weight. Create a composition that is appropriate to the overall feeling of your piece. Placement of basic shapes in a composition can drastically affect the quality that they communicate—be it strength, isolation, anger, fear, or vitality. Think about how shapes could be rearranged in a composition to help convey each of these qualities, and how these compositions would differ.

Placement of basic shapes in a composition also influences what is emphasized in a composition. Does your composition have a psychological center? Is something happening in your picture that you want the viewer to focus on? In a portrait of a person, for example, the face is a natural center of focus, which can be further emphasized or de-emphasized by your compositional choices. You could use diagonals to direct the viewer's eye to an important part of the composition. It might be helpful to keep a sketchbook and make little thumbnail sketches to ensure that you are beginning with a strong composition.

CONTRAST AND CLARITY

Contrast, in every respect, serves to clarify and call attention to compositional elements where it is desirable. Below are some types of contrast you can use to clarify your image:

Contrast in Value: Dark things stand out against light things, and vice versa.

Contrast in Color: A blue subject in front of a yellow background is likely to stand out clearly, but a blue subject against a blue background may not. A vivid element will stand out against a dull one.

Contrast in Line and Shape: A thick, bold, strong element stands out against delicate, tentative shapes, lines, or textures.

Contrast in Focus: Sharp things stand out against blurry things. Sharp elements against other sharp elements can work, but you'll have to use some of other types of contrast to achieve clarity.

Contrast in Detail: Simple shapes placed against shapes with a great deal of complexity and detail will clearly delineate both shapes. Focus can be drawn to either element, depending on the overall composition.

Consistent and personally expressive visual themes are important, but their impact will be severely diminished by a lack of clarity in your composition. Muddiness in key areas of your artwork will serve to de-emphasize the exact areas that you have worked so hard to draw attention to.

PROJECT:
Manipulating Photographic Images for Expressive Purposes

Create a digital artwork using only photographic elements. This project should be a practical application of the ideas and techniques discussed in this chapter. Think of the general feeling or quality that you'd like to communicate in your work. Rather than attempt to create the illusion of reality, distort, manipulate, and modify the photographic elements in a way that helps to communicate your feeling or quality to the viewer. Establish consistent visual themes that are appropriate to your work. On this page are some of my students' solutions to this project.

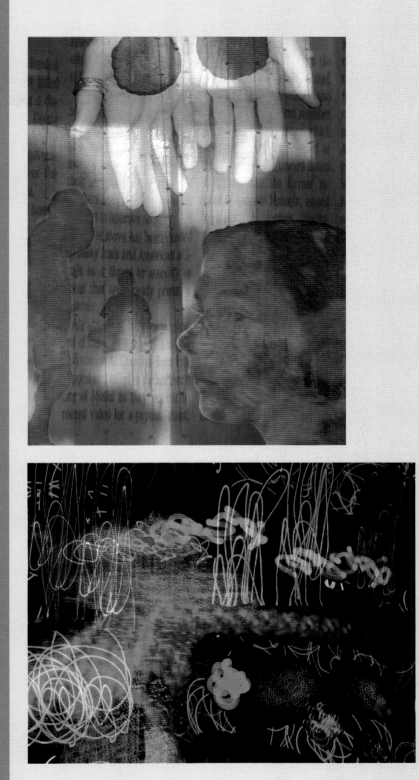

Top: Jacqueline Kennedy, Cleveland Institute of Art. Jacqueline's visual themes include low contrast in value, transparency, a limited color palette, and a stable composition that helps to emphasize the transcendent, meditative quality of the piece.
COPYRIGHT © JACQUELINE KENNEDY

Bottom: Molly Mathusa, University of Mary Washington. Molly took photos of various light sources at night using long exposure settings and moving either the light source or the camera. Compositing, layering, and modifying these images, Molly created a composition that exudes exuberance and motion. COPYRIGHT © MOLLY MATHUSA

PROJECT:
Fifteen Green Things

There's a project I often give to my digital classes when exploring the limitless, expressive possibilities of photographic source materials in Photoshop. I give students a folder containing the fifteen images shown here. All of them are lime green, of a similar value, and are processed in different, incompatible ways. Their task is to take these elements, which are nearly useless in their current state, and modify them to create a single, purposeful work of art. The rules are:

1. Students must use *all* of the fifteen elements in the folder.

2. Students must use *only* the elements in the folder and nothing else. They *must* use every element. They are allowed to use the elements more than once.

3. Students cannot paint, draw, or create new elements from scratch. They can only use the photographic tools that we have covered so far.

4. Students may alter various elements in color, size, position, value, or texture in order to create themes and build structure. They may use image adjustment tools. They may crop or distort any object. They may use the Sharpen, Blur, Distort, and Liquify filters.

5. Students must create a balanced, interesting composition.

On the next two pages you will find some of my students' solutions to this project.

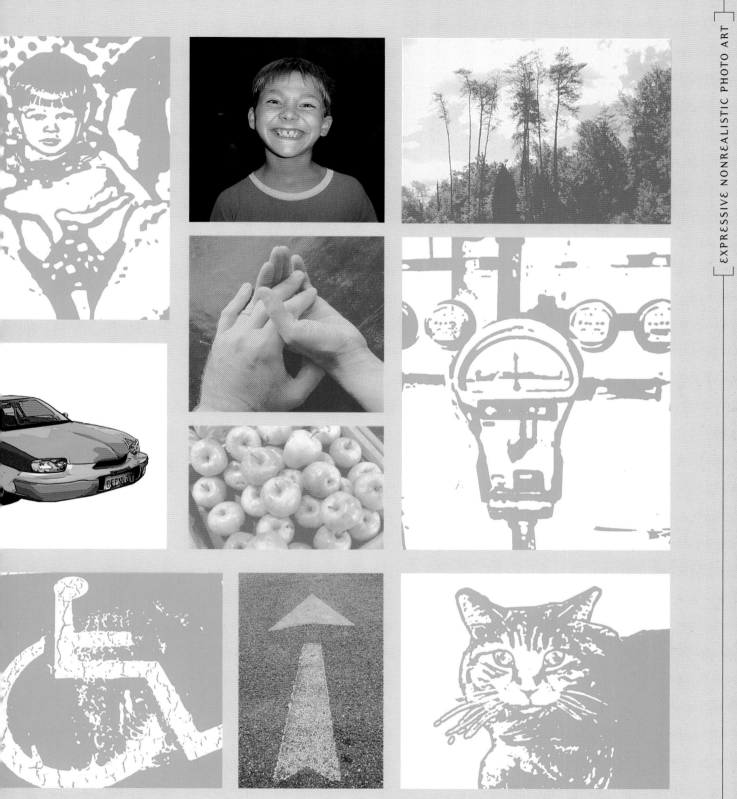

The fifteen green things in their original forms.

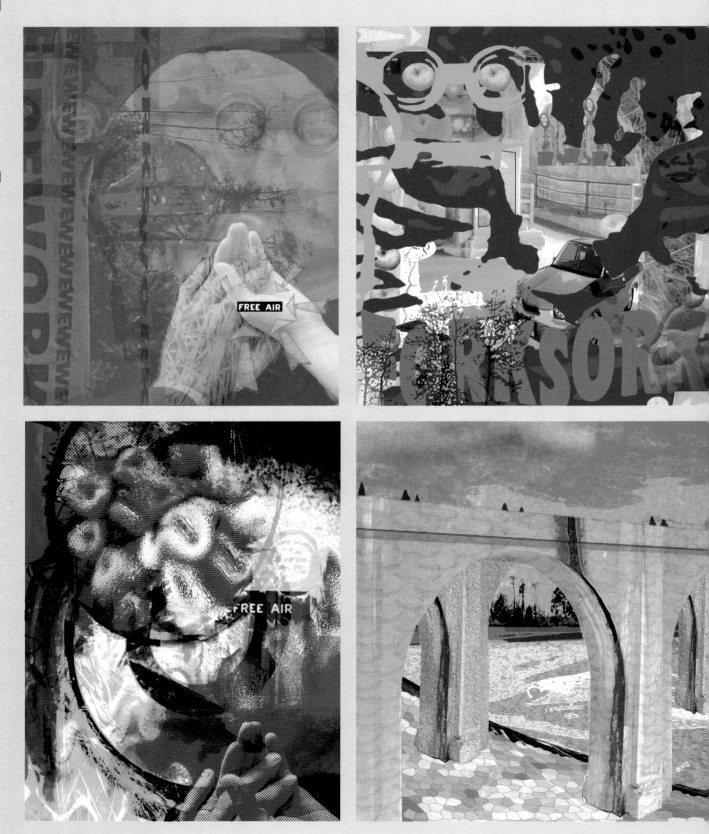

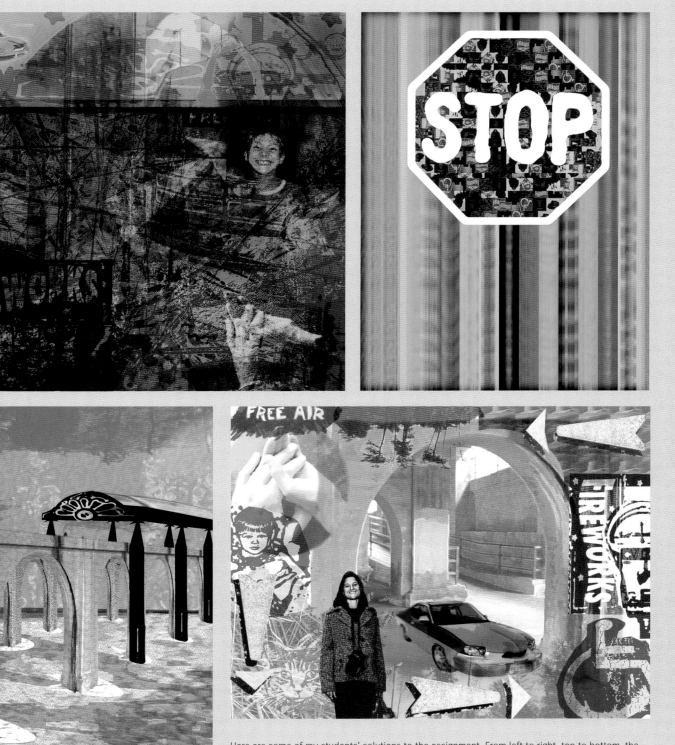

Here are some of my students' solutions to the assignment. From left to right, top to bottom, the project solutions are by: Elizabeth Schumacher, Donna LoGrasso Howson, Milvi Gill, Steven Vote, Nicole Young, Gabriel Pons, and Josh Hodges. Try this project yourself! You can download the Fifteen Green Things at the companion website for this book (see Resources on page 248). All images are the property of their respective artists.

EXPRESSIVE NONREALISTIC PHOTO ART

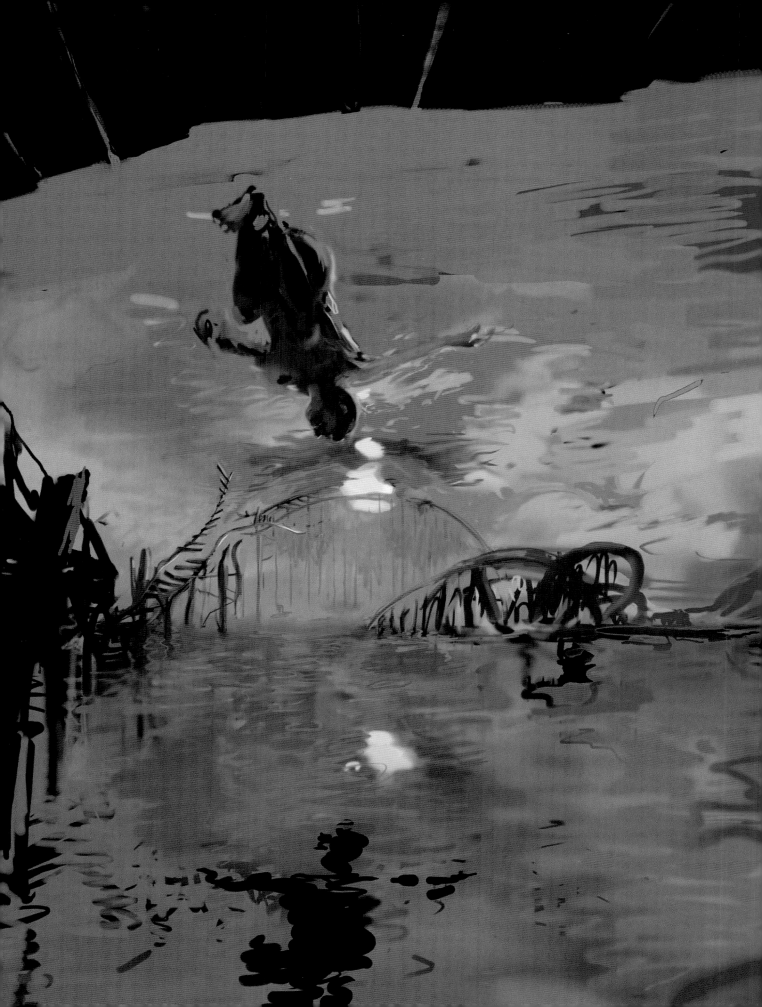

CHAPTER SIX

PAINTING WITH PIXELS

Using Photoshop and a drawing tablet with a pressure-sensitive pen allows you, with practice, to produce a very painterly, textural, organic piece of work that is virtually indistinguishable from physical paint. More importantly, it offers fascinating, new possibilities that are combined with the ability to endlessly experiment or "undo" when the results are unsuccessful. Since there is no mess, clean up, or drying time, you can grab a laptop and tablet and paint anywhere, anytime! This chapter, the first on digital painting, covers the basics of the painting tools and pixel-based painting techniques available in Photoshop. In this chapter's exercise we will first explore the time-honored tradition of creating an underpainting and then gradually build up tone and color using multiple layers of semitransparent "paint" from our digital tools.

Brush Features in the Control Panel

As you might imagine, the Brush tool is the indispensable, workhorse tool for digital painting. We'll begin this chapter by covering the Brush tool in detail to prepare for our exercise. Select the Brush tool in the Tools Panel and let's get started. As we discussed briefly in chapter three, when you click and hold on the arrow to the right of the word **"Brush"** in the Control Panel, you can access a pop-up menu offering a variety of brush presets. These presets can include standard **non-blurry** brushes in a variety of sizes, standard **blurry** brushes in a variety of sizes, and many specialized brushes. Some of these brushes can be decorative, some textural, and some respond in a specific way to various pen movements when you use a drawing tablet.

There is a small arrow on the upper right corner of the pop-up menu that calls up an additional sub-menu. In this sub-menu, there is a grouping of choices that allow you to choose the way you view your brush presets. I generally like to use the **"Small Thumbnail"** option. It provides a good visual clue to the character of the brush and doesn't take up a lot of space in your dialogue box. At the bottom of this same sub-menu, there are various sets of brushes grouped into specific categories. You can select any of them and they will appear among the brush choices. If you select **"Faux Finish Brushes,"** for instance, a dialogue box will appear which asks you if you'd like to **"Replace current brushes with the brushes from Faux Finish Brushes.abr."** If you click **"OK,"** these new brushes will indeed replace your current brushes. In this case, it's desirable to add to your current brushes, rather than replace them. To do this, when the pop-up asks you if you want to replace the current brushes, hit **"Append"** rather than "OK." Your new brushes will now be added to your existing choices. If you inadvertently get rid of brush presets or just want to start fresh, select **"Reset Brushes"** in this same pop-up menu to revert to Photoshop's default brush settings.

Presets can be selected and then modified. Once again, we will access the appropriate menu by clicking next to the word **"Brush"** in the Control Panel. The top slider, **Master Diameter,** adjusts the size of your brush. You can also type a brush size, in the number of pixels, in the box above the slider. The slider underneath it, **Hardness**, changes the stiffness of the brush. Moving this slider to the left makes your brush blurrier.

You can choose a brush and then adjust its size and "blurriness" in the pop-up menu in the Control Panel.

Brush Options in the Control Panel.

You can adjust the blending mode and opacity of a brush in a manner that is similar to layer blending modes and layer opacity. Mode (or blending mode) defines the method your brush uses to react with existing pixels when you paint over them. Experiment with the different modes to become familiarized with each one. Painting with **"Soft Light"** might just be the thing you need when painting in a highlight area. **Opacity** defines how opaque or transparent your paint is. Painting with a semitransparent brush allows you to build tones gradually. A semitransparent brush may also produce more natural-looking or subtle results when retouching photos. We'll work with transparency later in our exercise.

Flow affects (1) how quickly and easily your virtual paint moves around the "canvas" when you start painting and (2) how a color builds up when you click and hold over an area, giving it some of the characteristics similar to physical paint. Choose a high percentage, but not quite 100 percent, as a starting point and then adjust to your preference.

Airbrush simulates the smooth, gradual build up of paint that you would associate with a physical airbrush. We'll leave this option unchecked for our exercise.

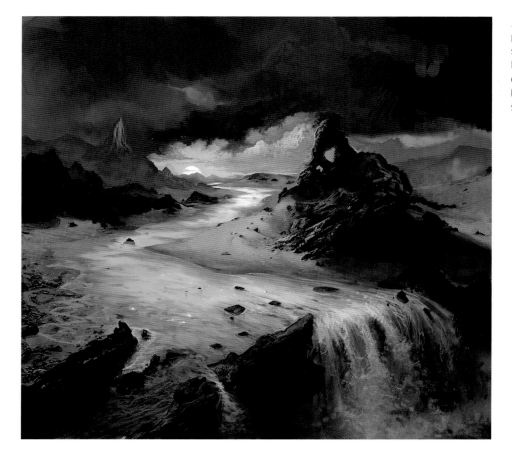

Fallen by John Spofford. John paints his landscapes in Photoshop, often from his imagination. He uses loose gestural strokes to create convincing, yet expressive, landscapes. COPYRIGHT © JOHN SPOFFORD

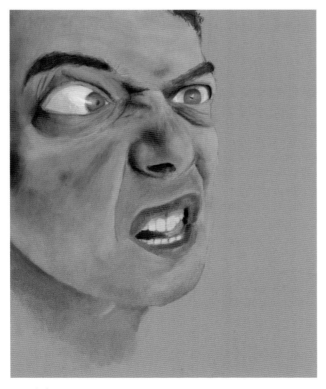

The Brushes Panel offers sophisticated choices for brush creation and modification.

Untitled by Sean Kraft is another example of pixel-based Photoshop painting. COPYRIGHT © SEAN KRAFT

THE BRUSHES PANEL

The **Brushes Panel** offers more detailed control over numerous variables when creating a new brush preset. Go to **WINDOW>BRUSHES** to access this panel. Clicking an option under **"Brush Tip Shape"** within this panel accesses sliders for adjusting the selected parameter. The choices near the bottom of the panel, such as **"Noise"** or **"Wet Edges"** are simple on/off parameters.

If you create a brush with unique, customized parameters, you can save it as a new brush preset by clicking on the rectangular **create a new preset from this brush icon** in the upper right corner of this panel. Name it and click **"OK."** Your new brush preset will now appear in the panel. You can make a new, customized brush out of any image or texture. Create a selection mask around the area you'd like to use and go to **EDIT>DEFINE BRUSH PRESET.** Name your new brush and click **"OK."** If you selected a full color image as the basis for your brush, it will be converted to variations in value, using whatever foreground color you have currently selected. There are many third-party custom brushes available that are created by companies or individuals. They may be sold or given away. Visit www.photoshopsupport.com, which is a good Adobe-sponsored site with links to many free third-party brushes.

THE STANDARD, ROUND, NON-BLURRY BRUSH

After telling you all about the different brush presets and how to obtain or create custom brushes, I'm now going to ask you *not* to use them! When you are drawing or painting in a somewhat traditional manner, I strongly recommend that you paint with a **standard, round, non-blurry brush**. This gives you the most control and options in your painting. You can modify the lines later, if you wish, in a way that is unique and personal. A blurry brush can be good for photo retouching or specialty applications, but it will just become muddy if you try to paint an entire painting with it.

Similar to some of the filters we discussed in previous chapters, the texture brushes can be mechanical and repetitive. If a brush pattern repeats over and over, even if it has some degree of variation, it becomes more decorative than expressive. Many people produce great works using a variety of brushes. In fact, the use of textured or decorative brushes is the norm rather than the exception. Textured

brushes (brushes with specialized patterns) can be made less repetitive by altering their strokes or combining them with other tools and methods of working, such as partially obscuring the strokes with a semiopaque eraser or blending these brushstrokes with digital paint created with other types of brushes. Nonetheless, in keeping with our philosophy of producing a unique and personally expressive work, I urge you to regard a standard, round, non-blurry brush as the indispensable foundation of your digital painting and to use this brush exclusively for our painting projects. If your style lends itself toward specialized brushes, they may later prove to be valuable additions to your visual vocabulary.

The "Flowing Stars Brush" paints with a specialized pattern.

Using only this single, ordinary brush may seem limiting, but I can tell you from personal experience that it is not the case. I create visual images in Photoshop every day, and I rarely use anything but a standard brush. Using this brush, I can obtain varying degrees of transparency and line quality with every possible character and technique, from bold and strong to delicate and ephemeral. I can work in any combination of colors. Once the brushstrokes are recorded, they can be blended, smudged, blurred, partially erased, or processed by image adjustments and filters and then placed on layers using different modes. Working with a standard brush and adjusting the size, I possess the majority of options that the great painters had throughout the history of art—in addition to many options they did not have!

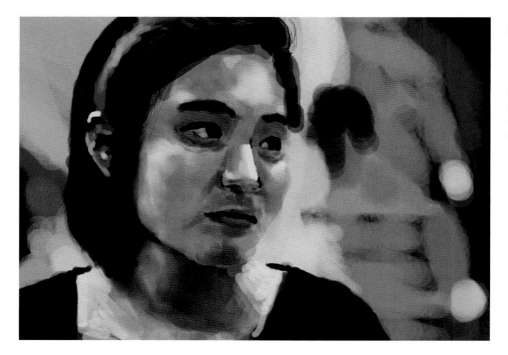

Self-portrait by A-Young Kim. The artist painted the image in Photoshop using transparent layers of digital paint over a sepia underpainting. This time-honored technique, adapted from traditional painting, will be covered in detail in exercise 1. COPYRIGHT © A-YOUNG KIM

Mixing Colors

When painting with the Brush tool, you paint with the currently selected foreground color, as indicated in the Tools Panel. In Photoshop, there are several methods you can use to select or create colors.

MIXING "PAINT" IN THE COLOR PICKER

You can change the foreground color, the color with which you paint, by double-clicking on it in the Tools Panel in order to access the Color Picker, which we first saw in chapter three. This panel contains a small, vertical strip containing transitions through the full range of colors in the visible spectrum. This is the color slider. In order to select an approximate color, you can click directly on a color area inside the Color Slider or drag one of the little triangles on the outside of the strip to choose an approximate color. The **Color Field** is the large square area on the left side of the panel. In this area you can fine-tune color parameters by clicking and dragging the hollow white circle within it. The Color Picker dialogue box also offers other systems of color to work with, which you can access by clicking **"Color Libraries."** Before you leave the Color Picker, you can save a color that you create by clicking **"Add to Swatches."** Name it, click **"OK,"** and your newly created color will appear in the Swatches Panel.

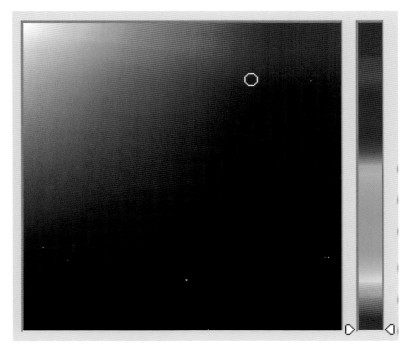

The Color Field (left) and the Color Slider (right) in the Color Picker.

ORGANIZING COLORS WITH THE SWATCHES PANEL

Go to **WINDOW > SWATCHES** to view the **Swatches Panel**, if it is not already visible. The Swatches Panel contains multiple preset colors. Clicking on one of these colors selects it as the foreground color in the Tools Panel. If you have created a customized color, you can save it as a new color in the Swatches Panel by clicking on the **create new swatch of foreground color icon** at the bottom of the panel. In digital painting, this process is very useful for establishing a consistent palette of colors that you can use as recurring themes in your work. You can double-click on a swatch to give it a name. You can delete a swatch by either dragging it into the trashcan or selecting the swatch and then clicking on the **delete color icon** 🗑 at the bottom of the panel. There is a tiny triangle near the upper right of the Swatches Panel. When you click and hold this triangle, you access Menu Options that include viewing options and other **Color Libraries.**

You can select and save colors in the Swatches Panel.

ADJUSTING COLORS IN THE COLOR PANEL

To view the **Color Panel**, go to **WINDOW > COLOR.** The Color Panel has separate sliders for red, green, and blue, the primary colors in additive color (light). You can modify the colors by adjusting these individual color sliders. A general color can be selected as a starting point by clicking on an area within the **Color Ramp,** which is the horizontal strip at the bottom of the panel.

Individual RGB (red, green, blue) color sliders in the Color Panel.

CHANGING COLORS

You can alter colors and values of anything, at anytime, and then simply hit "undo" if you don't like the results of your changes. You can use **IMAGE** > **ADJUSTMENTS** > **REPLACE COLOR** or the Color Replacement tool to replace individual colors.

Visions by Cindy Jerrell. The artist created this work in Photoshop. She began with a scanned, vintage black-and-white photographic portrait and completed it using digital painting techniques. We'll see more of Cindy's digital work in chapter ten, when we will discuss combining digital art with traditional media. COPYRIGHT © CINDY JERRELL

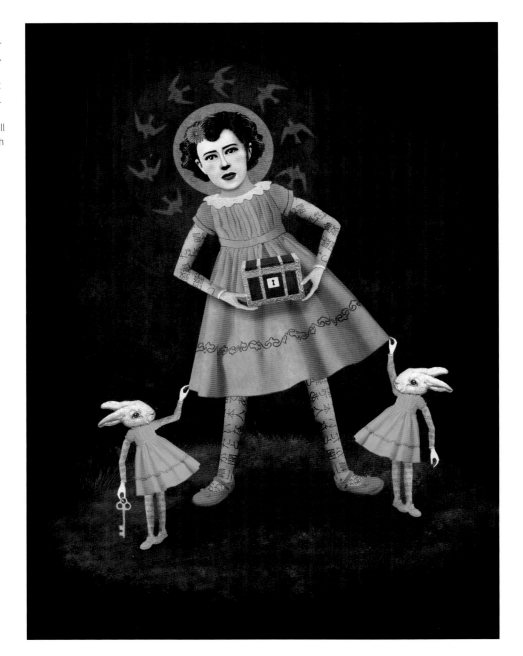

More on the Drawing Tablet and Pen

It would be very difficult to draw and paint digitally without the use of a drawing tablet and pen. Painting with the stylus (pen) allows you a degree of control similar to that of traditional painting and drawing, although it may take practice in order to achieve it. Additionally, the drawing tablet has many degrees of pressure sensitivity. The harder you press, the thicker the line. By varying pressure as you draw you can create many variations in thickness and character within a single line. This is necessary for nuance in observational drawing (drawing what you see) as well as creating expressive, rather than mechanical, brushstrokes.

You can create expressive lines with a drawing tablet and pressure-sensitive pen.

Wacom Intuos3 drawing tablet with pen and mouse. Photo courtesy of Wacom.

When working with a stylus, select a brush size that is larger than you need, so that you can get enough variation in line width. Make your lines thinner by not pressing down as hard. Initially, it may seem disorienting to draw with the tablet, and you may find it difficult to control the pen sufficiently. Don't give up! With practice, it becomes very intuitive, and you'll wonder how you ever worked without it.

Of necessity, a stylus operates differently than a mouse. A mouse's cursor has a relative position. You can scoot the mouse repeatedly in the same area and the cursor will move up the page. A pen has an absolute position. Wherever you place the pen on the tablet, your cursor will go to the corresponding position in the document. This is necessary in order to draw. Keep the tablet parallel to the monitor. When you draw a line going straight up on the tablet, you want to make sure it goes straight up on the monitor. Wacom is the most widely used brand of drawing tablets. Wacom also makes monitors that can be directly painted and drawn upon. As of this writing, these monitors are still relatively expensive, but are becoming more affordable every year.

You can customize and change the tablet settings by accessing the software that is installed with your tablet driver. You can access tablet settings by going to System Preferences and selecting **"Pen Tablet"** on a Mac, or going to the **"Pen Settings Control Panel"** on a PC. You can adjust the pen tip so that it requires either more or less pressure to create variation in line thickness. You can adjust numerous other settings and apply customized functions to buttons and actions associated with the tablet. When you are using your tablet for the first time, experiment with these settings to make the pen easier to control and to increase productivity when working.

Get used to the drawing tablet by simply doodling! Discover the possibilities in mark making. Create a new document. Choose black as the foreground color. Select the Brush tool. In the Control Panel, select a standard, non-blurry, round brush from among the first presets in the menu and experiment with different brush sizes. Have fun. Fill the page with lines and doodles. Write your name. Try to get as many different line qualities as possible. Practice varying the pressure on the pen to create multiple variations in thickness within a single line. Try drawing quickly, and then slowly. Try thinking of different emotional qualities and draw lines that represent them. Work to get as much variety as possible.

The Season's Dance, digital painting by Myriam Lozada-Jarvis. The artist uses Corel Painter as her primary painting tool. Corel Painter is a popular painting program that is adept at emulating natural media. This software is very compatible with Photoshop. Myriam generally begins the painting in Corel Painter, saves the Painter file in Adobe Photoshop (.psd) format, and then takes it into Photoshop for final tweaking and proofing. COPYRIGHT © MYRIAM LOZADA-JARVIS

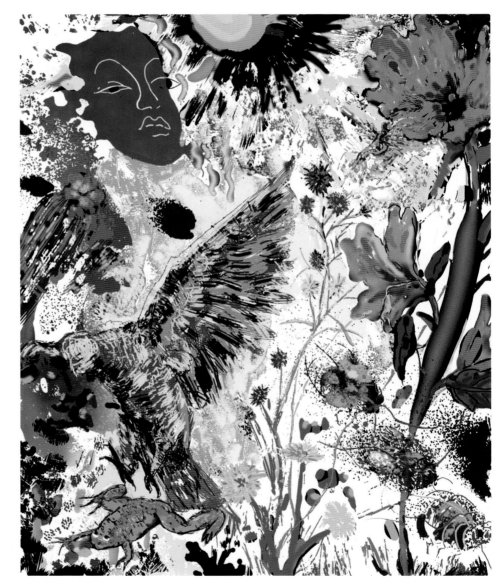

Painting with Transparency

The following exercise is about painting with translucent "glazes" of color. You can build up subtle variations of tone by placing semitransparent strokes of paint one on top of the other. It is an adaptation of a traditional method of painting. It involves rendering an underpainting in sepia (brown) tones, applying semitransparent color over it, and then using less transparent color to give the painting definition.

WHAT IS AN UNDERPAINTING?

An **underpainting** is a road map. It's a rough sketch indicating the placement of forms and objects and their general values. Underpainting often uses only tones of a single color. Full color work could also be considered to be underpainting if it is done quickly and renders general shapes rather than details. Underpainting is often perceptible in the finished work, obscured to various degrees by paint that is placed on top of it. Quickly drawn gestural strokes that are partially visible in your painting can add excitement or a feeling of motion to the work. You can structure and tighten the work by obscuring the underpainting or painting over it entirely in certain key areas. It is also possible for an underpainting to be used as a guide that is completely painted over in all areas of the work, leaving no trace of it by the time you are finished.

WHY TRANSPARENCY?

In traditional painting, color, light, and shadow are built up gradually by adding layer after layer of transparent glazes of color, allowing for great subtlety and variation. Colors that contrast, or complement, the major color themes can be added to the underpainting to create depth and visual interest. Continue to limit yourself to a standard, round, non-blurry brush. Keep the mode as **"Normal."** Adjust the brush opacity with the slider or by typing in the Opacity box. I recommend starting with 30–35% opacity, and increasing the opacity with subsequent layers. You may eventually use the Brush tool at 100% opacity for fine details, highlights, and areas that require structure or clarification. You can paint over troubled areas rather than erase them. The more times you go over an area with semitransparent "paint," the darker and more opaque it will become. You can build a significant range of values in shading and modeling using a single color and a single degree of brush opacity.

THE TRADITIONAL RENAISSANCE METHOD OF PAINTING 2.0

This exercise begins with the assumption that you are painting a portrait of one or more people either from life or a photographic reference. This portrait will use layers of transparent color. It will begin by mapping out the basic values in sepia tones. Sepia tones are closely related to human flesh tones. In addition to providing more warmth than rendering an underpainting in shades of gray, for instance, would, sepia tones are more easily integrated with subsequent layers of color.

1 Create a New Document

Go to **FILE > NEW** and choose **"U.S. Paper"** as a preset and **"Letter"** as the size. Double-click on the foreground color in the Tools Panel and make a light brown color. Make sure this color is fairly light but dark enough to contrast with white highlights. This color will fill your entire document, and you will place all subsequent shading on top of it. Go to **EDIT > FILL**. In the Fill dialogue box that pops up, make sure **"Use: Foreground Color"** is selected under Contents. Click **"OK."** Since no individual element was selected, your entire document will be filled with this color. You can also select the **Paint Bucket tool** and click anywhere in the document to fill it with the foreground color. Save your color by clicking the new swatch icon at the bottom of the Swatches Panel in case you want to use it later.

2 Add a New Layer

Before drawing anything, add a new layer in the Layers Panel. You will draw the initial sketch on this new layer. Do not draw the sketch on the background layer. You will need to create elements on layers in between the background and your sketch layer, so they must be separate.

3 Create the Initial Sketch

In the Control Panel, select a standard, non-blurry, round brush. This will be one of the first six brush choices in the default brush preset menu. Use the slider in the brush preset menu to adjust the brush size. The brush size must be large enough to allow you to vary line thickness with a pressure-sensitive pen. About 74 pixels is a good starting size if your document is 300 PPI.

Select a very dark brown color for the drawing, almost black. Make sure your brush opacity is at 100% for this initial sketch. Save this color in the Swatches Panel as well. Remember to save *every* important color and shade for later use as the painting progresses. Start drawing your subject. Make sure you are creating an interesting, balanced composition. Map out the basic shapes and relationships before you go further! Your drawing is not set in stone; it's made of light! You can select any portion of your work and alter it in any number of ways, at any time, in service of your composition. This is a great and unique

A sepia tone fills the entire document. The initial sketch was then drawn on a separate layer.

way to correct things like proportion and line quality, or rearrange individual elements to make them work better in the design.

All the possible methods for modification that we discussed in the previous chapter can be used in this project. You can select an area and move it with the Move tool to improve the composition. You can use **EDIT > TRANSFORM > SCALE** on a selected area to change its size and proportions. You can use **FILTER > LIQUIFY** to alter shapes and line quality. Don't forget the Eraser tool, **EDIT > UNDO**, and the History Panel! All of these good tools can be used to retrace your steps when necessary.

If you are using a Wacom pen, the eraser side of your pen actually erases. You can adjust the eraser settings by selecting the Eraser tool in the Tools Panel and changing the settings in the Control Panel. Your pen eraser will reflect these changes even when you switch back to the Brush tool.

④ Begin the Underpainting

Make a new layer. In the Layers Panel, place this new layer under the sketch layer by dragging the new layer below it in the Layers Panel.

Choose the Brush tool in the Tools Panel. Select an initial opacity of 35% for your brush. This is a good starting point. You can adjust the level of opacity to suit your own preferences and needs once you get a feel for this method of working. Select a sepia color of medium darkness. It should be significantly darker than the first color used to fill the background layer. It must be light enough so that there is room to build up gradual transitions in value with repeated strokes.

When you created your initial light brown "fill" color, you (hopefully) saved it in the Swatches Panel. If you wish, you can use this fill color as the basis for creating and saving a darker variation of the color. Reselect this color in the Swatches Panel. This light brown color should now appear as the foreground color in the Tools Panel. Double-click on the

Beginning the underpainting using semitransparent sepia tones.

foreground color and modify it into a darker tone in the Color Picker by dragging the hollow circle in the Color Field. Save this new modified color to the Swatches Panel as well.

You can sample a color from your document by clicking on it with the Eyedropper tool in the Tools Panel. This sampled color then becomes the current foreground color. Since you are painting with transparent variations of your foreground color in this project, it would be difficult, using the Eyedropper tool, to be certain that your original color was captured at 100% opacity. This is why it's important to save each color to the Swatches Panel as it is created so that you can access these colors in the Swatches Panel when they are needed.

Observe the areas of darkest shadow and start mapping them in broadly with this new medium-value sepia tone. Use a large brush. Observe how, in life, the shadows blend and gradually transition in value as they curve around shapes.

When you begin working, you may discover that your color needs to be darker or lighter to work effectively. Adjust the color appropriately. Once you have a color and value that works well for you, stick with it for a while. Initially, do not pick other colors or tones and do not adjust the opacity. Try going over an area multiple times, building the shading and blending gradually with this single color.

Adjusting the Flow in the Control Panel can help the tones to build more gradually. You will see the character of individual strokes at this point. These strokes of color can later be blended using other tools or obscured by subsequent layers of color.

The layer on which you are currently working should be placed below the initial sketch so that the lines of the drawing are not obscured by the shading. Continue painting until every area of the composition has rudimentary shading in dark to middle values.

⑤ Add Highlights

Create a new layer under the original line drawing. You can change the layer order at any time by dragging the layer in the Layers Panel. Create and save a very light brown color, almost white. This color needs to be significantly lighter than your background fill layer. Map out the highlight areas in broad strokes. Emphasize the areas where light strikes the subjects the most intensely.

Applying semitransparent highlights onto a new layer.

⑥ Create a New Layer

Create a second, new highlight layer, this time above the layer containing your initial sketch. Paint lightly and begin partially obscuring some of the lines in your initial sketch to create a more painterly effect. As long as you are working on a separate layer, the sketch lines will still there and can be uncovered at any time by erasing on the layers above them.

⑦ Shade Further

Create another new layer. Reselect the medium brown color you used to create the shading. This time leave the layer on top of the sketch layer and further develop and refine the shading. As we did with the highlights, partially or totally obscure some of the sketch lines by painting over them as appropriate. Be selective and subtle in obscuring the information in your line drawing. This will be a gradual process. Leave sketch areas visible where they add definition or character. Obscure sketch areas, partially or totally, to create a more gradual blending of tones instead of a coloring book outline.

Selectively obscuring the initial
sketch with additional shading
and highlights.

⑧ Add Initial Color Layers

Don't use every color in the rainbow. Limit your color palette. Use colors as recurring
themes with variation. Try using semitransparent dark blue or green tones in the flesh
tones, especially in the shadow areas. These tones would be subsequently painted over,
in varying degrees of opacity, using the colors that are dominant in the flesh tones. Blue/
green colors are the approximate complementary colors of dominant flesh tones.

Initial color is added onto new
layers.

As we know from chapter one, colors contain no trace of their complementary color, which means complementary colors appear to pop when placed next to each other. This will give the skin tones an appearance of greater depth and volume.

Other little accents of unexpected color, used as reoccurring themes, can add visual interest in all parts of your painting. Try a yellow ochre color, or other earth tones, that are analagous (closely related) to your sepia underpainting. Try little sparks of bright red, or other vivid colors, to add excitement. Make sure these accent colors reoccur in varying degrees throughout the composition. In fact, make sure any general colors that you use are distributed throughout the composition. If the figures contain some of the dominant background colors, and the background contains colors that are significant in the figures, your work will appear much more complete and unified. Shapes are still shapes in a composition, regardless of whether they represent people, objects, or landscape elements. Treat them uniformly in color and painting techniques.

9 Apply the Main Colors

Use as many separate layers as needed when applying color in order to maintain maximum flexibility as you work. Begin by using fairly transparent tones. Allow your underpainting to show through and interact with your subsequent painting. Gradually increase the paint opacity as you progress. Use more opaque colors in some places to give structure, clarity, and definition to the image.

Make sure that individual elements are well defined against their background. Consider all the ways that you can create contrast between important elements and use those methods to clarify your image. Look at the basic shapes created by shadow areas. Make sure they are properly delineated in your work. Don't lose your color themes! Just because something is a certain color in real life doesn't mean it can't be changed in service of your design. Gradually reduce the brush size to add detail. As the painting progresses, you may wish to use pure white, near 100% opacity, for small areas of greatest brightness.

10 Blend

It is beneficial to add separate layers liberally as you work. Eventually, however, you may want to merge some layers into a single layer in order to blend and manipulate your digital paint. Before you merge the layers, I recommend saving your document and then immediately choosing **"Save As"** to change the name of the document. If you do this, you can merge layers and still have them as separate layers in the original document. Merge layers on the new document, as desired, and save the changes. Go to **FILE ˃ OPEN RECENT** and select the name of your original document from among the choices. Open your original file, with the original name, so that it is open at the same time as your new renamed version. You can drag a separate, un-merged layer from your original document into the new version any time you wish.

On the merged layers, try blending the paint using the **Smudge tool** in the Tools Panel. You can blend colors like wet paint. Adjust the **"Strength"** setting in the Control Panel until you get the desired effect when blending.

NOTE: Another popular technique among traditional painters is to create an underpainting that is a single, uniform color fill that is the approximate complementary color of the dominant flesh color that you will use. This would be somewhere between blue and green. This color would fill the entire background layer, and semitransparent paint would then be placed on top of the color in subsequent layers. Allowing a complementary color to be integrated with the figure and show through in varying degrees can help to unify the painting, generate visual interest, and make the image pop or create a three-dimensional effect.

Tools associated with the Liquify Filter are also useful for altering paint after the fact. They may produce results that are less analogous to physical paint, but the possibilities are vast. The Blur tool can sometimes be useful for making surfaces smoother or blurring smaller elements to blend them, or place them, in atmospheric perspective.

Painting, to coin a cliché, is an art, not a science. I can show you the tools, get you started, and point out potential trouble spots, but your unique work, with its specific visual relationships, will require your own judgment at every stage of its creation. Digital paint can be as opaque as you need it to be. You can paint right over any area that doesn't work. Add and subtract. Keep the things that are effective. Modify the things that aren't. Continue painting until everything works.

Step away from the work occasionally and come back later to gain a fresh perspective. Examine each area of the work. Is anything random or does everything work in support of your visual themes? Does anything look rushed or underdeveloped in comparison with other more interesting parts of the composition, or has everything been given the appropriate amount of attention? If you feel tired and impatient, take a break rather that rush any part of your work. Make sure every part of your work is well loved and works exactly as it should, in support of your design. You're done when you're done; not when you're tired.

The finished piece.

PROJECT:
Portrait with Sepia Underpainting

Using the methods described in this chapter, create a digital painting that begins with a sepia underpainting. Gradually build the image by adding layers of semitransparent color and finish as desired. In this assignment, have a friend (or friends) pose for you and paint from life. You will create a portrait. You could even paint a self-portrait using a mirror. It would also be acceptable to look at a physical photo for reference. For this project do not paint over a photo in the computer. Your image should be based on observation and digitally painted on a blank "canvas." To the right are some of my students' solutions to this project.

Top: Kathleen Manderfield, Cleveland Institute of Art. Kathleen began this digital painting with a very light sepia tone and finished it using a very limited palette. The light purple color in the background is also incorporated into the figure, and the dominant flesh tone is still present in the background, unifying the composition. COPYRIGHT © KATHLEEN MANDERFIELD

Bottom: Davey Christian, Cleveland Institute of Art. Davey created this digital painting using broad, loose strokes combined with more refined areas, and descriptive lines that add definition in key areas. COPYRIGHT © DAVEY CHRISTIAN

PAINTING WITH SHAPES

In chapter six we focused on digital painting using organic methods and a steady hand to create painted images. There is a second approach to digital painting which involves geometric shapes, smooth curves, straight lines with perfect edges, flat colors, and smooth, gradual blending of one color into another. Photoshop offers many tools and options for creating this kind of work using both raster (pixel-based) and vector elements. The lessons in this chapter focus on the creation of images using a flat, geometricized approach. These techniques and tools have been given their own chapter for the purposes of instructional clarity. In real life, of course, these techniques can be incorporated into numerous visual styles.

CHAPTER SEVEN

Our first exercise involves pixel-based solutions for constructing shape-oriented artwork. Although there is a bit of actual drawing in this exercise, the majority of steps involve constructing selection masks and then using the underlying math behind the Photoshop tools to apply a solid color or smooth, predictable blend of colors to the masks. This approach requires us to (1) imagine the appearance that a certain process might create; (2) set up appropriate parameters; and then (3) apply the process. Although this might be perceived as a less organic approach, human judgment is still paramount, and it is your decisions that will define the work.

Absorption of Self by Jenn Verrier. Jenn painted this piece in Photoshop using textures, flattened patterns and colors, and stylized lines created with various brushes. COPYRIGHT © JENN VERRIER

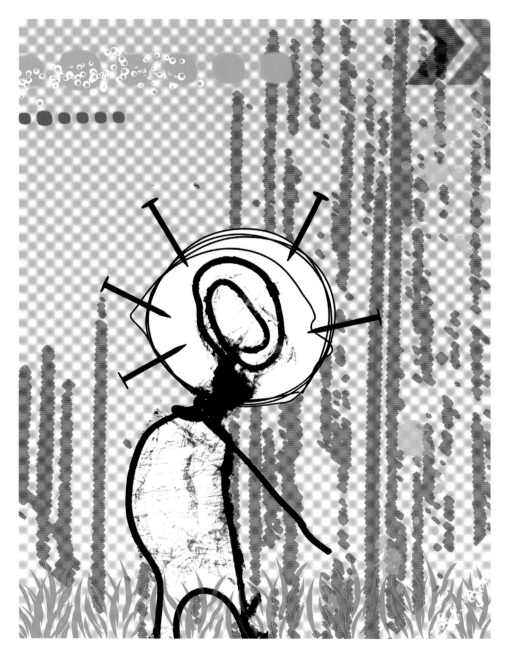

PIXEL-BASED SOLUTION

In this exercise I will create a highly stylized image of a woman diving over ocean waves. The work will be created primarily with flat shapes, outlines, and smooth blends of color.

1 Create a New Document

Start by creating a new document at 11 x 14 inches at 300 PPI.

2 Fill the Background

You can use any of the selection tools in Photoshop to create a selection mask and then fill it with a solid color. When no area has been selected, Photoshop will fill the entire layer with color. For this exercise I select a light gray-blue as the foreground color and go to **EDIT> FILL**. In the dialogue box I make sure **"Use: Foreground Color"** is selected, the mode is **"Normal,"** and the opacity is **"100%."** I hit **"OK."** Since nothing was selected, our entire document is filled with the current foreground color.

I begin the composition by filling the entire document background with a gray-blue color.

3 Make a Simple Gradient

A **gradient** is a smooth, gradual blend between two or more colors. The **Gradient tool** in the Tools Panel can be used to create such blends of color. The Gradient tool, by default, creates a blend between the currently selected foreground and background colors. Select the Gradient tool. In the Control Panel, there are five little icons that represent various kinds of gradients. Click, hold, and drag the Gradient tool across the selection and a **gradient blend** between your foreground and background colors will be made. Changing the direction and length of the line you draw with the Gradient tool changes the direction of the gradient and the amount of each color that is present in the blend. The following gradient options can be found in the Control Panel:

◆ **LINEAR GRADIENT:** Creates a gradual color transition in a straight line, one color slowly changing into another.

◆ **RADIAL GRADIENT:** Creates shading in a circular pattern.

◆ **ANGLE GRADIENT:** Shades in a sweep around a solid edge, resembling an aerial view of a shaded cone.

◆ **REFLECTED GRADIENT:** Creates shading in which the gradient halves are mirror images.

◆ **DIAMOND GRADIENT:** Radiates outward in a diamond pattern.

You can adjust the blending mode or transparency of a gradient in the Control Panel. We'll use the Gradient tool to create a bubble that will be duplicated, resized, and used as a decorative motif throughout our design. It's important to create a new layer on which to create our bubble so that it's separate from our blue background.

I click on the new layer icon at the bottom of the Layers Panel to create a new layer. I select the Elliptical Marquee tool. I hold the Shift key as I draw a selection in order to make it a perfect circle. I draw the circle about 3 inches in diameter.

I click on the foreground color and change it to a light blue, almost white, color. I click on the background color in the Tools Panel and select a somewhat darker blue color.

I then select the Gradient tool and choose the radial gradient option, the second of the five options in the Control Panel. I click and hold on an area within my circle at the approximate position where I want the color to be the lightest. I drag the cursor diagonally down and to the left. I go slightly beyond the selected area. My blend is defined by the position and direction in which I drag. My goal is to create a blend that resembles light falling across a three-dimensional sphere. I draw my gradient several times, dragging in slightly different areas each time until I am happy with the blend of colors.

Creating a radial gradient with the Gradient tool.

4 Make More Bubbles

Once I have created our gradient "bubble," I want to dulicate it. With the layer containing the bubbles selected in the Layers Panel, I hold down the Alt/Option key and use the Move tool to drag and make a copy of the bubble. I do this multiple times and drag the bubbles to various positions throughout the composition. By default, this method creates the duplicates on the same layer as the original, so I make sure that no bubbles overlap—or I won't be able to separate them later without leaving a hole in the bubble that is partialy covered. If I wish to move or scale a single bubble on this layer later, I'll use the Rectangular Marquee tool, or any selection tool, to select the area containing the desired bubble and then move it. Later, I'll add some overlapping bubbles and keep them on a separate layer.

⑤ Add a Stroke (Outlining a Selection)

Now I want to place a thick outline, or **stroke**, around all of the bubbles. With the bubble layer selected, I use the Magic Wand tool to click on an empty area of the layer, selecting everything but the bubbles. I go to **SELECT › INVERSE** to select the opposite of my current selection. The bubbles are now all selected. I then add a new layer directly above the bubble layer. We'll place our stroke on this new layer. Keeping the stroke on a layer that is separate from our bubbles keeps our options open. With the selection active and the new blank layer selected, I go to **EDIT › STROKE**. The thickness of a stroke is defined by number of pixels. By default, this stroke would be created using the current foreground color. This time, however, I click in the solid rectangle next to the word **"Color"** in the Stroke dialogue box to change the stroke color to a yellow gold.

Applying a stroke (outline) around the bubbles.

Under **"Location,"** you can choose whether you would like your stroke to appear *inside* your selection area, *outside* your selection area, or *centered* in the middle of your selection boundary. If you are creating a thick outline, this can make a big difference in determining what is obscured by the outline. I choose **"Outside"** and **"20 Pixels"** for the size of my stroke. I hit **"OK"** and gold outlines appear around my bubbles. As I mentioned, I'll add more bubbles on a separate layer later. I select this new layer and add a stroke to these bubbles as well.

⑥ Create a More Complex Geometric Shape

You can create more complex geometric shapes by combining several shapes made with the Rectangular and Elliptical Marquee tools. When you select one of these tools, choose **"Add to Selection"** or **"Subtract from Selection"** and draw repeated geometric shapes that add or subtract from your selection.

You can also use Lasso tools to create or add to complex selections. These shapes can have their curves smoothed out in order to appear more mechanically precise. Click on **"Refine Edge"** and slide the smooth slider to the right to simplify your shape. I use the Polygonal Lasso tool to create a selection mask in the shape of highly stylized waves. I do not smooth or refine this selection. Instead, I take advantage of the blocky straight lines that are created by this tool and use them as a design idea. I add and subtract from my mask until I am happy with it.

Creating waves with the Polygonal Lasso tool.

The Gradient Editor can be used to create complex gradients containing multiple colors.

⑦ Create a Multicolor Gradient

You can use the **Gradient Editor** to modify gradients and create complex blends between multiple colors. Select the Gradient tool. In the Control Panel there is a color gradient strip that shows a blend of the currently selected gradient colors. Clicking inside this gradient strip causes the Gradient Editor to appear.

At the top of the Gradient Editor are a series of presets. Clicking and holding the little triangle near the upper right corner of the Gradient Editor will reveal a panel menu with additional presets that can replace or be added to your current choices. In the bottom half of the Gradient Panel, you'll see a color gradient strip indicating a blend of your currently selected colors. Under this gradient strip, you'll see squares with triangles on top of them, pointing at the gradient area. These square/triangle symbols are called **color stops.** You can make a selected color more prominent or less prominent by dragging a color stop to a different position under the gradient strip.

I'll use the Gradient Editor to create a blend of three colors and then apply it to our waves. In order to add a third color to my gradient, I simply click on an empty area under the gradient strip, which causes a new color stop to appear. You can get rid of an additional color stop by dragging it away from the gradient strip until it disappears. You can also select it and hit **"Delete"** at the bottom right corner of the dialogue box.

To change one of the colors in the current gradient, I click on one of the color stops under the gradient strip to select it. I then click on the box marked **"Color"** at the bottom of the panel to access the Color Picker. I do this for each color, selecting black, purple, and blue for our color stops.

Directly above the gradient strip there are symbols that are upside-down versions of the color stop icons called **opacity stops.** You can adjust the transparency of a single color within the gradient by selecting an opacity stop icon and adjusting its opacity in the appropriate box below the gradient strip. You can add, delete, or change the position of opacity stops in the same manner as color stops. I leave the opacity of all colors at 100% for our exercise.

When I complete my new gradient blend, I hit **"OK."** I then select the Gradient tool and drag a diagonal line across my selection mask. When I release the mouse, the gradient appears, containing the three colors I selected.

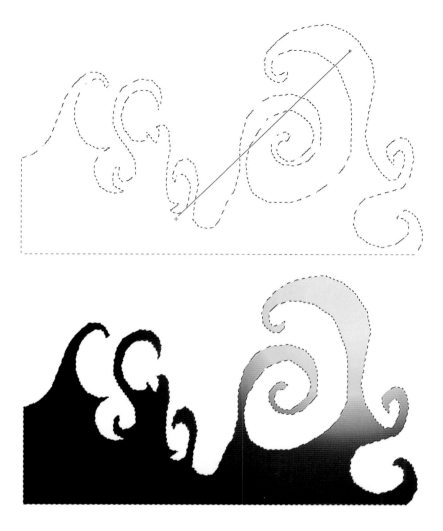

Applying a three-color linear gradient to our selection mask.

The result.

8 Apply Another Stroke

With my gradient still selected, I create yet another new layer and apply a stroke to this new layer, using the same gold-yellow color as the stroke around the bubbles and a 30-pixel width. I save my selection mask for later use by going to **SELECT > SAVE SELECTION**.

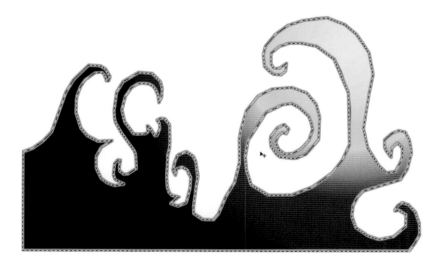

Using **EDIT > STROKE** to create an outline around the waves.

9 Draw a Pattern

I create another new layer, directly above my blue background fill. I use the Brush tool to doodle a spiral pattern across the entire picture plane.

Creating a pattern for the background.

10 Paint the Pattern

I reduce the opacity of the layer containing my black lines, to about 85%. I then create another new layer and begin applying broad strokes of flat color over my circular lines. I work to get some of the angular characteristics of the wave outline into the doodles.

Applying flat strokes of color over the doodled lines.

11 Scribble

When a selection is made, it determines the area that can be affected by any change, including painting. It's impossible to "color outside of the lines" of your selection mask. You can create smooth, uniform borders by filling a selection mask with color, while painting freely within the mask using the Brush tool.

I load my wave selection by going to **SELECT > LOAD SELECTION** and then scribble into the wave with a thin brush. I use about 80% opacity for the brush. I draw right over the gradient. Reducing the opacity of my brush allows the gradient colors to influence my scribbles, adding some character and nuance where the lines overlap. This linear texture will echo the line quality of our drawn swirls. I make all the layers visible and then look over the composition. I make the bubbles semitransparent and desaturate their color a bit.

Our assembled composition so far, with scribbles in the waves and transparency applied to the bubbles.

12 Create a Figure with Selection Masks and Fills

I now create a simple image of a diver. I make the figure with simple, flat fills of color. I create a selection mask around the figure and apply a stroke on a new layer. I make the stroke width 30 pixels, the same as that of the waves. This time, however, I use a dark blue color for the stroke color around the figure. I try to match the dark blue color inside the waves.

A stylized figure of a diver created by selection fills with a dark blue stroke.

Applying the airbrush using a selection mask and a huge, semitransparent brush.

⑬ Use Airbrush to Shade the Figure

I then apply a smooth blend of color shading using the airbrush, found within the Brush tool options in the Control Panel. I create a separate new layer for my airbrush paint. I click on the eye icon next to the layer containing the stroke around the diver in order to render it invisible so that I can see the edges of my figure when I paint.

I apply a few extra definining lines and a tiny suggestion of shading with a small, semitransparent brush, and then click on the airbrush icon in the Control Panel. The airbrush option creates a gradual buildup of paint. It simulates the kind of smooth spray of paint associated with a physical airbrush.

I adjust the flow and opacity until I find a good setting for creating smooth transitions of color. This works best using a drawing tablet and pen. I create a giant blurry brush with only about 30% opacity. I begin by pointing the cursor a couple of inches outside the selection so that only the "overspray" falls into the selection mask in order to create a more subtle blend. I use various colors to create a simple, smooth layer of shading that is consistent with our gradient bubbles.

⑭ Add More Bubbles

I make the stroke around the figure visible again and regard the composition with a critical eye. I add additional bubbles on a new layer in an effort to improve the composition. Although the colors of the diver figure are similar to the colors in the composition, I can tell that everything still isn't quite tying together, even with the additional bubbles. I still have to modify the composition further and solve some fundamental problems.

More bubbles added. All the basic elements are in place.

⑮ Colorize the Figure

I duplicate the layer containing the diver and use Colorize under Hue/Saturation to adjust the hue of the duplicate figure to a blue-green color. I combine this duplicate layer with the orignal layer by reducing the opacity of the green duplicate layer to 60%. It's better, but all the different visual ideas don't quite tie together yet. I save my document and then use **FILE › SAVE AS** under a different name. It's time to experiment!

Changing the color of the figure to fit the design.

Stumble!

Thomas Edison once said, "I didn't fail ten thousand times. I successfully eliminated, ten thousand times, materials and combinations which wouldn't work." And so it is with the creative process. I started all of the exercises in this book with a plan, an approximate idea of the work I would create. All of the exercises involved modifications of these plans along the way. Some modifications merely involved refining and clarifying details; others involved significant changes.

Some artists create work by following an incredibly detailed checklist of technical steps that they follow without variation to complete a work. Other artists create a work from nothing, with no preconcieved idea, modifying and reacting to the work as they progress. Most creative people are in-between these two extremes. At a certain point they sit back, regard the work, and ask themselves honestly, "What does it need?" Afterward, it's time to throw out or modify anything that doesn't support the work as a whole. If I were

to have documented the entire process of each of my example works in the book, it would have involved adding lots of extra little side notes in the steps such as, "I thought this approach might work, so I tried it and saw that it didn't work; so I took it out." Although these extra tidbits of information would not have been helpful to you during the instructional steps, it is important to recognize that they were an important and necessary part of the creation of the example works for each exercise.

If you are creating something new or exploring unknown territory like Thomas Edison, stumbling is part of the creative process. We explore, try various things, and must be willing to abandon hours, or days, of work when we realize that we have gone in a wrong direction. This is how we learn and improve! We learn what doesn't work, and this narrows our field of possibilities. This is how we increase our knowledge and refine our vocabulary as artists.

16 Experiment

As part of this stumbing (see Stumble! on the previous page), I made a copy of the background. I adjusted the duplicate background so that everything is an orange-red color, the aproximate complementary color of the diver figure. I then erased parts of this layer so that some areas are red-orange and some areas are their original blue-gray color. I was not pleased with the result of this endeavor, which took the better part of a day. It did, however, let me see how vibrant reds and blues could work in the composition.

Before I began this experiment, I used **SAVE AS** to save my work as a different file with a new name. When it became apparent that my experimenting was reaching a dead end, I closed this document and reopened my original document. I use **SAVE AS** again, and save a new version of my file to try another experiment.

17 Merge Layers

I then merge all the layers into a single layer except for those layers pertaining to the figure. Next, I create a new layer and fill it completely with a red-orange color. I drag this layer underneath all the other layers. Directly above this new red layer is the layer containing all my merged background elements (everything but the figure). I set the Blending Mode of this layer to **"Difference." Difference mode** essentially blends the layers by emphasizing the differences between them. This mode transforms the waves and other areas into the vibrant red-orange of the fill I created. Lighter areas become a highly saturated blue color, and the gold outlines become darker. The background has a vibrant, psychedelic look that I find appealing. I am now getting a much better relationship of colors and shapes. I use **LAYER > MERGE DOWN** to merge these two layers, tweak the color and value, and paint a little with the Brush tool to add definition where needed.

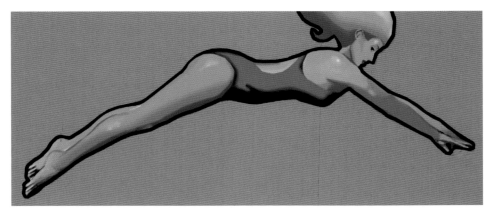

A new layer, filled with a vibrant red-orange color. This layer will be used to modify the background colors.

18 Apply a Second Stroke

I'm not done yet! I apply a second stroke around my figure. The original dark blue stroke had been merged into the figure when I merged my figure layers in the previous step. I select the figure by clicking on the empty background on this layer with the Magic Wand tool and then use **SELECT › INVERSE** to select the figure rather than the background. I create a new layer (just in case) and apply a red-orange stroke to the figure, matching the color in the background.

A red stroke is added around the figure.

I now pronounce the work finished. *Whew!* Some aspects of the work, such as the original gradient on the waves, are no longer detectable, but nonetheless influenced the appearance and character of the finished piece. Even the version of the work that was completely abandoned was necessary to inspire the direction of my finshed work.

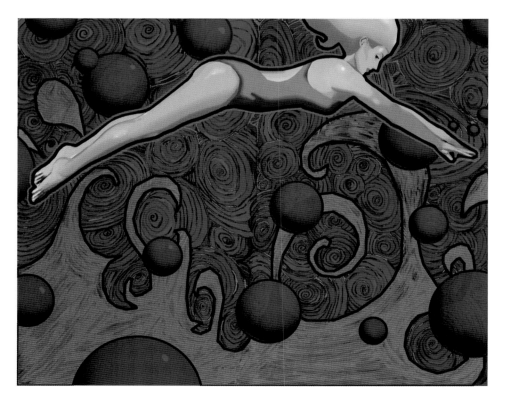

Finally finished!

Posterize

Posterizing reduces an image to a few levels of flattened color and value. Click the **posterize icon** in the Adjustments Panel to access this image adjustment. Adjust the levels slider to control the number of colors and values in your image. It's very easy to identify a posterized image as having been processed by this filter, and the resulting image may appear somewhat predictable and impersonal—reflecting that it was created by a "push button" operation. Posterize is a tool that is best used as a starting point for further work within a fine-art context.

A posterized image is reduced to a few levels of color and value.

Sketch Filters

Some of Photoshop's **Sketch Filters** can be useful starting points for transforming photographic images into shapes with flattened, simple colors. These filters can be accessed by going to **FILTER > SKETCH** and selecting a specific filter. When you do this, you'll be taken to the Filter Gallery where you can adjust, preview, and apply many Photoshop Filters. The Filter Gallery can be accessed directly using **FILTER > FILTER GALLERY.** We'll cover the Filter Gallery in detail in chapter eight.

Most of the Sketch Filters will generate an image using the currently selected foreground color. Any negative space in the image will be converted to the currently selected background color. **Stamp, Torn Edges,** and **Halftone Pattern** have good potential use for our purposes. Use these filters as a starting point and then modify the images further, in a more personal manner.

CREATING A FIGURE WITH A FILTER AND THE PATTERN STAMP TOOL

In this short exercise I'll process a figure using the Stamp Filter, turn the figure into a pattern, and then paint the pattern using the Pattern Stamp tool.

① Open Document

I open the document of the zombie figure we used in exercise 1 in chapter three.

② Select Colors

I select a dull red color for the foreground color and white for the background color.

③ Apply the Stamp Filter

I go to **FILTER > FILTER GALLERY** and chose **"Stamp"** from among the Sketch Filters. I adjust the light/dark balance and smoothness until I am happy with the image and then hit **"OK."**

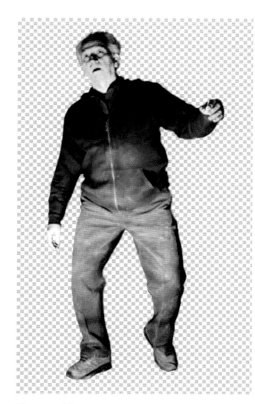

The original figure.

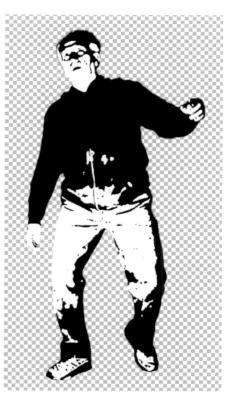

The figure processed by the Stamp Filter.

Creating a new pattern from an image and then naming it.

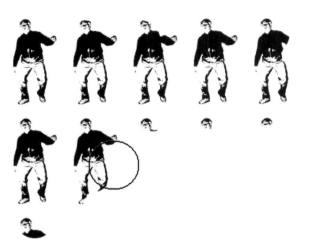

Painting with the Pattern Stamp tool.

The finished work, with apologies to Andy Warhol.

4 Paint a Pattern

Repetitive patterns of varying complexity can add another level of visual interest to a composition which is based on simple geometric shapes. The **Pattern Stamp tool** takes a predefined image area and paints with it as a repeated pattern. When the Pattern Stamp tool is selected, you can choose a preset pattern in the **Pattern Picker,** which can be accessed by clicking on the pattern image, near the right side of the Control Panel. You can replace or add to these presets by accessing the menu under the little triangle on the upper right side of the Pattern Picker.

It may be advantageous to create your own original pattern that is specifically appropriate for your purposes. For this exercise, I create a pattern from our figure and "paint" with it. I make a selection using the Rectangular Marquee tool, including negative space around the figure. I go to **EDIT > DEFINE PATTERN.** I name the pattern and hit **"OK."** The selection I have made is now one of the choices in the Pattern Picker in the Control Panel.

I select the Pattern Stamp tool and, with my new pattern selected, I begin painting to create a pattern of evenly spaced figures. When I finish my pattern of red figures, I choose a gold-yellow color for the foreground color and process my original figure once again, using the Stamp Filter. I select and delete one of our red figures in the pattern (just hit the Delete key). I drag our new gold-yellow figure into the composition, scale it to size, and then use **EDIT > TRANSFORM > FLIP HORIZONTAL** to create a mirror image of the figure and emphasize its difference from the other figures. I move it into the position previously occupied by our deleted figure and our exercise is now complete.

Adobe Illustrator

Photoshop's sister application, Adobe Illustrator, is a vector-based program whose specialty is the creation of flat, uniform shapes and smooth gradients. Vector-based approaches to painting might be done easier, and better, in Illustrator. If you work in a style that emphasizes the creation of such images, you would be well advised to investigate Adobe Illustrator, the industry standard for the creation of vector images. You can download a free thirty-day, fully functional trial version of Adobe Illustrator (see Resources on page 248).

You can modify an image using both Illustrator and Photoshop. You can drag images and layers back and forth between the two programs and use the application that is most appropriate for your intentions. Vectors function similarly in Photoshop and Illustrator, so learning the vector tools in Photoshop will give you a head start in Illustrator. Additionally, the principles of the visual language remain constant, no matter what software you are using. You should be able to learn the technical tools of *any* program and apply the design ideas from this book toward the goal of personal expression.

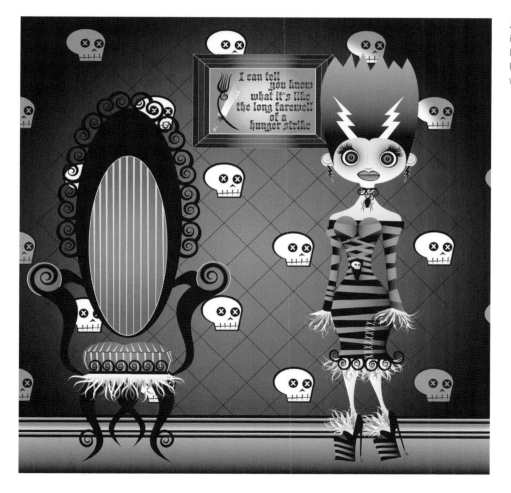

Elsa by Sean Welker. This vector image was created in Adobe Illustrator and further refined in Photoshop. COPYRIGHT © SEAN WELKER

Vector Modes, Tools, Paths, and Layers in Photoshop

Photoshop has several tools that create vector images on separate **vector layers.** These tools can be used to create vector lines known as "paths." Paths can form the outlines of vector shapes and masks. Vector tools in Photoshop can operate in three different modes. Before we begin using our vector tools, we'll have to understand these **vector modes** and what they do. When a vector tool is selected, the following modes can be accessed on the left side of the Control Panel:

♦ **SHAPE LAYERS MODE:** Creates a vector fill shape, defined by a path, on its own vector layer. The fill can be a flat color or something more complex. You can select a preset style from choices in the Control Panel or by accessing the Styles Panel through **WINDOW> STYLES.** More preset styles can be added from the sub-menu accessed from the triangle in the upper right corner of the pop-up menu in the Control Panel or the Styles Panel. To create a new style, select the layer containing the vector image you'd like to use as a style and then click on the **create new style icon** in the Styles Panel.

You can use the Styles Panel to select or create fill styles for Shape Layers.

♦ **PATHS MODE:** Creates an invisible, temporary path that can be saved and assigned characteristics such as a fill or stroke. To assign a stroke to a path, select the Brush tool or other painting tool. Pick a brush type, size, and color in order to assign the characteristics to your path. Select the path using the Path Selection tool. In the Paths Panel, Alt-click/Option-click on the **stroke path with brush icon** and choose the appropriate tool from the pull-down menu to apply its characteristics to your path. To assign a fill to a path, click on the **fill path with foreground color icon** .

♦ **FILL PIXELS MODE:** When using a shape tool, this mode creates a shape on the currently selected layer using pixels instead of vector graphics.

CREATING A "GENERIC" SELF-PORTRAIT USING VECTOR PATHS

1 Draw a Path with the Pen Tools

The Pen tool is the default tool for vector drawing in Photoshop. Unlike pixel-based images, vector objects are *resolution-independent,* and thus can be rescaled in an unlimited fashion without loss of quality. The Pen tool is ideal for creating complex shapes (and selections) with crisp, sharp edges and geometric curves. The outline of a shape created by a vector tool in Photoshop is called a **path.** Paths, by themselves, are invisible. They can be assigned fills and strokes or be converted into selection masks.

The Pen tools, Photoshop's vector drawing tools.

An open path is essentially a line. To complete an open path, click on the Pen tool in the Tools Panel once the path is drawn. In order to complete a closed path, you must connect the end of the path with the beginning. A hollow circle will appear next to your pen tool icon to let you know you are in the correct spot to complete the path. When the Pen tool is selected, I click on **"Rubber Band"** in the Pen options in the Control Panel so that I can preview my path as I work. I make sure that **"Paths Mode"** is selected on the left side of the Control Panel.

The Pen options in the Control Panel.

There are two possible types of points in a path. A **corner point** creates a sharp edge that defines a corner between segments. A **smooth point** creates a gradual curve between points. To create a **straight segment** in a path, I click on an area in my composition to create a corner point and then click on another area to create another point. A straight segment will appear between the two points. To draw a curved segment in my path, I click one point, click and hold a second point, and drag to pull the line into a curve, creating a smooth point. The Pen tool can be frustrating when first using it, but it is well worth mastering.

179

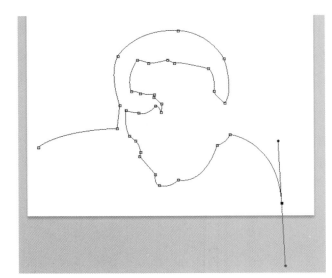

Here I draw a path with the Pen tool. Curves can be reshaped by dragging nonprinting handles.

I click on a point to begin my path. Once I have drawn a curved path, I hold the Alt/Option key to change the Pen tool to the **Convert Point tool**. I use this tool to click on my previous point before clicking on my next point if I want a straight segment to be created after a curved segment. This is also useful to create a new curve instead of continuing the arc of a previous curve. I hold Alt/Option and click on the previous point before creating more new segments in my initial path. The Convert Point tool is also available as an option under the Pen tool in the Tools Panel and can be used to modify a path after it has been completed.

② Save the Path

When a path has been completed, it is a temporary **work path**. I save my path by going to **WINDOW > PATHS** to access the **Paths Panel**. I go to the sub-menu beneath the little triangle in the upper right corner of the Paths Panel, select **"Save Path"** from the menu, name it, and click **"OK."**

③ Create a New Layer and Fill the Path

I create a new layer and leave it selected in the Layers Panel. With my path selected, I click on the fill path button at the bottom left corner of the Paths Panel. This fills my path with black, my current foreground color.

Filling the path with my foreground color.

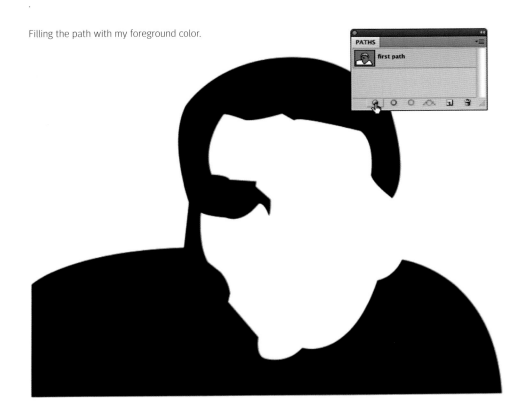

4 Make Additional Paths

Next, I draw and save three new paths that correspond to the mouth, nose, and second eye. In addition to the Pen tool, the following tools can also be used to draw or modify paths:

◆ **FREEFORM PEN TOOL:** Creates a path by drawing it. Points are created along the path automatically.

◆ **ADD ANCHOR POINT TOOL:** Creates new edit points by clicking on a path.

◆ **DELETE ANCHOR POINT TOOL:** Deletes an edit point when you click on it.

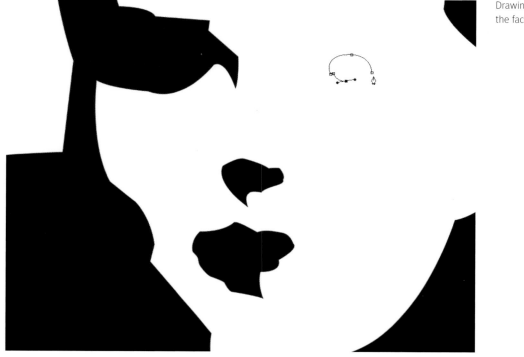

Drawing new paths to complete the face.

5 Improve Path Selections

When a path has been created, you can move the entire path by clicking on it with the **Path Selection tool**. You can use this tool to resize a path when **"Show Bounding Box"** is selected in the Control Panel. You must first click on the path to select it. You can use the **Direct Selection tool** to edit an individual point within a path. I improve the shape of the path representing the second eye using the Direct Selection tool. I click on an individual point to select it and then click and drag the point to reshape it.

The Path Selection and Direct Selection tools.

Reshaping a path with the Direct Selection tool.

⑥ Define the Background

I use the Pen tool to create a rectangular shape around the figure. Since the right side of the face is undefined, I'll use this new path to define the edges of this open space.

I create a new layer once again and fill my path with an orange color. In the image below, I make the (white) background layer invisible. The "white" part of the face is actually invisible, rather than white, since I never created a fill or path for this area.

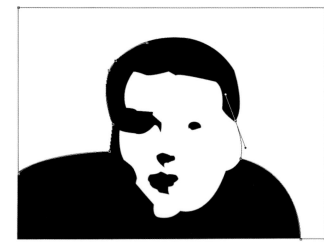

Making a path to define the area behind the figure.

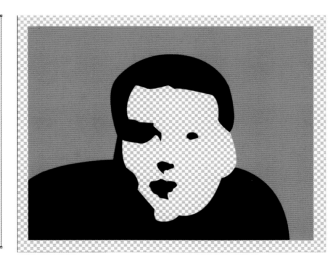

The current path filled with orange. The background layer is turned off, showing the areas that have no fill or path.

⑦ Create a Path with the Shape Tools

The **Shape tools** create completed paths by dragging various predefined shapes. These shapes include **Rectangle, Rounded Rectangle, Ellipse, Polygon, Line,** and **Custom Shape**. When the Polygon tool is selected, you can define its number of sides in the Control Panel. You can choose between smooth corners and star under Polygon Options.

Left: The Vector Shape tools.

Right: You can change a polygon into a star by accessing Polygon Options in the Control Panel.

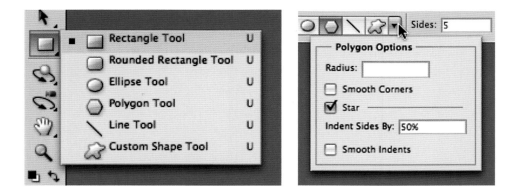

When you select the Line tool, you can access the sub-menu in the Control Panel to assign an arrowhead to a line that you create. When the Custom Shape tool is selected, you can access a menu of preset shapes such as musical notes, hearts, and lightning bolts. Click and hold on the arrow to the right of the panel next to the word **"Shape"** in the Control Panel to access these presets. To save a path as a new custom shape, go to **EDIT › DEFINE CUSTOM SHAPE**. Name it, click **"OK,"** and the new shape will appear among the preset choices.

NOTE: You can draw and combine multiple shapes in order to create a single, more complex shape. Use the Shape tools to draw multiple overlapping shapes. Hold the Shift key and use the Path Selection tool to click on each vector shape to select it. Choose "Add to path area," "Subtract from path area," "Intersect path areas" or "Exclude overlapping path areas" in the Control Panel. Hit "Combine" to create a single path.

My path, saved as a new shape.

I now use the Rectangle Shape tool to create a white square. I select the shape layers mode and choose white as my color (both in the Control Panel). I drag to draw my shape.

Creating a vector shape with the Rectangle tool.

A new vector layer will automatically be added in the Layers Panel. I move this vector layer so it is below my other visible layers.

A vector shape layer.

The image, with the white rectangle placed behind the other visible layers.

Next, I choose a gray color in the Control Panel. I drag another rectangular shape so it almost fills the image. I drag this shape layer so it is now behind all visible layers, framing the piece.

Creating another large vector shape with the Rectangle tool.

The gray rectangle placed behind the other visible layers.

8 Add a Stroke with Layer Styles

As we saw in chapter four, Layer Styles are special vector effects that can be applied to shapes on a layer. They include Drop Shadow, Outer Glow, and the three-dimensional Bevel and Emboss. Layer Style effects are *nondestructive*. They can be edited or deleted at any time.

I click the eye icon next to the background layer in the Layers Panel so the white color will again be visible around the edges of the design. I then select the layer containing the orange fill and go to **LAYER › LAYER STYLE › STROKE**. In the dialogue box, I choose **"Position: Inside,"** so that my stroke is drawn inside my orange shape rather than around it. I choose white as the color. I adjust the size and hit **"OK."** Once the stroke is applied, my work is complete.

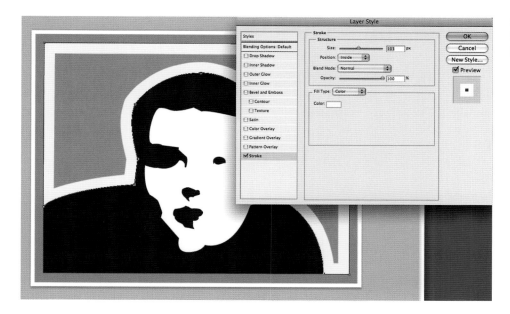

Using a Layer Style to apply a thick white stroke (outline) inside the orange fill.

A generic self-portrait of the author.

Converting Paths into Selection Masks

You can create a vector path and then convert it into a selection mask. This is useful for creating uniform geometric selections that go beyond simple ovals or rectangles. In the Paths Panel, select the desired shape, click on the **load path as a selection icon** ⬚ . The path is then converted to a selection.

You can also convert a selection into a vector path. When a selection mask is active, click on the **make work path from selection icon** ▱ in the Paths Panel. Your selection is now an editable vector path.

Rasterizing Vector Layers

When you create or import vector images it will be necessary to **rasterize** them, or convert them into pixels, before you can manipulate them using many of the pixel-based options available in Photoshop. To rasterize a vector shape layer, vector mask, or smart object, go to **LAYER > RASTERIZE** and select the appropriate choice from the sub-menu that pops up.

Vector Masks

Similar to the pixel-based layer masks that we began working with in chapter three, vector masks are resolution-independent masks created with paths. To create a vector mask, first make a vector path surrounding the area you wish to be visible in the layer. Go to the Masks Panel and click on the **vector mask icon** ▦ to create a mask from your path. The vector mask is fully editable with any of the path editing tools discussed in this chapter.

A vector mask will appear as a white rectangle within the designated layer in the Layers Panel. Select a mask icon in the Layers Panel to modify it. You can drag the rectangle to the trash to get rid of your vector mask, or disable it by Shift-clicking on it, just like a pixel-based layer mask.

PROJECT:

Make Some Smooth, Flat Artwork

Choose a combination of techniques and approaches discussed in this chapter and use them to create a composition using fills, strokes, gradients, vector lines, and shapes. Make lines with the Pen tool or apply a stroke to a selection—rather than creating lines with the Brush tool. Treat objects in a consistent manner where appropriate, and develop your treatments into visual themes. To the right are some of my student's solutions to this project.

Top: Jackie Mancini, University of Mary Washington. Jackie's poignant image is a pixel-based solution to the project created by filling selection masks with color. COPYRIGHT © JACKIE MANCINI

Bottom: Kathleen Manderfield, Cleveland Institute of Art. Kathleen created a vector-based solution to the problem, building the image out of vector lines and paths. COPYRIGHT © KATHLEEN MANDERFIELD

H6

H7

D.P. Toy No. 08 by Viktor Koen. Here, we see photographic compositing; paint; charts; diagrams; assorted, found materials; and amazing examples of how drastically different source materials can be integrated into a cohesive composition within Photoshop. Some elements are colored artificially, and others retain their original colors. Most of the shadowing is created from scratch in order to create consistent lighting and enhance three-dimensionality. COPYRIGHT © VIKTOR KOEN

MIXING PAINT, PHOTOS, AND EVERYTHING ELSE

Collage is the assembly of elements from different sources that are combined into a single, cohesive work. Arguably, the greatest benefit of digital art as a medium of expression lies in its limitless depth of unique possibilities for this synthesis of information and ideas. Regardless of where an element comes from, once inside the computer it is reduced to binary ones and zeros. Once an image enters the digital realm, it is converted into tiny pixels, each with a single color and value. Here, then, is where we get to use all of the tools and techniques we have learned thus far and combine them in a unique, personal manner, choosing from an infinite array of possibilities. You are only limited by your imagination. In this chapter we'll talk about gathering materials and how to integrate and repurpose non–art-related documents into your work, as well as how to combine photographic techniques with digital paint. We'll also look at some artists who routinely integrate a number of techniques and materials from varied sources into their works.

Materials that you gather and use are visual images, but they are also potential art supplies. So powerful is the digital medium that anything can be used as a raw material and changed into virtually anything else. Of course, when anything is possible, it becomes even more important to (1) make conscious choices from among the field of possibilities; (2) commit to your choices; and (3) refine them by using visual ideas consistently when developing a body of work. Because we'll discuss this concept in more detail in chapter ten, let's first explore some methods that you can use to obtain or create images that can be used in your work.

Science by Bradley Wester. Bradley's highly original and engaging work is made entirely of common stationery-store labels, stickers, and burst signs, which are converted into vector shapes and arranged into great compositions.
COPYRIGHT © BRADLEY WESTER

Using a Digital Camera

If you don't have one yet, get a good digital camera. Taking your own photos ensures that you are working with original images as source materials. Take as many pictures as you can. They can be used for reference or as part of your actual artwork. Entire objects from your photos can be used. You can create a collaged image out of fragments of photos with different colors, values, and textures. They can also be combined with other photographic elements or painted and drawn images.

TAKE PICTURES OF PEOPLE

Photographs can include (1) portraits that capture something unique about an individual; (2) posed photos used as specific references for a work; or (3) random, unusual pictures that generate inspiration for a work. You can take recognizable pictures or focus more on the details and interesting aspects of a subject.

TAKE PICTURES OF THINGS

Animals, landscapes, interior rooms, objects, cars, or anything else that catches your attention are great source materials. Create a multitude of photos of a variety of subjects and save them in an organized fashion. Digital material is information, and the more information you have to work with, the easier it will be to follow your muse without interruption. A time may come when you want a photograph of a cactus, and, if you took one, you'll have it!

FOUND TEXTURES

Photographic textures are great for incorporating into painterly or expressive works. They can add grit and, well, texture, to a piece. Photographic textures can be further modified in a specific manner that is appropriate to the artwork.

Group One by Ben Howson. Found and modified textures figure prominently in this photo-based work created in Photoshop. COPYRIGHT © BEN HOWSON

SCAVENGER HUNT

Spend a day, or several days, going around your town taking pictures of interesting textures you discover. Find the most run-down area you can safely visit. The most interesting textures can be found in older neighborhoods, where nature has taken its course and partially reclaimed man-made surfaces. The visual language is based on our perceptions of physical reality. We respond to the manner in which nature processes things as part of our perception of beauty and meaning. In addition, we have emotional associations with concepts like dirt or decay. Utilizing organic textures gives you the chance to capture some of nature's tactile qualities and bring them into the digital realm.

Photographs of textures are great organic source materials for digital art.

The Ethics of Found Images

Traditional collage artists have a long history of appropriating images, or pieces of images, and using them in a new context within an original composition. The legal and ethical use of other people's images is a complicated matter. The use of found images in digital art has the same possible ramifications as would using them in traditional collage. Even if you are taking your own photos, you may have to address legal issues if you take a photo of a recognizable person or an object that is associated with commercial use.

Although there may be a good deal of overlap between legal use and ethical use, it's important to regard them as separate issues. Legally, you must understand and adhere to existing laws regarding copyright and intellectual property. Even if you are able to make a compelling argument that you have created an original work, it may still technically violate the law. If you wish to use found images in your work, it is advisable that you fully investigate the legal ramifications of their use. See Resources on page 248 for a good government website that gives basic information on issues of copyright and fair use.

Let's turn our attention, now, to the ethics of using found images. Ethically, you have the responsibility to create a finished work that is original in spirit and which doesn't represent other people's creative work as your own. If an artist has created a stylized image, regardless of whether it is painted or photographic, this stylization represents visual ideas and choices on the part of this artist. If an image has been modified or created in a unique manner by the conscious decisions of another artist, you should not use this artist's image, in its original context, within your work, because you are using this artists ideas rather than your own.

So, when is it ethically okay to use found images in your work? Generally speaking, you may be justified using found materials when they are (1) used out of context; (2) used in an unrecognizable manner; or (3) used in a completely original context that never would have been intended or foreseen by the original artist. The prime directive should be that the creative voice in your work is entirely your own.

You may find an old photo or illustration that represents something to you that is completely removed from the original creator's intentions. Or, you may find value in images that were never intended to be art but, instead, created for other functions. Irony and satire can be legitimate reasons to utilize recognizable images within your work. You may find images that you want to frame in a new context and present in your work. Your goal may be to show not how great a found image's visual idea is but rather how horrible, funny, or interesting it is that people once held such a viewpoint or visual aesthetic. People may use old copyright-free advertising images from bygone eras to make a comment on consumerism in popular culture, for instance. Art can use historical or political images out of context to elicit a specific response or communicate a viewpoint that is very different from its original context. It also may be ethically acceptable, in some cases, to take images that are incredibly generic or devoid of original creative thought and use them in a new and creative way in the finished work.

These ethical guidelines I have suggested should be a starting point in clarifying your own thoughts on the subject. Again, I am addressing the ethical aspects rather than the legal. In the following pages we'll explore possible sources of found images that can be used as raw material for your work. Legal issues that pertain to your work should be thoroughly researched and understood so that you can make an informed decision about incorporating found images in your work.

Mom with Alzheimer's by Scott Ligon. A wrinkled manila envelope acted as an underpainting for the entire piece. COPYRIGHT © SCOTT LIGON

Look on Your Hard Drive

Many times I work with whatever happens to be on my hard drive or whatever is available in my immediate environment, and you can, too. Every visible element has specific characteristics that could be emphasized or modified and incorporated into your work. Additionally, personal possessions, objects, or documents on your hard drive could possess both a visual and emotional resonance for you. Because this is a particularly prominent aspect of my work, I'll talk about some specific ways I have incorporated found elements into my art.

The image to the left is a portrait of my mother after she had developed Alzheimer's disease. She kept an envelope full of tweezers with a warning note on it, because she was convinced people were stealing them. I scanned the envelope and used it as the underpainting for the portrait. The underpainting worked visually, and it also had an emotional resonance and personal connection with the subject of the work.

TEXT

I recently completed a series of digitally painted works using found text (words) as texture. I took documents from my hard drive, opened them, and dragged them into the paintings I was working on. I used a semitransparent Eraser tool to obscure and fashion the type until it was unrecognizable. As a result of this selective erasing, the remaining text is concentrated around areas of shadow, as a kind of halftone pattern in the shading. I enjoy the fact that you can take words, the chief method of left-brained linear expression, and use them as an element of nonverbal, emotional expression.

Left: *Marianne* by Scott Ligon.

Right: Detail from the same work. Partially obscured typography was incorporated as a recurring visual idea. COPYRIGHT © SCOTT LIGON

DOODLES AND HANDWRITING

If I have a pen in my hand, I doodle. Many documents that I scan and send as e-mail attachments contain hand-written notes and doodles in the margins. I love to take these fluid, non–self-conscious images and incorporate them into my work. In the example below, I incorporated (with permission!) other people's doodles into my work.

Summer by Scott Ligon and his family. During a school function, my wife kept my kids occupied by doodling with them. I incorporated their artwork, as well as handwriting and geometric shapes, into the image. COPYRIGHT © SCOTT LIGON

FORMS, DOCUMENTS, MAPS, AND DIRECTIONS

Look at everything on your hard drive from a visual perspective! Look at the unique characteristics of every document that is sent to you, including things like inadvertent textures created by faxes or copy machines. Something may already be in your possession that has the perfect and appropriate visual characteristics for a specific work.

Skateboarder by Scott Ligon. The underpainting of this work consists of fragments of a map to an event from a friend's e-mail. COPYRIGHT © SCOTT LIGON

Items from Your Other Artwork

You may have previous artwork that never really came together and that you felt was either incomplete or unsuccessful. You may discover that a portion of this work, with modification, could work in a current piece. It may push your new work in a previously unconsidered, but inspired, direction—even if you ultimately get rid of this old image. An element can have significant impact on a work by influencing its direction, even if it is not part of the completed work.

Right: *Runner I*; bottom: *Landscape* by Scott Ligon. Both of these images started out as the same work. They were saved under different file names and taken in different directions as they progressed. COPYRIGHT © SCOTT LIGON

MIXING PAINT AND PHOTOGRAPHIC REFERENCE

A photograph, or series of photographs, can function as a starting point for your artwork. You can then continue modifying and adding to an image to take it in any number of directions. Some finished works, such as the one found in this exercise, may emphasize or exaggerate characteristics of the photo, and some may bear little or no resemblance to the original reference photo once they are finished—they can, however serve as a starting point.

① Create a New File

First I go to **FILE › NEW** and create an empty document at 300 PPI at 11 x 14 inches, which is 100% of the size the finished artwork will be.

② Open Reference Image

I open my photographic reference image. I liked this image as the basis for my work. It is a childhood photo of my sister, which looks cute, vulnerable, and a little goofy. It has some definite qualities that we can exaggerate and take further in our finished artwork. You may use images from multiple photographs in your project, of course!

The original photo, taped on an ancient scrapbook page.

③ Scale the Photo

I drag the photographic image onto my newly created document. I resize my small photo to fit my document using **EDIT › TRANSFORM › SCALE**. The poor quality caused by enlarging a smaller image doesn't matter as much in this case, since the photo is just a starting point for our subsequent work. If images are used for reference and will be painted over, things like color, value, and selection masking may not have to be perfect either.

④ Paint over the Photo

I add a layer in the Layers Panel and begin painting on the new layer. Keep your options open. Always paint on a new layer rather than on the layer containing the photographic image.

Beginning to paint over the photograph on a new layer.

Holding the Alt/Option key turns your brush into an eyedropper to sample a new color.

The goal, initially, is to make a representative painting of the photographic elements, which will be used as a starting point for the composition. For this project, let's keep the brush opacity at 100%. When using the Brush tool, holding down the Alt/Option key turns the brush into the Eyedropper tool. You can quickly click on an area of the photo to sample a new color and then release the key and continue painting.

Start applying paint. Use a regular, non-blurry round brush. Adjust the brush size as needed. Observe the general shapes defined by areas of color in the source photograph. When a color in the photo changes significantly, sample a new color and continue painting.

I occasionally make a new layer as I paint into various areas or apply different techniques. You should make as many layers as needed to maintain control of separate elements. You can always merge layers later if you wish. Before merging, **"Save"** and then **"Save As"** to preserve a copy of your artwork with the individual layers intact. I periodically click on the eye icon on the layer containing the photograph in order to make it invisible, as it can be hard to tell the difference between painted and photographic areas as you work. You may not realize how much of the image is left unpainted. Rendering the photograph invisible shows you exactly where the holes in your painting are.

5 Blend the Paint

I use the Smudge tool to blend paint where appropriate and create strokes with character and visual interest. The strength of the Smudge tool can be adjusted until you get the desired blending effect. Here, I generally work with the strength at about 45% as a starting point, and increase the strength when needed to achieve my desired effect. When you select **"Finger Painting"** in the Control Panel, it is as if you were to dip your finger in the currently selected foreground color before you begin each stroke. I leave Finger Painting unchecked in this exercise.

Using the Smudge tool to blend paint.

6 Twirl the Hair

The hair already had a kind of humorous flip to it, so I decided to use the tools in the Liquify environment to take these characteristics further. I use the **Forward Warp tool** at a moderately small size to drag the painted hair in the direction of the flip. I also use the **Twirl Clockwise tool** to twirl the hair on the right by selecting a very large brush size and then clicking and holding the cursor until I obtain the proper twirl. (Holding the Alt/Option key will allow you to twirl in a counterclockwise direction.)

7 Add New Elements

I liked the texture of the aged scrapbook page to which the photo was taped. I use this texture and color as an underpainting for the image. By the time I finish the piece this will be the only actual photographic element that remains. I decide to paint into the background using an off-white color, allowing the scrapbook page to show through in various places. I also clone the scrapbook texture to put it in places it didn't previously exist.

Next, I use one of the texture brushes I cautioned you about earlier to apply the initial paint. I use the Plastic Wrap Brush, from the Faux Finish Brushes. These brushes can be accessed from the Control Panel if the Brush tool is selected. I select this brush—not for any purpose associated with its name. I use it because it has a specific rough texture that I think will be helpful in my process.

I set my brush opacity at 70%. I use a large brush and go over areas repeatedly to create a variety of strokes and levels of transparency. I then use a standard brush to further modify the white color and make the brush texture less predictable.

Using **FILTER › LIQUIFY** to "twirl" the hair.

Selecting the Plastic Wrap Brush from the Faux Finish Brushes.

Painting a semitransparent white background using the Plastic Wrap Brush.

I use the **Pencil tool**, ✏ found under the Brush tool in the Tools Panel, to draw over the background and figure with a thin, shaky line. The Pencil tool draws with no variation in thickness. I make sure to integrate this new visual idea throughout the composition. In some places I partially obscure lines with semitransparent paint, essentially using these places as transitional areas between the painted areas and the drawn areas. This helps to integrate these two different approaches and make them look like they belong in the same composition.

Drawing with the Pencil tool.

By this point no trace of the original photographic figure remains visible. I continue painting and drawing, adding, subtracting, and refining. I add blues and purples. I use a really thick brush to paint a pattern on the dress in quick, gestural strokes that echo my thin line drawing in the work.

The finished piece.

Photoshop Filters

Photoshop has a number of filters that can be used to transform images or achieve certain effects, some of which we have already incorporated into our earlier projects in this book. I urge you to use them judiciously and suggest that you combine them with other tools, and the human hand, to create something unique.

Many filters emulate techniques used in physical painting. The Art History Brush in the Tools Panel does this as well. The problem with many of the filters used "right out of the box," is that their use requires little in terms of human judgment. When you select the Crosshatch Filter, for instance, you will get an image that has a surface resembling traditional crosshatching, but the result will be uniform, repetitive, and very predictable in the details. This image may appear uninteresting and, frankly, art-less. Some of the other filters that emulate physical painting techniques include Water Color, Charcoal, Colored Pencil, Crosshatch, Dry Brush, Panel Knife, Smudge Stick, and Spatter.

Once the novelty wears off and people have seen these filters used a few times (that day may already be here!), works that are created by simply processing a photo with a filter will seem even less inspired. This is not a fault of Photoshop. These filters are part of a well-rounded program that is useful in many different kinds of situations. In fact, many times when a novice is exploring Photoshop, one of the first things he or she is likely to do is play with all of the cool filters. In a fine-art context, however, it is generally undesirable to let the software make important visual decisions. Digital art offers wildly expressive possibilities. Realizing those possibilities means keeping human judgment in the equation. If you want to crosshatch, take your drawing tablet and pen and draw lots of little crosshatched lines that have individual character. If you decide to use the Crosshatch Filter, you could paint into work and modify it so that it becomes something indicative of a unique sensibility. Our next exercise provides an example of combining a photograph and digital paint with an appropriate use of a filter.

NOTE: When painting over photographic images, change colors to support your color themes. Simplify, change, move, and eliminate elements for compositional interest and clarity. You can add other elements. You can drag new photographic references into the piece and paint over them. You can delete the original photograph. If you do keep the photograph as part of the image, you could use one of the filters found under **FILTER > NOISE** to reduce the photographic grain and help it blend well with painted lines and strokes. You can flatten the image and blend and manipulate the photo and paint pixels together. The image is a starting point. It is inspiration. If you haven't added something unique and significant to the original photo, then what's the point?

INTEGRATING PHOTOSHOP FILTERS INTO DIGITAL ART

In this exercise we will use a filter for a certain effect, but modify it and integrate it with other techniques. We'll begin with an image of two women taken in front of a green screen. This image is a video still from a film project I worked on. I use **FILTER > BLUR > SURFACE BLUR** to flatten the colors slightly. This gets rid of video imperfections and allows the image to better integrate with our digital paint.

The original video image, with Surface Blur applied to remove video artifacts.

① Replace Color

I use **IMAGE > ADJUSTMENTS > REPLACE COLOR** to select and replace individual colors in the image. I then paint and smudge a bit, just to get our image a little further along before processing it with the filter.

② Create a New Layer

Next, I use **LAYER > NEW LAYER > LAYER VIA COPY** to make a copy of the video still. We'll process the copy using a filter and then combine aspects of both the filtered and unfiltered images.

❸ Access the Filter Gallery

Many, but not all, of the Photoshop filters, are found in the **Filter Gallery**, which can be accessed by going to **FILTER > FILTER GALLERY.** In the Filter Gallery, you can preview various filters and their effect on your image by selecting them and then viewing your image in the preview window of the gallery. Each filter, when selected, has its own set of controls for adjustment. You can zoom in or out within the image preview by clicking on the "plus" or "minus" icons in the lower-left corner of the Filter Gallery. When you move the cursor over the image, it becomes a hand. You can click, hold, and drag on the preview image to change the area that is viewed. You can only see and affect the current layer.

You can apply more than one filter in the Filter Gallery by clicking on the **new effect layer icon** 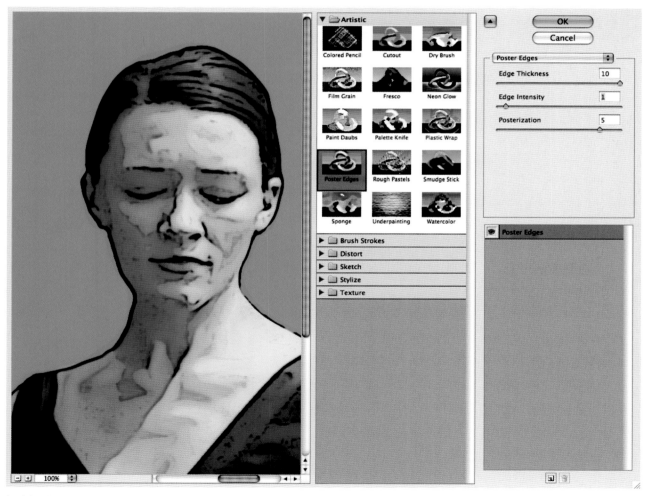 at the bottom right of the Filter Gallery and then choosing another filter effect. In our exercise I use **FILTER > FILTER GALLERY > POSTER EDGES.** This filter creates a tidy, comic book kind of look with black lines and simplified colors. I like this effect, especially in the hair. Many of the descriptive black lines in the facial features, however, seem mechanical and arbitrary. I also don't like the darkened edges of color areas, and I find the speckled surface quality undesirable. We'll address these concerns in step 4. I adjust the slider settings until I get some decent shapes that I'll be able to incorporate. Then I hit **"OK."**

Applying **FILTER > FILTER GALLERY > POSTER EDGES** to a copy of the video image.

Erasing areas of the filtered layer and exposing the unfiltered image underneath.

④ Modify the Filtered Image

With the filtered image layer selected, I use the Eraser tool to erase the undesirable portions of the processed image. Since we made a copy of our image before filtering it, erasing on this processed layer will result in showing portions of the unfiltered image below it. When I am satisfied with my combination of these two layers, I select the top layer and use **LAYER › MERGE DOWN** to combine them into a single layer. I then select the Brush tool. I paint into the appropriate areas, including the hair, to clean them up and improve their appearance.

⑤ Outline the Figure

I want to create an outline around the figures. This will work well in combination with the well-defined lines of our filtered image. The Magic Wand tool is excellent for selecting uniform areas of solid color. I use the Magic Wand to click on the solid green color in order to select it. Since I want to apply our outline to the figures rather than around the edges of our image, I use **SELECT › INVERSE** to select the opposite of the currently selected area.

Next, I create a new layer on which to place our outline, just to keep my options open. I go to **EDIT › STROKE**, select black for the color, five pixels for the width, and choose **"Center"** to center the outline along my selection edge.

Using **EDIT › STROKE** to apply an outline around our figures.

The figures with outlines around them and more paint applied.

⑥ Refine the Figures

I then go to **SELECT > DESELECT** to deactivate my selection. I continue to refine the image using the Brush tool and the Smudge tool. In this exercise I'm applying these new tools in a more subtle fashion than I did in exercise 1. I'm keeping more photographic characteristics while smoothing and simplifying shapes and colors.

⑦ Create a New Background

I make a new layer. On this layer, I will create a geometric background. I make selections with the Rectangular Marquee tool and fill them with color. I use muted red/pink colors that are already present in small amounts within the figures. When my background is complete, I apply a Gaussian Blur to it in order to create a slight sense of depth in the image. I drag this layer behind the other layers. I use the Magic Wand tool again to select the green areas. When I select the Magic Wand, I make sure that **"Contiguous"** is selected in the Control Panel. This means that only similar pixels that are directly touching each other can be selected, which ensures that nothing inside the figures can be accidentally selected. When the green area is selected, I hit the Delete key to make it disappear, revealing the striped background underneath. Even though nothing of our original green background remains, it certainly influences and defines the colors in the finished image.

The finished image with a geometric background.

FILTERS WITH LIMITED BUT USEFUL SPECIALTY APPLICATIONS

You might not often need to make a photographic image appear as if it is behind a glass shower door. However when you do, **FILTER > DISTORT > GLASS** will do a great job. Likewise, **FILTER > ARTISTIC > NEON GLOW** and **FILTER > SKETCH > CHROME** will do pretty much do what their names imply.

Filters found under **FILTER > NOISE** are used to either add noise or graininess to a photo or reduce noise, often at the expense of detail in the picture. Adding noise can be used to match the grain of other photographic images. Reducing noise may be helpful in getting rid of photographic grain when combining photographic and painted elements.

Filters under **FILTER > RENDER** either add new elements or entirely replace existing images. Try playing with the **Clouds** and **Lens Flare Filters**.

Filters under **FILTER > TEXTURE** can be used to apply preset or user-imported textures such as a painting canvas. Although I think it's incredibly useful to acknowledge and emulate physical reality in your work, I'm wary of creating the illusion of canvas textures and other direct aspects of physical painting in your digital art. Canvas texture, for instance, is there for a reason in physical painting. It offers a good surface for the paint to adhere to. The canvas texture catches the paint in your brush and allows it to be pulled across the surface of your artwork more easily. The only reason you would apply a canvas texture to a digital work is to make it look more like a physical painting. The canvas texture serves no specific visual or technical purpose other than to resemble its physical counterpart. I believe the digital artist is better served by understanding and working with the characteristics and advantages of this unique medium rather than creating a second-rate imitation of another medium.

A compelling reason to use a texture would be if it is the perfect visual solution for your composition and would "work" visually, regardless of whether it evokes another medium or not. The best way to see what the filters are capable of is to play with them. Use your imagination. Think how you can combine these effects with other techniques in order to come up with something original. You can apply most filters to a Smart Object. These "smart filters" will be nondestructive. You can modify or delete the effect of a filter in the Layers Panel.

PROJECT:
Photos and Paint

Create an original work that combines both photographic and painted images. The photographs can be used as a reference or incorporated into the finished piece. They may be recognizable or transformed into something else completely. You can start with a photograph or by painting. You can drag multiple photos onto your document. You can drag anything and everything off your hard drive and into your art. You can add or subtract images as you work. Try adding new elements and react to them if you feel stuck. You can modify anything, using any combination of the tools and techniques we have discussed thus far in the book. It might even be time to use some of those textured brushes and filters, judiciously, with other tools. To the right are some of the solutions that my students made.

Top: Jess Ritsko, Cleveland Institute of Art. Jess used a nice combination of photographic and painted elements—processed, layered, and selectively erased to create a very energetic, cohesive work. COPYRIGHT © JESS RITSKO

Bottom: Michael Brainard, Cleveland Institute of Art. Michael combined photographic textures, vector shapes, typography, and images processed by filters to create a very subdued, organic design. COPYRIGHT © MICHAEL BRAINARD

FINDING YOUR OWN VOICE

I've always admired artists that cut a wide path. I've always been drawn to artists that dove into the creative waters, took some risks, and surprised us—and perhaps themselves—with their results. From Picasso to the Beatles, I admire creative people that "paint" with a broad palette. I admire artists that explore; artists that are endlessly restless and curious; and artists that venture into unknown territory. As a student, I was very resistant to the idea of consistency in my work, and was even puzzled by the idea. Many of my teachers were artists who came from the sensibility of abstract expressionism and painted spontaneously, yet they still urged me to commit to a style. Wasn't this contradictory to the idea of painting whatever occurs to you? Wasn't this limiting the possibilities of personal exploration? Wasn't the idea of a style something artificial, with arbitrary, unnecessary boundaries? I start the chapter by asking these questions because you might be asking them yourself, too. In this chapter I offer you the chance to learn from my thick-headedness and save yourself some time and frustration.

Above: *Storm*; opposite page: *Descend* by Qian Li. Qian makes paintings on rice paper; scans them; adds photographic elements, layers, and shapes; and then modifies these elements in Photoshop. Her large-scale digital prints are suspended invisibly by wire from the ceiling of the gallery, like ominous floating rectangles. This manner of display adds one more consistent and recognizable visual treatment to these works. Other distinctive characteristics of this work include fluid line quality, a sense of motion, a very limited color palette, subtle use of texture, and prominent use of negative space. COPYRIGHT © QIAN LI

I once discussed my concerns about stylistic consistency with the head of my graduate school, who was a great painter and had an illustrious career with many highs and lows. She was someone whom I would describe as curious and brave in her work. She strongly advocated committing to a style in order to create a consistent body of work. She called it "mining a vein," which I think is a great way of putting it. You can't do everything at once, and you certainly can't do everything well at once.

Mining a Vein

What does "mining a vein" mean? It means picking certain stylistic elements and themes that interest you and then committing to them for a while. It means using variations of these themes in all of your works. What happens is that the more you practice these parameters, the better you get at them. Just as flowing water gradually polishes a stone by wearing off the rough edges, you refine your style over time. You eliminate the things that don't work. You practice the things that do work until they reach their full potential. You add new things that keep you off balance and interested, which, in turn, helps your work grow, change, and keep people interested. Commitment does not imply stagnation. Your work will evolve naturally over time until your mature work is quite different from where you started. You can add to your stylistic parameters as you progress and widen your visual palette.

Some artists may occasionally feel stuck and will throw everything out and start mining a new vein. We call this "reinventing yourself." If you start every work as a novice with no reference point, you cannot progress. It's something of a paradox, but by choosing limitations (a commitment to a certain way of doing things), you develop an individual voice. Something unique comes out of your exploration and from the choices you make and how those choices develop with repeated application. Only when you become adept at your basic techniques and can do them without thinking will you be able to concentrate on the creative part of your work—and that's when something really interesting can happen. When you have done this successfully, I will be able look at your work and recog-

nize it as yours, because your particular use of the time-honored elements of the visual language will have become unique and distinctive. Your style will become *your* voice.

Is it arbitrary? Kind of, but so what? You're not stuck with your choices. They are just a starting place, and you *do* have to start somewhere. You will evolve over time and learn what works and what doesn't. Awkward things will be refined or replaced by something better over time. That "something" is often impossible to discover without putting in the work and mining the vein. The more work you do within the style you have chosen, the better you will get at it—and the more personal it will become. Just choose something of interest to you as a starting point.

Although Picasso's style certainly ran the gamut, each vein was properly mined and explored. He had a brilliant, inquisitive mind, a strong work ethic, and lived long enough to explore a multitude of directions. Because he possessed mastery over a wide range of techniques, not every visual motif made it into every painting he made. There were even times where he was exploring more than one direction at the same time. He was fully committed to each direction, however, and explored it thoroughly. He even copied the styles of other artists, like a student, so that he could understand what they did and then incorporate that understanding into his working vocabulary.

The Beatles, on a similar musical note (no pun intended), were all over the map. Even though their music is surprising and incredibly varied, The Beatles developed a style that is immediately recognizable and continues to influence songwriters today. In fact, the term "Beatle-esque" is one of the most prominent adjectives used to describe a pop musical style. Their style is so vivid and distinct that anyone familiar with The Beatles would know exactly what is meant when an artist's music is described as "Beatle-esque."

Reacting to the Outside World

If an artist is lucky enough to be noticed at all, he or she will encounter opinions and responses from their audiences. Everyone is somewhat tempted to do more of something if it is applauded by an audience. Everyone, to some degree, experiences self doubt when faced with negative criticism. Criticism itself can be either valuable feedback about how effectively an artist is communicating with the viewing audience, or it can simply undermine his or her confidence and discourage the artist before he or she fully develops an exceptional idea. As a broad generalization, there are three possible reactions to the outside world when an artist endeavors to develop and maintain a personal style.

1. THE TREND COPIER

One thing I would strongly urge you *not* to do is to work in a style you're not passionate about, just because it seems popular. There are a lot more efficient ways to make money doing something that you *don't* want to do. Other people who do feel passionate about working in a certain style will work harder and do a better job. It takes time for interesting ideas to percolate. Creative trends often exist and develop for quite some time before they gain mainstream media attention. By the time you get a sense of what's fashionable in the mainstream, it is just about over. Those risk-taking, innovative people who created the trend will then already be off creating something new. If you want to be successful in any but the most fleeting and unsatisfying of ways, you have no choice but to do what interests *you*.

2. AN ISLAND UNTO ITSELF

Some people have an idea and a point of view that is relatively constant. They are content to work in one style and sensibility, with variation, for their entire career. This style can go in and out of fashion several times. A person working in this manner can expect waves of public interest and indifference, but will continue to work according to his or her intent.

3. THE "ACCIDENTAL" TRENDSETTER

If you do the same thing over and over again in exactly the same way, people will grow bored with it. You will probably grow bored with your work as well. The creative people who stay relevant over decades do so by taking creative risks, slowly changing and evolving over time. They are aware of what's occurring in their time and place—and may take it into consideration—but continue to constantly surprise us. These are people whose natural curiosity and spirit of adventure outweigh the fear of failure or the fear of losing the success that they have already achieved. They don't adapt to trends; they create them with the force of their interest and imagination—and at an intersection of time and place where the public is receptive to their ideas. Setting trends is a side effect of doing work that you are passionately interested in. Evolving is just as important as mining a vein. Even if you are standing still, things change around you.

Style vs Subject

When I talk about style in my classroom, a student occasionally will say something like, "My style is that I draw monsters." Monsters are not a style; they are a subject. You can render monsters in many different styles. Although you may utilize a subject that is especially appropriate for your style, you should be able to render *any* subject in your style.

Style can work in support of a subject. If you have specific subjects or types of subjects that you use frequently in your work, you might want to consider developing a style that supports the general feeling you wish to communicate about your subject matter. It's also possible to consciously pick a style that conveys a feeling or quality that is contradictory to the subject matter. A scene depicting a horrible atrocity, for example, could be rendered in a cute, inviting, cartoon style. The contrast between the subject and the manner in which it's rendered could make it all the more horrifying.

How can you consciously develop a style? Commit to some specific ways of doing things, and then allow these parameters to change as you progress. Make choices that appeal to you.

GENERAL MOOD

The overall feeling or quality that you want to convey will determine which specific elements you will use in your developing style. Consider the following:

◆ Your personality

◆ Your point of view

◆ The general mood or quality of your previous artwork

◆ A subject matter that interests you and your specific feelings about it

◆ What you would like to say as an artist

◆ What is the general mood or quality that you would like your work to possess? Somber? Cheerful? Serene? Energetic? Angry? Simple? Busy?

STYLISTIC CHOICES

Once you have a sense of the general quality or mood you are working toward, make specific choices about how individual visual elements will be treated in service of the quality.

LINE QUALITY

Is there a way to introduce a distinctive, recognizable line quality that is especially appropriate for your work? Ask yourself the following questions about your line quality. Is it:

◆ Vigorous and expressive?

◆ Clear and clean?

◆ Organic?

◆ Geometric?

COLOR PALETTE

Is there a distinctive color palette that would be appropriate to your style? Is it:

◆ Black and white?

◆ Black and white and red?

◆ Earth tones?

◆ Grays with very muted colors?

◆ Solid blocks of bright colors?

◆ Complementary colors?

◆ Only variations of the three primary colors, with a clean black outline?

Left: *The Cloning*; right: *My Funny Valentine* by Geoff Ault. Inanimate objects are used as "recurring characters" in these pieces. Some phrases you might use to describe the style and visual motifs shared by these images include high contrast in value and warm yellows and reds used as primary color themes with little accents of vibrant blue. The figures are all similarly distorted, leaning to the left. COPYRIGHT © GEOFF AULT

TREAT SIMILAR ELEMENTS CONSISTENTLY

Treating similar objects consistently within a composition, unless there is a visual reason not to, creates a purposefulness that will greatly contribute toward developing a recognizable style. Is there a consistent way that you can treat figures and other prominent recurring shapes? Could you use:

◆ High contrast?

◆ Faded out?

◆ Bright and saturated?

◆ Muted color?

◆ Loose paint strokes?

◆ Smooth gradients of color?

◆ Flattened colors?

◆ Outlines around figures?

◆ Soft curves or sharp angles?

◆ Elements that are distorted, stretched, or abstracted in a consistent way?

CONSISTENCY IN COMPOSITION

Composition is another important aspect to consider when developing a consistent style within a body of work. The placement of objects contributes greatly to the general feeling of your work. The specific compositions don't have to be the same in all your works, but it's beneficial to commit to a general compositional idea that is consistent and appropriate to your work, and then begin composing each work with this idea in mind. Could your general compositional ideas include:

◆ Lots of empty space?

◆ Crowded and busy?

◆ Horizontal and serene?

◆ Prominent, aggressive diagonals with conflicting directions?

◆ Are the figures or prominent elements always central to composition?

◆ Are the figures always up close, in your face or are they always isolated in the distance?

Top: *Atomic Rhythm*; bottom: *Cellular Flow* by Milad Meamarian. These works both have a light background with no variation in value. The background shows through the elements in the composition as if the elements were translucent. Among many other distinctive characteristics, these images both have a single circle as the compositional focus. The circle almost seems to exert a gravitational influence on the other elements in both compositions. Milad uses Photoshop to integrate images that he creates through more traditional means. This process allows him to easily copy, manipulate, and experiment with images, giving him a greater degree of control than he would otherwise have over the end product. COPYRIGHT © MILAD MEAMARIAN

215

FOREGROUND VS BACKGROUND

Is there a way to distinguish the figures or other important elements by making them consistently different from the background? If you do this, how can you create enough unity between the foreground and background elements to make them seem like they belong in the same picture? Or would you like to treat the foreground and background similarly? Perhaps you could create a flattened sense of space within your work and emphasize integration rather than distinct difference between the foreground and background elements.

TEXTURE AND PATTERN

Textures and patterns can be used, with variation, in all your works. They can become elements of your style and help make it more consistent and recognizable.

Left: *Testing the Persistence of Green*; right: *Breathing Room* by Susan Chapman. Susan's work is composed of digital drawing and painting, digital photography, and selected scanned items that are layered and combined in Photoshop. Texture and pattern play a big part in her style. Other prominent visual themes include solid black-and-white images (with no shades of gray) that are juxtaposed with smaller elements containing vivid color and a full range of value.

STYLISTIC DECISIONS SPECIFIC TO DIGITAL ART

As we discussed in chapter one, digital art blurs the boundaries between mediums. Your art can move, have sound, tell a narrative story, or interact with the viewer in many different ways. Your possibilities are vast indeed. Here are some parameters to consider when creating nonmoving digital images in Photoshop:

◆ Photographic, painted, or a combination?

◆ Original images or found elements?

◆ Are there certain images you can import that can be placed over unrelated elements as a unifying surface texture?

◆ Can you combine the elements in an unusual way?

◆ Can you incorporate images that have a personal and unique significance for you?

THROW IN SOMETHING NEW

Is there a way you can put something unexpected in your work? Some random examples are:

◆ Old, found documents or book pages?

◆ Outline shapes of objects or figures that are filled with found materials?

- Actual leaves, flowers, or other natural things that can be scanned into the artwork?
- Combining turn-of-the-century clip art with solid color shapes to use as a contrasting background for vigorous gesture drawings?
- Combining smooth fills of paint and gradients with flattened, high-contrast figures?

QUESTIONS TO ASK YOURSELF

Here are some questions that can help you clarify your thoughts when developing a personal style:

- Are there specific, stylistic qualities that you feel drawn to?
- What do you like to look at?
- What would be fun to make?
- What do you feel really strongly about?
- What do you love?
- What makes you mad?
- If you could contribute to changing something in the world, what would it be?
- Is there something in particular you'd like to express?
- What combination of elements could be appropriate to your viewpoint?
- Are there any particular subjects you'd like to portray on an on-going basis?
- What combinations of elements could you use to address your subjects from your unique point of view?

I provided all these bullet-point examples not because I want you to choose among them, but because it's simply easier to understand a general concept when you are offered specific examples of possible solutions. They are intended to get you thinking—it's always better to come up with your own ideas. I don't want you to make any particular decisions; I just want you to make *some* decisions. Many artists started their careers as blatant and inferior imitators of artists whom they admired. They put in the time and mined their vein until something clicked and their work became something mature and unique. Although it is usually very different from their derivative starting point, it would have been impossible for them to have reached their goals without putting in the work.

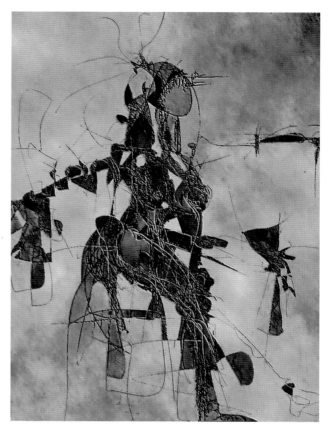

Deesse Egyptienne by Ric Grossman. This work was created with a combination of traditional drawing and painting techniques and Photoshop manipulation. COPYRIGHT © R. GROSSMAN

COPY/ANALYZE SOMEONE ELSE'S STYLE AND MINE YOUR VEIN

In this exercise you will need to do two things. First, pick an artist you admire. Pick a specific work by the artist with a particularly strong design. Study both the composition and the stylistic treatment of elements. Look at a physical print of the work and recreate it digitally. Do not paint over the image in the computer. You can gain great insight into the decision-making process of an artist you admire by retracing their steps. You will come to truly appreciate the structure, style, and emotional effect of a work when you spend a long time studying it. Do this several times with multiple works.

Second, commit to a series of consistent, recognizable, and visual parameters and create at least ten works using these parameters. Create even more works in this style unless you really feel drawn in another direction. When your methods have become too predictable or you feel bored, add another parameter. Find a way to challenge yourself yet still progress in your chosen method of working. The most important thing, once you've made some decisions, is to just do the work! Don't second-guess yourself; just do it. If you work in a consistent manner for an extended period of time, you are bound to get better and better as you go along. Practice makes perfect. It's the opposite of a vicious circle!

I realize that this is not merely an exercise in the strictest sense. I'm asking you to develop an entire body of consistent, mature work. While I highly recommend actually creating this body of work, you may wish to do it over the course of several months, once you have completed the book. You can begin this work by doing the project at the end of this chapter that requires creating a couple works in the your intended style.

Peacock by Ric Grossman. This work was created with a combination of traditional drawing and painting techniques and Photoshop manipulation. We'll discuss combining Photoshop with traditional media in detail in chapter ten. Visual characteristics of this work and Ric's piece on the previous page include playful, curving line quality; lines mixed with simplified, but organic, shapes; and large areas of solid colors with variation in texture and value. COPYRIGHT © R. GROSSMAN

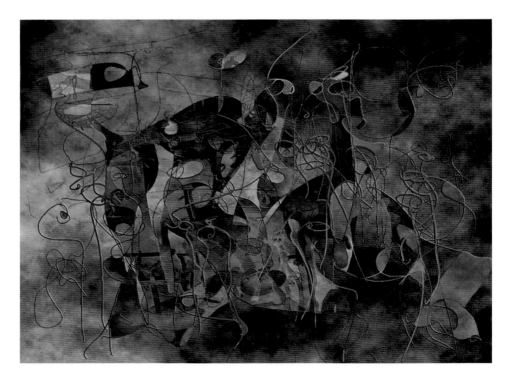

The Artist's Statement

A consistent body of mature work is probably the single, greatest asset in getting a gallery to show your work. When your are fortunate enough to have your work featured in a gallery, it is likely that you will be asked to provide an artist's statement that will be placed on the wall for viewers to read.

Many artists dread writing these statements, and are uncertain what to write. They feel that their art should speak for itself. Many artist's statements are unnecessarily written in complicated and pretentious art-speak. An artist's statement is not intended to show how smart you are. It's not meant to be a substitute for the careful viewing of your artwork. Its goal is to give the interested viewer an insight into what you are thinking as an artist. An artist's statement can talk about the process used in the creation of your work. It can explain what you are trying to express and why it is personally important to you. It can talk about your general philosophy of art-making. It may discuss why you make images and why you have chosen to make these particular images. If an artist's statement is done well, it will give the viewer a context in which to view the work. It should *not* tell the viewer how to feel about the work. It should create a deeper connection to the work by helping the viewer understand how you, the artist, sees it.

Take Inventory

Once you have decided upon some basic, stylistic parameters and are ready to begin your body of work, sit down and take inventory on your decisions. Have you come up with something unique? What makes your style different than other, similar approaches? If you produced a body of work in a particular style, would someone be able to look at your work and recognize it as yours? Does the work successfully convey the general emotion or quality that you want to communicate?

It may seem like putting the cart before the horse to talk about artist's statements before you have created a body of consistent work, but writing an artist's statement in advance, as if you have completed the works, can force you to clarify your thoughts. Think of this hypothetical artist's statement as if you were writing a manifesto. You will, in writing, be defining what is important to you, what you want to do, and how you're going to do it specifically. Once you have actually created your body of work, you can either modify the statement or toss it in favor of a real statement. Going through the process of writing an artist's statement can be a tremendous help in defining your direction as an artist.

Find something you feel passionate about. Do it a lot and get better at it. Think about what you are doing and why you are doing it. Ask yourself what's exciting or interesting about it. Write it down, and you have your artist's statement.

PROJECT:
Commit to a Style and Method of Art-making

Create two works as if they were the beginning a series and be able to clearly describe your style and its specific visual treatments and ideas. There's certainly nothing preventing you from actually expanding these ideas into a larger series of works using this style to create a consistent, distinctive body of work. To the right are some of my student's solutions to this project.

Left: Matt Czapiewski, University of Mary Washington. Matt's deceptively straightforward style includes the use of solid color backgrounds, comic book word balloons, a limited color palette, and simple shapes mixed with areas of greater complexity such as the hair on both figures and the checkered pattern in the first figure's shirt. COPYRIGHT © MATT CZAPIEWSKI

Opposite Page: Katie Matusik, University of Mary Washington. These two images by Katie could be the beginning of a very consistent body of work. Visual themes that are incorporated into Katie's style include strong use of transparency, very high contrast in value (especially in the white areas) integrated with areas of very low contrast. The colors are somewhat muted, but there are some areas where the color is vibrant and intense. The integration of contrasting approaches in these visual themes makes these works distinctive and identifiable as the work of this artist. COPYRIGHT © KATIE MATUSIK

Kuan Yin as Musician by Cindy Jerrell. Even if you enjoy the advantages of working in the digital domain, you are not necessarily limited to your digital toolbox in the creation of your artwork. These works started out as oil paintings, which the artist photographed, altered, and continued painting in Photoshop. COPYRIGHT © CINDY JERRELL

INTO THE REAL WORLD

In order for people to see your work, it must manifest itself in some form in the physical world. Essentially, the possible methods of presenting your digital artwork are (1) making a physical print of your image; (2) projecting it onto a wall, screen, or other object such as a sculptural installation; or (3) displaying it on a video monitor. When it is projected or displayed on a video monitor, it is also possible for artwork to move or interact with the viewer. Once you have brought your work into the real world, it can be combined with traditional mediums such as painting or sculpture. It is also possible to capture traditional artwork through scanning or photography, and then bring the real world into the digital domain for further manipulation. This chapter will discuss some of the possibilities of integrating your digital art with the real world. The simplest, most direct way of making a tangible object from a (nonmoving) digital image is to print it on paper. There are various approaches an artist can take when printing digital artwork, with varying degrees of color fidelity, archival permanence, and expense. This section of the chapter explores some of these options.

Home Ink-jet Printing

Ink-jet printers form images by spraying microscopic dots of ink onto the page. The RGB color mode should be used when preparing artwork for ink-jet printers, including high-end ink-jet printers that are used to create museum-quality fine-art prints. Ink jet print resolution is measured in **dots per inch** (or **DPI**). The more dots per inch, the smaller each dot is and the sharper the image will appear. Individual printers and printing technologies will play a large part in determining which DPI is best to use. Generally speaking, the higher the DPI, the sharper the image will be. However, there is a law of diminishing returns. The very highest DPI setting on a high-end printer may not produce noticeably better results than the setting below it—and it can use a lot more ink. Therefore, experiment with different DPI settings. If there is a difference in quality that merits the extra expense, then print at increased resolution. The most basic ink-jet printers use four colors. Photo printers may use six or more colors for better detail and greater color fidelity. Some printers use a second black cartridge for better black-and-white printing.

Large Format Printing

As of this writing, it is reasonably affordable to purchase high-quality printers that make **tabloid size prints** (11 x 17 inches) or slightly larger. Printers capable of making significantly larger prints are considerably more expensive, but are also becoming cheaper. It's more than likely that you will need to go to a commercial print shop to have really large prints made. If you use a commercial printer you will essentially choose between a quick-print shop or a more expensive higher-end printer that emphasizes greater color fidelity and archival permanence.

The Kodak ESP 5 All-in-One Ink-jet Printer. Photo courtesy of Kodak.

The Canon ImagePROGRAF iPF6100 Large Format Printer. Photo courtesy of Canon.

QUICK-PRINT SHOPS

Many quick-print shops have printers that can make huge prints using paper and ink of significant higher quality and permanence. These large format prints are fairly expensive, but may still be the cheapest alternative for local printing of large format images. Check with the print shop about the various options they offer for large format printing and how archival (long-lasting) they are. At a quick-print shop, the quality can vary with the knowledge and interest of the person printing your work. Once you find a person who does good work and is nice to you, be nice in return and request him or her for future projects.

FINE-ART PRINTERS

Some businesses specialize in archival, fine-art prints of the highest quality. These printers offer the promise of a high degree of personal attention and commitment to quality, along with a commensurately higher price. Fine-art printers use the best of conditions and materials to ensure that your digital prints will last a lifetime and beyond.

How to Improve the Permanence of Your Printed Piece

Use premium or "acid-free" paper. Paper contains acidic chemicals that can cause it to become brittle and deteriorate over time. **Archival paper** is acid-free and is likely to have a much greater longevity than normal paper. **Premium paper** usually has a treated surface that absorbs less ink and allows for more vivid, accurate color as well as a sharper image. Premium photo paper comes in **high-gloss, semi-gloss,** or **matte.**

In addition, use acid-free mattes and mounting materials. Acid-free paper is useless if you place it against a matte that contains acid or if you secure it with tape that is not acid-free.

Use inks of archival permanence. The cheapest inks for business-oriented printers may fade after a few years. Images printed with archival-quality inks can last for decades. This is something you may wish to consider when purchasing a printer. Keeping the work sealed under glass helps to protect it from atmospheric contaminants. *Keep your artwork out of direct sunlight and in a nonhumid environment!* Sunlight can fade an image over time and humidity can cause deterioration.

Framing

Framing your printed work can either greatly enhance your printed work or detract from its appearance. It is important to think of frames as extensions of your works; they should enhance and aesthetically complement them. As with printing, effective framing often comes down to a establishing a proper balance between quality and price.

It's ideal to commission a professional framer to custom frame and assemble your piece of work. If you are working with a competent framer, your art will be presented in the best possible light and will make a much more appealing purchase.

Another of the myriad advantages of digital art is that you can print to any proportional size. You can purchase an appropriate pre-made frame and print your work at a size that fits inside the frame. You can even purchase bargain frames in advance and set your document size accordingly when creating a work. When using pre-made frames, you are still limited by your own framing skills. It's harder than it looks to frame large prints and keep them flat, crisp, unwrinkled, and in our case, free of pet hair. If you are selling your work, you may wish to use archival mattes and mounting materials even when using pre-made frames.

Frames become part of the show in Susan Greenspan's creative display of her small, photographic works. COPYRIGHT © SUSAN GREENSPAN

Monitors, Screens, and Projection

In art galleries, digital work can be displayed on monitor screens. Large, flat-screen, high-resolution monitors can resemble traditional frames but contain images made from vibrant light. Digital picture frames are sold everywhere, and are becoming increasingly less expensive. Some can even display art that moves. Digital projectors, which are connected to computers or other devices, can project images onto walls or sculptural elements as part of a gallery installation.

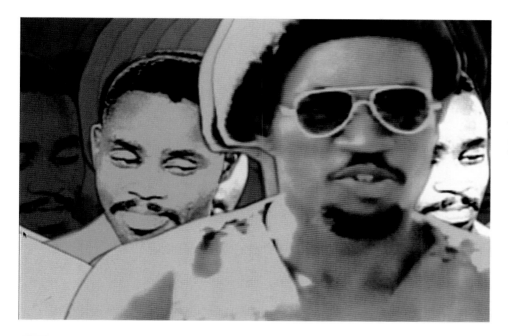

Left: *Farandole 7*; bottom: *Riot Police*. In these images from video art, artist Kasumi uses Photoshop to create layers from still images that she later animates in other programs. She also uses Photoshop to paint directly onto the files to create exciting hand-painted effects for compositing.
COPYRIGHT © KASUMI

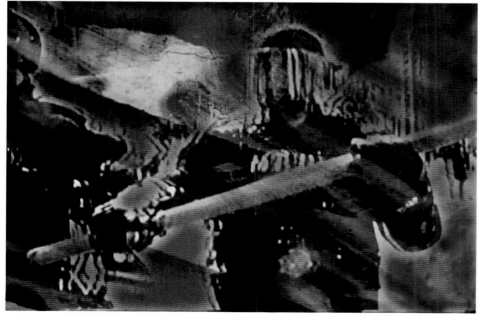

ANIMATION, VIDEO, AND INTERACTIVE ART

When digital art is projected or viewed on a screen, it has the potential to move and to interact with the audience. This introduces the concept of time into your work. Things occur and change. It is possible to use these changes over time for expressive effect. In digital art, the idea of visual movement can be taken literally. Elements in your composition can actually soar upward in a vigorous, curving motion filled with life, joy, and vitality. Elements can be trembling, tenuous, and slowly decay and collapse over time in a way that a nonmoving image can only imply. Diagonals can literally collide and create a sense of conflict or action.

To the right are images from various films created by filmmaker Jon Jost. For the past decade, Jon has worked exclusively with digital video. He creates beautiful, painterly moving images using only in-camera settings and great human judgment! COPYRIGHT © JON JOST

With digital art, movement does not have to be linear. The audience can become a participant rather than a viewer. They can interact with the work and make choices that influence the behavior of images as well as the sequence of their occurrence. As we have discussed earlier, digital art blurs the boundaries between media. Images that are created digitally have the potential to move and interact. Whether they do so or not should be considered an aesthetic choice among many others, rather than an example of an entirely different medium.

Any of the techniques and ideas in this book can be incorporated into animation and interactive art. Although it has limited animation capabilities, Photoshop is an indispensable tool for most animators, and can be used in conjunction with other programs such as Adobe After Effects or Adobe Flash. The extended version of Photoshop allows users to manipulate 3-D images for use with 3-D animation programs.

Combining Digital and Traditional Art

Once you start considering how you can bring your digital art into the real world, it may occur to you that, even if you enjoy the advantages of working in the digital domain, you are not limited to your digital "toolbox" in the creation of your artwork. It's possible, of course, to mix digital art with traditional, physical art such as "analog" painting and sculpture. It can become part of a physical environment as a component of installation art. Those who are inclined to mix traditional and digital media may enjoy the tactile, physical aspect of manipulating tangible materials yet still wish to take advantage of the unique opportunities afforded by digital art.

By combining digital art with traditional media, the artist can create a one-of-a kind, individual finished product. Any method that combines digital and analog art is likely to involve a process wherein every completed piece is at least somewhat unique. It is also possible for a digital artist to collaborate with other artists working in traditional mediums. If the artists possess rudimentary computer skills and internet access, long distance collaboration is possible, nearly instantly, from anywhere in the world.

Along with the advantages that traditional art offers, going analog requires the digital artist to address the limitations of physical media as well. The quality of your work is affected by the method used to convert artwork into digital information and then convert it back into the physical realm again. Care should be taken to minimize the loss of quality during this process. Utilize methods that result in the highest possible quality for your image.

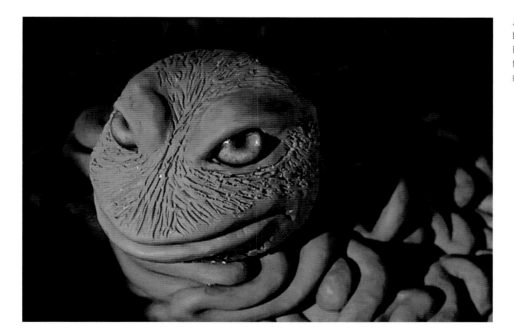

Lobe Massage is a video image by Megan Ehrhart. Megan uses Photoshop to edit individual frame details. COPYRIGHT © MEGAN EHRHART

Flutter by Mechelle Schloss. Mechelle combined traditional oil painting with digital exploration in Photoshop. Copyright © Mechelle Schloss

NOTE: Each scanner uses its own propriety software, so I can't give you step-by-step instructions about making your scan. Just keep it simple. Get a clear scan with a full range of information and then adjust color and value in Photoshop, where you have more control. Many people scan at a higher resolution to capture more detail and then reduce the resolution to 300 PPI at 100% of the finished piece.

Starting Analog, Finishing Digital

Artists may have many years of training and practice in working with traditional mediums. They may prefer to begin a work using physical materials that they are familiar with. They also may enjoy the inspiration found in the combination of different mediums.

When creating an initial sketch for a composition, what works better than pencil and paper? The process is quick and simple, with little set-up time. It is likely that you are familiar with the tools. When drawing with a pencil, it's easy and instinctive to alter and refine shapes and proportions for expressive purposes. When the pencil sketch is completed, place it on your scanner to bring it into the digital realm.

You can scan your sketch in **grayscale** (tones of gray) **mode** or **line art** (black and white) **mode**. Both modes have their advantages and drawbacks. Select the mode that works best for your purposes. Setting your scanner to grayscale mode preserves some of the subtlety within the light and dark areas of your pencil lines. You may judge this to be important in preserving the character of your sketch.

Line art mode could also be referred to as "black and white" in your scanner software. Setting your scanner to line art mode eliminates all shades of gray in your scan. All the information is either solid black or solid white. You may find that this gives you the cleanest lines to work with. Try both options and decide which works best for you. Make sure to preview your scan and adjust the settings within your scanner software window until you have adequate information to work with.

WORKING FROM A SCANNED PENCIL SKETCH

Family is one theme that occurs frequently in my work. I'm beginning this exercise with an old family photo featuring my dad and me. I am wearing some bizarre hybrid astronaut/soldier uniform. This definitely has some possibilities for creating a work that conveys a discernable quality or feeling!

1 Make a Pencil Sketch

I look at the photo and make a quick pencil sketch. Starting with a pencil sketch allows me to rearrange, exaggerate, or de-emphasize individual elements to suit my composition. As you will see, the composition will be changed significantly by the end of the exercise, but it would have been a very different work if it didn't begin with this organic approach.

2 Scan the Pencil Sketch

I elect to scan my pencil sketch in grayscale mode. Even though it's a simple line sketch, there are some lighter line values that can best be captured in shades of gray.

When you have scanned a pencil sketch and you wish to paint on the image, make sure that you change your working document mode to **IMAGE › MODE › RGB** after you have scanned the image; otherwise, you won't be able to paint in color. In this case, I drag my sketch into an existing RGB document that contains the original photo at the proper resolution of 18 x 18 inches at 300 PPI.

In the Layers Panel, the photo layer should be behind the sketch layer. Your scanned image will include the white paper as well as the pencil lines on it. I set the sketch layer's blending mode to **"Multiply"** in order to render the white of the paper invisible and see the photo behind the sketch lines.

The original photo.

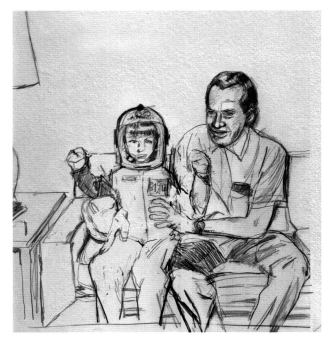

My pencil sketch of the photo, scanned and placed into our document.

③ Distort the Photo to Match the Sketch

We want to distort our photographic image to conform to our pencil sketch. I make sure the photo layer is selected and then use **FILTER > LIQUIFY** to move various parts of the photo image and stretch and modify the photograph so that it matches the proportions of the pencil sketch. I make sure that **"Show Backdrop"** is selected in the Liquify environment so that I can see the pencil sketch layer as well. I have to use the Clone Stamp tool to retouch a few areas as well. You could, of course, select, move, and resize individual areas of the photo and use any means of distortion to help the image conform to the sketch. Each artwork will have specific requirements requiring unique solutions. If you'd like your image to be more accurate than expressive, you could reverse the process and distort the sketch to match the proportions of the photo.

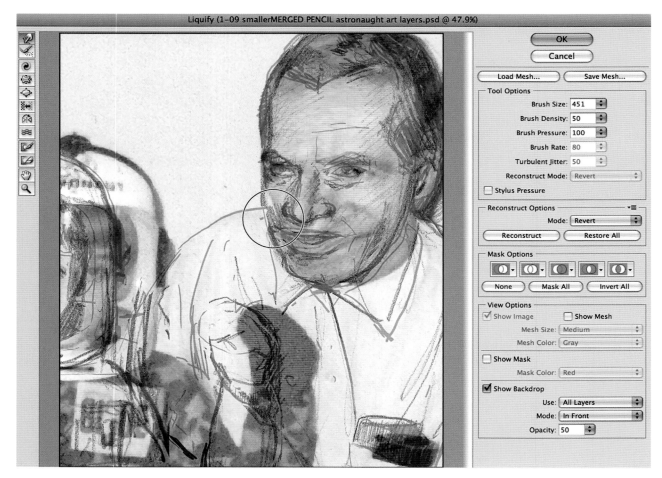

Using **FILTER > LIQUIFY** and the Forward Warp tool to distort the photo to conform with the pencil sketch.

④ Add Digital Paint

I adjust the values and saturate the colors of my distorted photo. I then create a new layer on top of both existing layers. I begin painting on this new layer, which is kept separate for more control over individual elements. I use a standard, non-blurry brush at about 60% opacity.

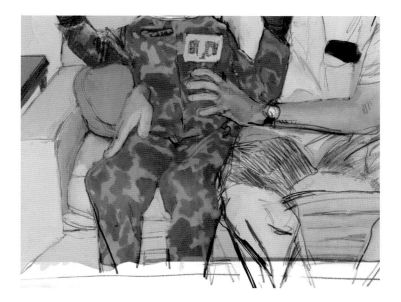

Initial digital painting over the pencil sketch and distorted photo.

I continue painting. I allow parts of my pencil lines to show through in places and use them as a recurring visual theme. I paint with a completely opaque brush in a few places in order to add definition and clarity.

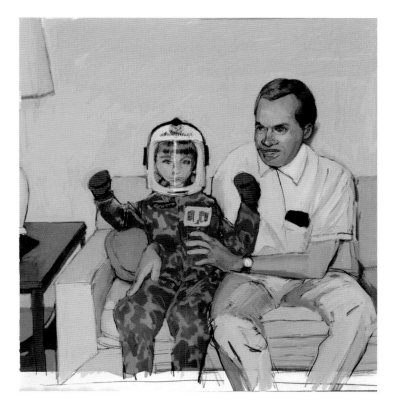

The "painted" image.

Using **FILTER > DISTORT > SPHERIZE** to modify the composition.

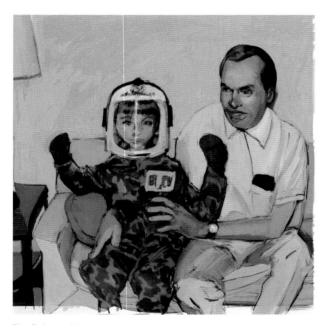

The Spherized image.

⑤ Take It Further

My initial goals are accomplished. I ask myself (as we always should), "What does the composition need?" The work could go in an infinite number of directions, of course, but I want to adjust the composition further with three goals in mind:

1. Emphasize the figures a little more.

2. Create a little more fluidity and sense of movement in the composition.

3. Accomplish the first two goals in a way that exaggerates the awkward quality of our young astronaut.

I merge the layers together and used **FILTER > DISTORT > SPHERIZE** to warp the image and modify the essential composition in support of my goals.

I like the complementary color relationship between the background and figure, but I feel the background lacks both interest and compositional integration. I scan another image, a family birthday list compiled by my father. I integrate it into the background and scale and position it in a way that helps to balance the composition. I erase this "list" image in the areas where I don't want it to obscure the figures and other elements. I modify the value and color of the list so that it reiterates the values and colors in the figures. I paint a little more on the figures and other areas and then determine that the work is complete.

You could, of course, use no photographic images in a work, simply applying digital paint over a pencil sketch. You could use a detailed, carefully shaded pencil drawing as an underpainting, either with or without a photo. It's possible to begin your work by creating a physical work in color and then digitizing it in order to continue working on it in Photoshop. It could be a rough sketch or a more developed work. It could be created using any medium, including oil, acrylic, watercolor, pastel, colored pencil, or even crayon!

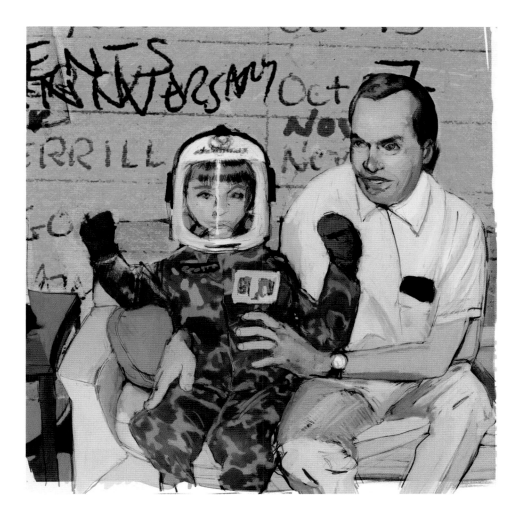

The finished image with another scanned document in the background, which was modified in color and value to enhance the composition.

If your entire work fits on the glass of your scanner without cutting off part of the image, I recommend scanning it. Keep the image motionless and pressed flat against the glass when scanning. If your physical artwork is larger than your scanner window, I recommend photographing the work using the best digital camera you can obtain and then importing the photo into the computer. Scanning portions of the painting and then reassembling it in Photoshop is also a possibility. You could also begin with a photograph of sculptural elements or entire installation environments and then modify the images in the digital realm. Your specific approach can involve a combination of techniques based on preference, necessity, and intention.

Starting Digital, Finishing Physical

It's possible to begin a work in the digital realm and then add to it and complete it in the physical world. You can print a digital image and paint on it with physical paint. You can integrate digital images with physical materials and structures. Your digital art can be silkscreened or transferred onto a wall or other surface and become part of a physical environment. Your digital work could also be projected onto surfaces or shown on monitor screens rather than being physically printed.

Buddha in Decay by artist Jackie Hoysted. Here, a digital image is mounted onto a wooden panel and then layered with encaustic medium and encaustic paints. We'll get a chance to see Jackie's creative process in detail in the following exercise. COPYRIGHT © JACKIE HOYSTED

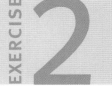

APPLYING A DIGITAL IMAGE TO A PHYSICAL SURFACE

Jackie Hoystead is an artist that routinely creates photo-based digital images in Photoshop and then integrates them with physical materials. Jackie has documented her process for us in the following exercise.

1 Gather the Materials

Jackie begins with a digital image and a wooden panel that has watercolor paper adhered to it and tape to protect the sides of the panel.

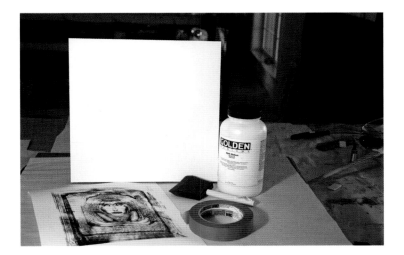

The materials.

2 Modify the Materials

She tears the sides of the digital print to help incorporate the print into the finished work. When this is complete, she glues the image to the panel and weighs down the work under heavy books overnight to ensure it is dry and that it has no air bubbles in it.

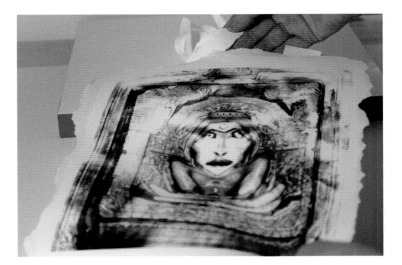

Tearing the sides of the digital print.

③ Use Encaustic Medium

Next, she covers the panel with melted encaustic medium, which is a mixture of beeswax and Damar varnish.

Covering the panel with encaustic.

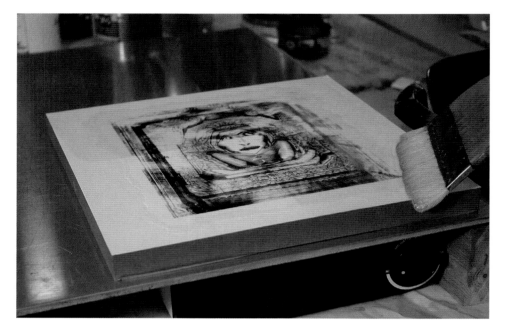

④ Apply Heat

She then fuses the encaustic medium with a heat gun so that it is absorbed into the underlying image and watercolor paper, ensuring a good bond.

Fusing the encaustic medium with a heat gun.

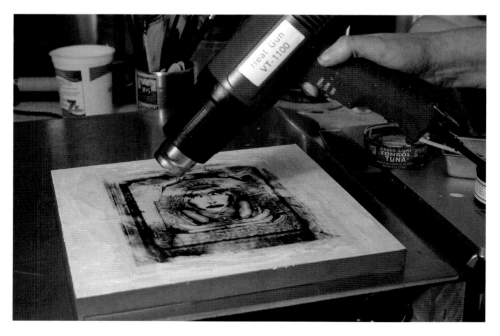

5 Apply Additional Layers of the Medium

Next, Jackie repeatedly applies layers of encaustic paint to the surface.

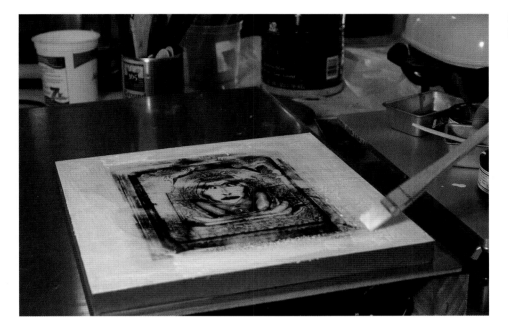

Applying more layers of encaustic paint.

6 Scrape the Medium

She then scrapes back the dried layers of encaustic paint with a variety of tools until a pleasing surface texture is created.

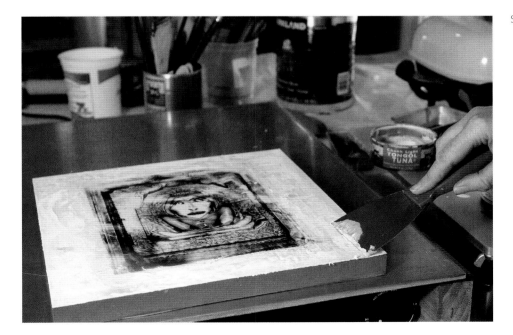

Scraping the layers back.

7 Add Color

Jackie decides to pick up some of the colors in the image: lemon yellow, zinc white, and blue. She lightly adds traces of the same colors to the image with encaustic paint.

Adding color.

The completed image.

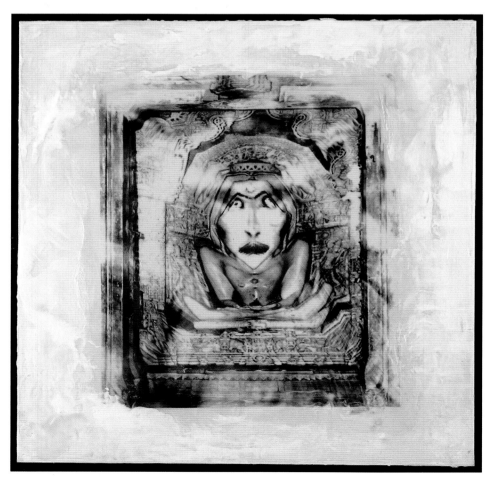

INTEGRATING A DIGITAL IMAGE INTO A THREE-DIMENSIONAL STRUCTURE

You can combine digital artwork with physical constructions and environments. Digital images that become part of sculptures or installations integrate with the physical world and invite direct experience and interaction. Marla Mclean is an artist that integrates digital images with elaborate physical structures, large and small.

In this exercise Marla will take us through the process of creating a "shrine" around a tiny digital image. Materials for the project include a digital photo printed on matte paper, a found rusted container top, a Mexican tin box, colored transparent glass, old metal game piece, and a small branch with vine.

There But for the Grace of God, Go I, 1-8 by artist Marla McLean. This sculptural work combines digital images with physical materials that include old wooden cheese drawers, mosaic, mirrors, and glass. COPYRIGHT © MARLA MCLEAN

1 Attach Photo to Container

Marla affixes a digital photo a found rusted container lid using an archival (acid-free) glue stick.

Attaching a photo to the container.

② Attach Container to Box

She then applies an epoxy adhesive to the rusted tin lid in order to attach it to the inside of the Mexican tin box.

③ Cover Print with Glass

Once the tin is adhered to the Mexican tin box, Marla encloses the digital print with colored transparent glass. She then attaches it by folding and bending the container lid over the glass.

④ Add Other Physical Elements

She then affixes a game piece to the glass using epoxy. Using a screw, a small hole is made into the tin box so that the branch and vine can be inserted. With the placement of these additional elements the work is complete.

Left: Epoxy is applied to the tin in order to attach it to the Mexican tin box.

Middle: Covering the print in glass.

Right: Making a small hole with a screw in order to attach the branch and vine.

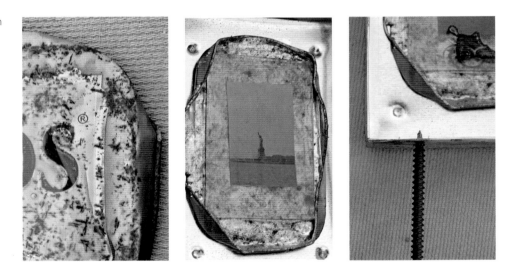

The final piece.

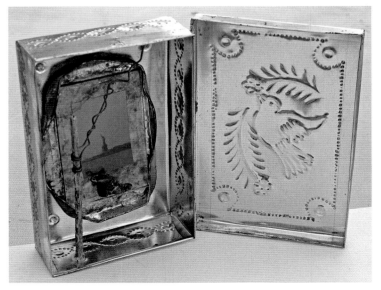

Type, Images, and Promotional Materials for the Artist

Whether postcards, posters, Web sites, flyers, business cards, résumés, or digital portfolios, digital images can interact with the physical world as promotional materials. Successful integration of typography and digital images is crucial to the creation of professional promotional materials for the artist. When used in a composition, type operates under the same principles as any other design element. Many artists don't understand this fact. They treat type as something stuck onto the composition as an afterthought. Artists that have a great understanding of composition and structure will damage their presentations by placing type randomly on top of a composition and ignoring the principles of the visual language they've worked so hard to master. Consciously integrating type as a design element will give your promotional materials a professional appearance and give you a head start over all those artists who just randomly plopped their type on top of their beloved art.

Great care should be taken to visually unify type with images and other elements in the composition through the use of related color, value, shape, line, and texture. You can get a full rundown of the type tools in Photoshop, as well as the preparation of digital portfolios and promotional material, on our companion website (See Resources on page 248).

TYPOGRAPHY AS ART

Typography is not limited to promotional materials. It can also be used as visual accents or even central themes within your work. It can be readable or obscured. It can function as a narrative or solely as a visual element. Type can be manipulated as an image with any Photoshop tool. The type tools create a separate vector layer for your words. You will have to rasterize your type before you can use many of the options available in Photoshop. Rasterizing converts the vector type into pixels. When you rasterize type you gain the ability to use features like liquify or other Photoshop filters, for instance, but you lose the ability to word process. You could rasterize a duplicate layer, leaving your original vector layer intact in case you need it later.

Suffering and Spirit: Emily Dickinson & I is an artist's book created by Kerry McAleer-Keeler. Kerry developed the type using Photoshop and then converted it to magnesium dies for use in traditional letterpress printing. COPYRIGHT © KERRY MCALEER-KEELER

PROJECT:
Hybrid Art

Create a work that is a combination of digital and physical art. Use any of the possibilities listed in this chapter, alone, or in collaboration according to your interest. To the right are some solutions that my students created incorporating physical elements into digital art.

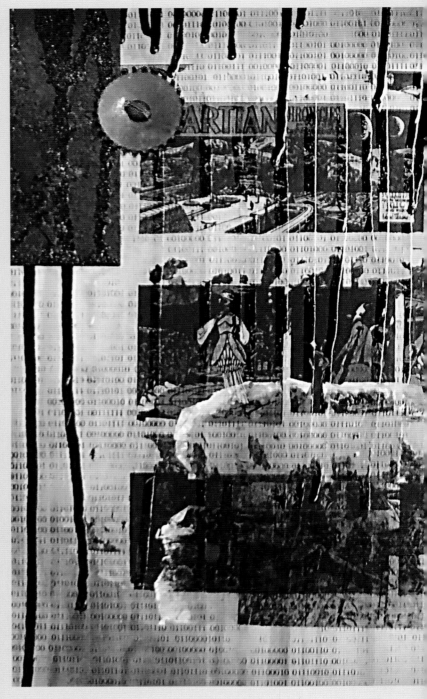

Nicole Cooke, Cleveland Institute of Art. Detail. To create this sculptural work, Nicole placed digitally manipulated imagery onto a board via gel transfer and integrated it with paint, varnish, and metal elements. COPYRIGHT © NICOLE COOKE

Jackie Mancini, University of Mary Washington. Jackie combined her digitally painted imagery with a scan of a real textbook. Elements of the textbook were moved around for compositional purposes and the color was modified to fully integrate all of the elements in the composition. COPYRIGHT © JACKIE MANCINI

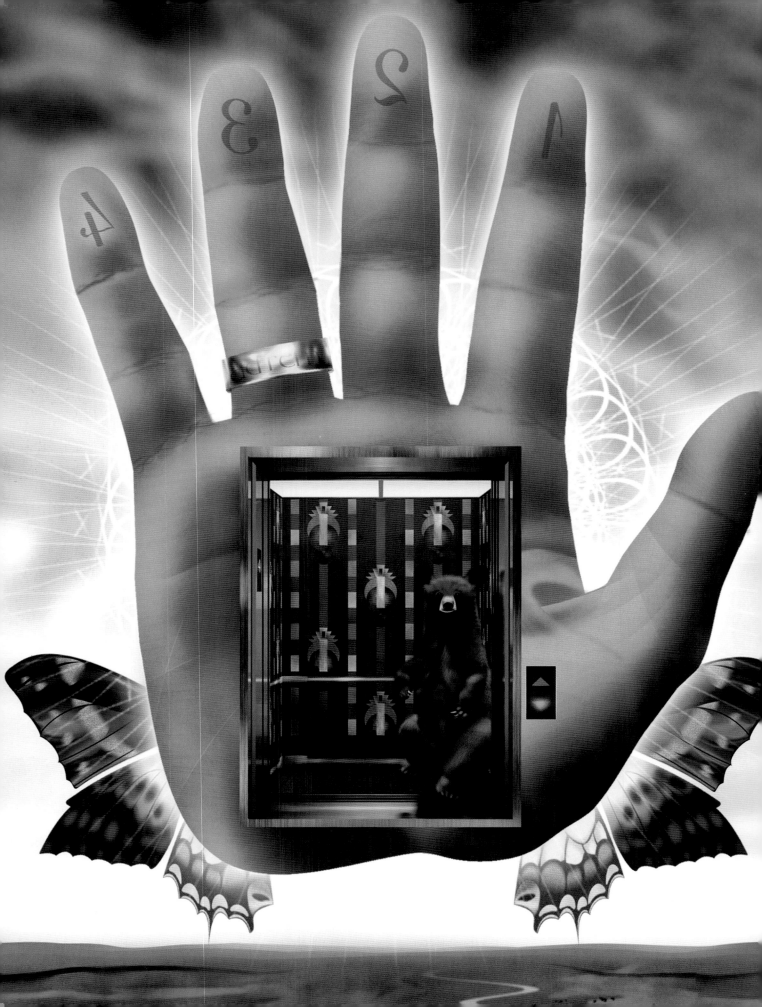

Show Us the Possibilities

I've hung out with a lot of creative people over the years, and in virtually every medium I've heard some common laments such as, "Everything has been done. The market is saturated with too many people doing the same thing. Every innovation has already been explored. The audience is jaded. The artists are jaded. The medium is thoroughly enmeshed in bureaucracy." Everywhere, it seems like people long for a forgotten golden age. "Oh, to have worked in film in the twenties. Oh, to have worked in radio in the thirties. Oh, to have worked in comic books in the forties. Oh, to have worked in television in the fifties."

We who work in digital media are extremely fortunate: our golden age is now! Even better, it's not quite here yet. We have time to get ready. Those among us who are aware of the full implications of this unprecedented creative revolution are in a unique position to get in on the ground floor and help to define the medium. The possibilities are vast and unknown. We make up the rules as we go along. The rules that work will become law; those that don't will become forgotten.

I've given you my opinions, observations, and my best ideas. I hope that I've given you enough basic information so that you can form your own opinions and make your own observations. Now give us *your* best ideas. Take advantage of this time when anything can happen. There are vast areas of possibility that have never been explored. It might as well be you who explores some of them. In the end, it all goes back to the basics. Master the elements of the visual language and use them to make us feel something. It's just a bonus that you may be able to do it in a way that's never been done before.

Resources

In addition to the various resources that were mentioned throughout the book, the following websites are great sources for additional information, guidance, and help.

DIGITAL ART REVOLUTION

The following website is for this book, which contains additional and updated information and instruction. Use it as a companion as you are reading and performing the exercises: www.digitalartrevolution.com. In addition, please visit my personal website, which I share with my wife, painter Laura Sherrill Ligon: www.ligon-art.com.

PHOTOSHOP SOURCES

The following websites contain helpful information, training, tips, shortcuts, and tricks to help Photoshop users of all levels:

- ◆ **WWW.ADOBE.COM**
- ◆ **WWW.PHOTOSHOP.COM**
- ◆ **WWW.PHOTOSHOP.COM/EXPRESS**
- ◆ **WWW.LYNDA.COM**
- ◆ **WWW.CREATIVEPRO.COM**
- ◆ **WWW.PHOTOSHOPWORLD.COM**
- ◆ **WWW.PLANETPHOTOSHOP.COM**
- ◆ **WWW.PHOTOSHOPCAFE.COM**
- ◆ **WWW.PHOTOSHOPESSENTIALS.COM**
- ◆ **WWW.PHOTOSHOPUSERTV.COM**

ORGANIZATIONS

The following websites are of great organizations and museums that serve, promote, and support many various forms of digital art:

- ◆ **WWW.SIGGRAPH.ORG** An organization that promotes the generation and dissemination of information on computer graphics and interactive techniques.
- ◆ **RHIZOME.ORG** An organization dedicated to the creation, presentation, preservation, and critique of emerging artistic practices that engage technology. They are located in the New Museum of Contemporary Art in New York City.
- ◆ **EYEBEAM.ORG** A non-profit art and technology center located in New York City that is dedicated to exposing broad and diverse audiences to new technologies and media arts, while simultaneously establishing and demonstrating new media as a significant genre of cultural production.
- ◆ **WWW.NMC.ORG** An international non-profit consortium of nearly 300 learning-focused organizations dedicated to the exploration and use of new media and new technologies.
- ◆ **WWW.PHOTOSHOPUSER.COM** The National Association of Photoshop Professionals (NAPP), publishes *Photoshop User* magazine, a great magazine dedicated to Photoshop.
- ◆ **WWW.LACDA.COM** The official website for the Los Angeles Center for Digital Art.

- ◆ **WWW.AMODA.ORG** The official website for the Austin Museum of Digital Art.
- ◆ **WWW.MOCA.VIRTUAL.MUSEUM** The official website for the Museum of Computer Art.

INFORMATION, NEWS, AND MAGAZINES

The following news and popular magazine websites contain valuable information on digital art and Photoshop:

- ◆ **WWW.DIGITALARTSOURCE.COM** Contains information on digital art and culture.
- ◆ **PHOTOSHOPNEWS.COM** Contains news and information about Photoshop.
- ◆ **PHOTOSHOPDISASTERS.BLOGSPOT.COM** A humorous blog full of examples from the media of what not to do with Photoshop.
- ◆ **WWW.COMPUTERARTS.CO.UK** The official website for *Computer Arts* magazine.
- ◆ **WWW.DIGITALARTSONLINE.CO.UK** The official website for *Digital Arts* magazine.
- ◆ **WWW.LAYERSMAGAZINE.COM** The official website for *Layers* magazine.
- ◆ **WWW.ADVANCEDPHOTOSHOP.CO.UK** The official website for *Advanced Photoshop* magazine.
- ◆ **WWW.PSDMAG.ORG** The official website for *.PSD Photoshop* magazine.

DIGITAL COLOR

The following websites contains information on digital color:

- ◆ **WWW.COLOURLOVERS.COM** Monitors and influences the latest color trends.
- ◆ **KULER.ADOBE.COM** Adobe's online community for color.

PRINTING AND ARCHIVAL SUPPLIES

The following websites will help you with your printing needs:

- ◆ **WWW.DPANDI.COM** Contains digital printing and imaging information.
- ◆ **WWW.DIGITALARTSUPPLIES.COM** Contains sources for archival supplies.

COPYRIGHT AND FAIR USE

Be sure to visit **www.copyright.gov** for guidance, information, and direction concerning copyright and fair use.

Contributing Artists

GEOFF AULT studied art at Western High School in Georgetown under Leon Berkowitz, a well-known Washington Color Field School artist and teacher. Later, he attended classes at the Corcoran School of Art, where he studied photography with Mark Power, and at George Washington University, where he learned printmaking under Fuller Griffith. Geoff is currently serving as chairman of the Capitol Hill Art League Steering Committee. www.apres-image.com

GIOVANNI AURIEMMA has a degree certificate in scenography from the Academy of Fine Arts. He has won several digital art competitions in Italy. He has shown several personal and collective exhibitions of computer art in Italy such as Vi Biennale d'Arte Postumia Giovani—Era Digitale at the MAM (Museo d'Arte Moderna e Contemporanea) Gazoldo degli Ippoliti in Mantua, Italy. www.giovanniauriemma.it

MAX CHANDLER studied math at Massachusetts Institute of Technology and attended graduate art school in Taiwan. He was an intern for several years to internationally known artist Chen Ting-shih. Working in both hardware and software, his software projects include Visicorp products and *Sim City*. His artwork has been shown nationally and internationally. www.maxchandler.com

SUSAN CHAPMAN was the cofounder and first president of the Digital Fine Art Society of New Mexico. She has exhibited in solo and group shows in New Mexico and New York. Her work is included in the Common Ground 2008 International Touring Exhibit, a juried digital fine-art exhibition from 2008 to 2010. www.azuregallery.com

MEGAN EHRHART is currently a professor of animation in the T.I.M.E. Digital Arts department at Cleveland Institute of Art. She holds an MFA in film (Syracuse University) and a BFA in illustration (Maryland Institute, College of Art). Her animated films and sculptural works are exhibited in galleries, film festivals, and art museums in the United States as well as internationally. www.tuscarstudiofilms.com

HOWARD GANZ founded the art department at MiraCosta College in 1965, establishing programs in sculpture and computer art. In the 1980s, Ganz lectured and exhibited in many academic venues, where he showed and discussed how computers can be programmed to create organic forms. He is represented in the Long Beach Museum's permanent collection and wrote one of the first drawing and painting programs for artists, published by Apple Computers. www.ganzartwork.com

MILVI GILL graduated with a BA degree in art history from the University of Maryland, European Division. For the past sixteen years she has been involved in the Fredericksburg, Virginia, art community. She has won numerous awards. Her current work includes digital photography, digital art, mixed media, and painting.

SUSAN GREENSPAN is an instructor at the Cleveland Institute of Art. Her work has been exhibited nationally and internationally. She recently participated in a two-person show at the Nova Gallery in Chicago. Her project, "My Rock is a Purse," will appear in the Spring issue of *Cabinet Magazine*. www.susangreenspan.com

SALLY GRIZZELL LARSON Sally's photographic work has been published in, among others, *Photography Reborn* (Abrams Press, 2005); *Writing the World: On Globalization* (M.I.T. Press, 2005); and *Rethinking Marxism: A Journal of Economics, Culture, and Society*. Her work has been exhibited at numerous venues. Film festivals and presentations include Rencontres Internationales, Paris, Berlin, and Madrid; Anthology Film Archives; Rio de Janeiro Festival of Electronic Media; the Image Forum Festival of Experimental Film and Video in Tokyo; and the National Museum of Women in the Arts in Washington, D.C.

RIC GROSSMAN is a contemporary fine artist. He works in a wide spectrum of traditional mediums. His passion for original ideas has inspired him to diversify into digital art. Ric's work has been exhibited and sold through museums, galleries, brokers, and art shows. www.ricfinearts.com

MATTHEW HAMON is a member of the Expressive Arts faculty at Evergreen State College. Matt has a background in visual art and continues to be a practicing artist and art instructor. Before arriving at Evergreen, Matt taught courses in aesthetics and visual display of information for students working in engineering and science. www.matthamon.com

KEN HOPSON is the Manager of the Media Department at the Virginia Commonwealth University libraries. His areas of expertise include multimedia software and hardware. He teaches courses, tutors individually, and consults on digital media conversion and delivery. His award-winning photography and artwork are a familiar presence in the Richmond area. www.people.vcu.edu/~kwhopson

BEN HOWSON is a printmaker, photographer, and mixed-media artist. He received a BFA from Virginia Commonwealth University and an MFA in printmaking and painting from Winthrop University. Ben's work ranges from traditional printmaking and photography to digital work, incorporating hand-painted details and sewn embellishments.

DONNA LOGRASSO HOWSON received a BFA from Moore College of Art and Design and an MFA from the Tyler School of Art at Temple University. Her work has been included in exhibitions throughout the United States as well as in Rome, Italy. She currently lives outside Atlanta.

JACKIE HOYSTED has a degree in computer science from Trinity College, Dublin, Ireland, and also a degree in fine arts from the Corcoran College of Art & Design, Washington, D.C. Her work has been selected for national and international juried shows and has been awarded multiple solo shows throughout the mid-Atlantic region. www.JackieHoysted.com

JD JARVIS received an MFA in video and mixed media. His artistic output migrated to digital painting and printmaking in 1994. He began writing and lecturing about topics related to digital fine art shortly thereafter. In 2001, he was awarded the Grand Prize in the international Toray Industries annual Digital Creative Awards. He is a contributing editor for both the Museum of Computer Art and DP&I. In 2005 he coauthored the book *Going Digital: The Practice and Vision of Digital Artists*. www.dunkingbirdproductions.com

CINDY JERRELL is a fine artist living in Georgia. She graduated from the University of Georgia with a BA in photographic design. She has continually experimented with the combination of photography and paint, and won a Georgia Council for the Arts Individual Artist Grant for mixed-media work twice.

JON JOST began making films in January of 1963. Since 1996, he has worked primarily in digital video (DV). The Museum of Modern Art, New York, screened a complete retrospective of his work. Jost has been recipient of numerous grants and awards including the Los Angeles Critics award for Best Independent Film 1992. In March 1991, Jost was honored with the IFP/West's first John Cassavetes Lifetime Achievement Award for independent filmmaking. Mr. Jost is presently a professor at the Graduate School of Communications and Arts, Yonsei University, Seoul, South Korea. www.jon-jost.com

KASUMI is recognized as one the leading innovators of a new art form synthesizing sound, film, and live video manipulation. She has won acclaim for her work in performances, and venues with collaborators worldwide from the Lincoln Center with the New York Philharmonic to Carnegie Hall with the American Composers Orchestra. Kasumi is a former lecturer at the Tokyo College of Music, and is currently an associate professor at the Cleveland Institute of Art. www.kasumifilms.com

KAETHE KAUFFMAN received an MFA in studio fine arts from the University of California, Irvine, having previously studied at the University of London; the University of Belgrade; the Instituto de Bellas Artes, Spain; and the Instituto Allende at the Universidad de Guanajuato, Mexico. Her paintings, drawings, and murals are in many private and corporate collections, and have been exhibited around the world. She is an associate professor at Chaminade University in Honolulu. www.kaethekauffman.com

DAVIDA KIDD is a photo-based artist who resides in Burnaby, British Columbia. She received an MVA from the University of Alberta, and since 1996 has been teaching print media at the Visual Arts Department of the University of the Fraser Valley. Davida has exhibited internationally and nationally, receiving several awards, scholarships, and grants for her work. www.davidakidd.com

A-YOUNG KIM is an artist and fashion design major at the Sungshin Women's University in Seoul, Korea.

VIKTOR KOEN holds a BFA from the Bezalel Academy of Arts and Design in Jerusalem, Israel, and an MFA with honors from the School of Visual Arts. Mr. Koen serves on the faculty of Parsons School of Design and the MFA program at the School of Visual Arts. His images are regularly published in *The New York Times, Time, Newsweek,* and *Esquire*. His award-winning prints are exhibited in galleries and museums in the United States, Europe, Japan, and Australia. www.viktorkoen.com

SEAN KRAFT is currently working in the game industry as a modeler and technical artist. He is a recent graduate of Cogswell Polytechnical College in Sunnyvale, California. www.kraftarts.com

QIAN LI has been recognized for her unique style and diverse techniques as the winner of the Ohio Art Council 2008 Individual Excellence Award. She was educated at the Central Academy of Fine Arts in Beijing. She earned an MFA in 2003 from the University of Massachusetts Dartmouth, where she embraced digital processes. Qian has exhibited frequently in the United States, Europe, and Asia. She has taught courses in new media art and design at Cleveland State University's Art Department since 2003. www.qiandesign.com

MYRIAM LOZADA-JARVIS was born in New York City and graduated with art degrees from the School of Visual Arts and Hunter College. Her interest in all things new in art lead her to adopting a computer to create her energetic compositions, which she and her husband use to produce fine-art prints on paper and canvas. www.dunkingbirdproductions.com

JESSICA MALONEY received both a BFA in photography and an MFA in digital art from Bowling Green State University. Currently, she is an assistant professor of digital art at Ashland University in Ohio. She studied in Florence, Italy, with Studio Art Centers International (SACI). In 2001, Jessica was invited to speak about her artwork on a panel at the annual Siggraph Computer Art and Technology Conference. www.jessicamaloney.com

KERRY McALEER-KEELER Kerry's work appears in the collections at the National Museum of Women in the Arts, the Corcoran College of Art and Design Library, Corcoran Gallery of Art, George Washington University, Saint Mary's College, and the Southern Graphics Council Archives. Her work has been selected for individual, group, and juried exhibitions throughout the United States. She currently teaches at Corcoran College of Art and Design and is the program coordinator for the Masters of Art and Book Program.

MARLA McLEAN is an artist living and working in the Washington, D.C. metropolitan area. She completed her masters in studio art from New York University and studied in New York City and Venice, Italy. Marla teaches art at Peabody, a Washington, D.C. public school, and at the Corcoran College of Art and Design. Her work is frequently exhibited, recently including a group show at Exit Art in New York City. www.marlamclean.com

MILAD MEAMARIAN received a BFA from George Mason University. His work has been featured at several shows and museums in the Washington, D.C. area. He is now pursuing a graduate degree as a doctor of naturopathy. miladmeamarian.blogspot.com

MARK MOTHERSBAUGH With DEVO, his most successful music project, Mark was able to showcase his artistic abilities on a larger scale, and to millions of people. During his downtime on early worldwide tours with DEVO, he began illustrating postcards to send to his friends, which he still creates. Mark decided to share his postcard works in his critically acclaimed solo shows during the 1980s and 90s, and then with his gallery tour in 2003, entitled "Homefront Invasion!" Since 2005 Mark's gallery tours have featured new works from both his "Postcard Diaries Prints" and *Beautiful Mutants* photographs. www.mutatovisual.com

JACK PABIS started drawing and calling himself an artist when he was a very small boy. He attended The Art Institute of Philadelphia and Maryland Institute College of Art, but considers himself mostly self-taught. www.jackpabis.com

STEVE PARKE is an award-winning artist, illustrator, and photographer. Steve was the digital artist for the first-of-its kind graphic novel *I, Paparazzi*. He followed with *In the Shadow of Edgar Allan Poe,* the first ever all-digitally photographed graphic novel. Steve is an industry pioneer and advocate in the sequential photography technique. flickr.com/photos/imagecarnival

STEPHEN JOHN PHILLIPS is a professor of photography at The Art Institute of Philadelphia. His work has been shown in numerous international shows, including exhibitions at the Museum of Modern Art of the City of Paris, the Museum of American Illustration, and the National Museum of American Art, where his work is in the permanent collection. www.stephenjohnphillips.com

GABRIEL PONS Although a formal education in architecture was the starting point for his pursuits in painting, Gabriel's inspirations are rooted in science fiction and fantasy literature. Pons works in a variety of media, including collage, digital illustration, and skateboard graphics. Since 2005, he and his wife, Scarlett Suhy-Pons, have been working and educating out of their studio, PONSHOP, in Fredericksburg, Virginia. www.ponshopstudio.com

JOSHUA ROWAN is a digital artist and graphic designer from Illinois. Josh likes to tiptoe through abandoned buildings and collects interesting trash from parking lots. He also enjoys traveling, photography, and making music. His work has been exhibited at the Los Angeles Center for Digital Art and many other venues. www.joshuarowan.com

TAVET RUBEL lives and works in Brooklyn, New York. His animations and music videos have appeared on MTV, RESFest, *Stash Magazine,* and in several documentary films. www.tavetrubel.com

MECHELLE SCHLOSS is a visual artist and musician currently living in the Washington, D.C. metro area. Her main areas of interest include working with oil, photography, and digital media. www.mechelleschlossfineart.com

DAVID SPATZ is an artist living in New York with his wife and two daughters. He earned an MFA in painting from the New York Academy of Art. David also worked for many years as a Photoshop retouching and imaging specialist for a major news magazine.

JOHN SPOFFORD is an artist living in the Cleveland, Ohio, area. He attends the Cleveland Institute of the Arts. He has created design and illustration for many national and international clients. www.johnspofford.com

JENN VERRIER is an artist who works and lives in Washington, D.C. She primarily works in digital photography and also enjoys using the computer as a tool for digital construction. She has shown her work in several group shows in the D.C. area, including galleries at MOCA and the Capital Hill Arts Workshop. She is a graduate of the Corcoran College of Art and Design with a BFA in fine-art photography.

STEVEN VOTE is an award-winning Australian photographer who divides his time between New York and western Massachusetts. His work has been featured in *American Photo, Popular Photography,* and *Applied Arts.* His work was singled out by Graphis Photo Annual for exceptional imagery. www.stevenvote.com

SEAN WELKER is an artist living and working in Washington, D.C. His visual language is inspired by street art, comic books, Internet culture, urban life, and pop esoterica. Sean is currently working on new ways to bring the digital toolbox to more traditional forms of art. www.secretworm.com

BRADLEY WESTER lives and works in New York City. His work has been featured in numerous solo and group exhibitions across the United States, as well as part of prestigious museum, corporate, and private collections including those of Edward Albee and Ross Bleckner. He has been published twice in New American Paintings. Bradley has designed sets for theater and television. His work was seen in a recent Ben Stiller film. www.bradleywester.com

Add to Selection tool, 68, 69, 165
Adjustment Layer, 60, 70–71, 73, 95, 127
Adjustments Panel, 56, 59, 60, 64, 69, 70–71, 73, 92, 124, 174
Adobe Bridge, 51
Adobe Illustrator, 177
Airbrush, 143, 170
Amount slider, 72
Application Bar, 46, 47
Atmospheric perspective, 33, 66, 103–104, 158
"Auto" adjustments, 56
Background
 creating new, 205
 de-emphasizing, 72–73
 foreground vs. style and, 216
 layers, 87, 94, 128, 129, 152, 182
Background Eraser tool, 98, 108
Bitmap, 44
Black & White Panel, 64
Black-and-white photo, creating from color, 63–64
Bloat tool, 122, 123, 125
Blurring
 background, 74
 Blur tool for, 91, 108, 158
 Feather tool for, 69
 refining edges by, 69, 108
Brightness/Contrast Panel, 73, 124, 125
Brushes Panel, 144
Brush tool(s), 78. See also Color Picker
 about, 78
 adjusting layer mask with, 92
 airbrush option, 143, 170
 control panel features, 142–145
 drawing tablet and, 150
 Faux Finish Brushes, 142, 199
 Healing Brush tool, 80, 125
 Master Diameter slider, 78, 142
 modifying, refining images, 204, 205
 painting with, 146, 150, 153.
 Paths Mode and, 178
 Plastic Wrap Brush, 199
 in Quick Mask Mode, 75–76
 retouching with, 96, 100
 for shadows, 101, 102, 106–107
 Spot Healing Brush tool, 79
Burn tool, 61, 62, 98, 101–102, 107, 125
 See also Dodge tool
Camera RAW files, 43
Channel Mixer Palette, 64
Chroma, 31
Clone Stamp tool, 79, 96, 125, 232
CMYK format, 44
Color. See also Adjustments Panel
 adjusting, 60–61, 92–93, 147
 "auto" adjustments, 56
 changing, 148
 Channel Mixer Palette, 64
 chroma, 31
 complementary, 31
 converting into black and white, 63–64
 de-emphasizing background, 72–73
 desaturating, 61, 63, 73
 enhancing value and, 56–62, 65, 70–71
 mixing, 146–148
 organizing, with Swatches Panel, 147
 in paintings. See Painting references
 palette, style and, 214
 primary, 31
 saturating, 61
 secondary, 31
 Swatches Panel, 146, 147, 152–154
 tertiary, 31
 warm and cool, 31
Color Balance Panel, 60–61
Color Field, 146
Color modes, 44
Color Picker, 78, 127, 146, 166

Color Replacement tool, 124, 148
Color sliders, 64, 78, 146, 147
Complementary colors, 31
Composite images
 adding light and shadow, 101–103
 adjusting color and value, 92–93
 changing layer order, 94
 changing light source, 98–100
 constructing figure from multiple sources, 97
 creating new file for, 87
 creating shadows, 98, 101–103, 106–107
 dragging new elements into, 87–89
 layer mask for, 92
 linking and grouping layers, 104
 making new (blank) layer, 100
 making rough composition, 100–101
 merging layers, 105
 placing figure into, 91
 refining edges, 108
 replacing sky, 98
 resizing individual objects, 90
 retouching elements, 96
 Revealing multiple layers, 97–98
 rotating individual objects, 96
 Smart Objects in, 91, 95, 100
 using atmospheric perspective, 103–104
 using Layer Styles, 95
Composition
 about, 25
 importance of clarity in, 134
 symmetrical and asymmetrical, 25
Contrast. See also Color; Value
 Brightness/Contrast Panel, 73, 124, 125
 clarity and, 134
 creating focal points with, 30
 sharpening figure and, 72
 types of, 134
Control Panel (Options Bar), 47
Create Plane tool, 110
Cropping images, selection mask for, 66–67
Crop tool, 55
Desaturating images, 61, 63, 73
Distorting images, 106–107, 112, 114, 117, 121–123, 131, 132, 135–137, 232–233, 234
Document window, 46
Dodge tool, 61, 62, 101. See also Burn tool
Drawing tablet and pen (stylus), 51, 149–150
EPS (.eps) files, 43
Eraser Tool, 91, 97–98, 107, 153, 194, 204
Expressive nonrealistic photo art, 117–139
 about: overview of, 117–118
 adding figures, 129–130
 adding texture, 130–132
 copying layer, 125
 creating background, 126–127
 creating new document, 121
 deciding on color themes, 123–124
 distorting images, 121–123, 132
 finishing touches, 133
 Liquify to enhance distortion, 122–123
 using layer blending modes, 127–128
Eyedropper tools, 69, 124, 129–130, 154, 198
Faux Finish Brushes, 142, 199
Feather tool, 69
File formats, 41–43
Files, creating, 87
Fill pixels mode, 178
Filters
 about, 201
 accessing Filter Gallery, 203
 integrating into digital art, 202–205
 modifying filtered image, 204
 Sketch Filters, 174–176
 with specialty applications, 206
 Stamp Filter, 175–176
Flow, of paint, 143, 154
Focal point, 28, 30

Forward Warp tool, 82, 122–123, 133, 199, 232
Found textures, 191
Framing work, 226
Freeze Mask tool, 122
Fuzziness slider, 69, 124
GIF (.gif) files, 43
Gradient, 163–167, 169, 187
Grayscale mode, 44, 230
Hand tool, 50
Healing Brush tool, 80, 125
History Brush tool, 49
History Panel, 49
Implied shapes, 28
Ink-jet printing, 224
Intersect with Selection tool, 68
Large format printing, 224–225
Lasso tools, 67–68, 91, 100, 165
Layer masks, 70, 92, 186
Layers. See also Composite image
 Adjustment Layer, 60, 70–71, 73, 95, 127
 background, 87, 94, 128, 129, 152, 182
 blending modes, 127–128
 changing order of, 94
 copying, 125
 creating new, 100, 155, 164, 172, 180, 182, 202, 204, 233
 linking and grouping, 104
 merging, 105, 172
 in paintings. See Painting references
 revealing multiple, 97–98
Layers Panel overview, 60
Layer Styles, 95, 185
Lighting Effects Panel, 99–100
Light source, changing, 98–100
Line, 26
Liquify, 82, 103, 122–123, 158, 199, 232
Magic Eraser tool, 98, 107
Magic Wand tool, 75, 165, 173, 204, 205
Magnetic Lasso tool, 67
Masks. See Selection masks
Masks Panel, 69, 92, 100, 186
Master Diameter slider, 78, 142
Menu Bar, 47
Merging layers, 105
Mirror tool, 122
Move tool, 50
Navigator Panel, 50
Negative space, 27
New Selection tool, 68
Nonrealistic photo art. See Expressive nonrealistic photo art
Opacity, 75, 76, 95, 107, 130–132, 143, 150, 153
Opening documents, 40
Options Bar (Control Panel), 47
Orienting images, 41
Outlining figures, 204
Paint Bucket tool, 152
Painting, with physical paint, 20
Painting (with pixels), 141–159. See also Color; Painting (with transparency)
 brush features, 142–145. See also Brush tool(s)
 drawing tablet, pen (stylus) and, 51
 mixing colors, 146–148
 project assignment, 159
 standard, round, non-blurry brush, 144–145
Painting (with shapes), 161–187. See also Vector paths
 about: overview of, 161–162
 adding strokes (outlining sections), 165, 167
 Adobe Illustrator and, 177
 airbrush shading, 170
 applying second stroke, 173
 colorizing figure, 171
 complex geometric shape, 165
 creating figure with selection masks/fills, 169
 creating figure with Stamp Filter and Pattern Stamp tool, 175–176
 drawing/painting patterns, 168

DIGITAL ART REVOLUTION

experimenting, 172
gradient and, 163–167, 169
making simple gradient, 163–164
merging layers, 172
multicolor gradient, 166–167
pixel-based solution, 163–173
scribbling and, 168–169
with Sketch Filters, 174–176
with Stamp Filter and Pattern Stamp tool, 175–176
types of shapes and, 27–28
Painting (with transparency), 151–158
adding highlights, 155
adding new layers, 152, 155, 156–157
applying colors, 157
benefits of, 151
blending, 157–158
creating new document, 152
initial color layers, 156–157
initial sketch, 152–153
shading, 154, 155–156
underpainting, 151, 153–154, 157, 159
Panels, 48
Paper types, 225
Patch tool, 81
Paths Mode, 178
Pattern
drawing, 168
halftone, 174, 194
painting, 168, 176
style and, 216
texture and, 34, 130–131, 216
Pattern Stamp tool, 175–176
PDF (.pdf) files, 43
Pencil Tool, 200
Perspective
atmospheric, 33, 66, 103–104, 158
EDIT > TRANSFORM command, 112, 114
guides, 109
other methods for creating, 112–114
vanishing point and, 33, 109–111
Photo basics. See also Retouching photos; Selection masks
about: overview of, 53–54
converting color to black and white, 63–64
enhancing value and color, 56–62, 65, 70–71.
See also Color; Value
improving composition, 55
Magic Wand and Quick Selection tools, 75–76
Photoshop
Adobe Bridge and, 51
color modes, 44
drawing tablet, pen (stylus) and, 51
file formats, 41–43
installing, 38
opening documents, 40
orienting images, 41
overview of, 37–38
resolution definitions and, 40
resources, 248–249
saving work, 41–43
Photoshop layout, 45–50. See also specific tools
and commands
about: overview of, 45
Application Bar, 46, 47
Control Panel (Options Bar), 47
document window, 46
getting closer look (zooming), 50
History Panel, 49
Menu Bar, 47
Navigator Panel, 50
Panels, 48
Tools Panel, 47, 49
Pixel vs vector, 39
Plastic Wrap Brush, 199
PNG (.png) files, 43
Polygonal Lasso tool, 67, 68, 100, 165
Positive space, 27
PPI (pixels per inch), 40

Primary colors, 31
Printed work
about: overview of, 223
framing, 226
improving permanence of, 225
ink-jet printing, 224
large format printing, 224–225
Projecting artwork, 223, 227–228
Promotional materials, 243
.psd files, 41–43
Pucker tool, 122
Push Left tool, 122
Quick Mask Mode, 75–76
Quick Selection tool, 75
Radius slider, 72, 74, 103
Rasterizing vector layers, 186
RAW format files, 43
Reconstruct tool, 82, 122
Red Eye tool, 77
Refine Edge Panel, 69
Refining edges, 69, 108, 165
Resizing individual objects, 90
Resolution, 40
Retouching photos, 77–83. See also Color; Value
Brush tool, 78. See also Brush tool(s)
Clone Stamp tool, 79, 96, 125, 232
Healing Brush tool, 80, 125
individual objects, 96
Liquify for, 82, 103, 122–123, 158, 199, 232
Patch tool, 81
Red Eye tool, 77
Spot Healing Brush tool, 79
Rotate View tool, 47, 50
Rotating images, 41, 47, 50, 89, 91, 96, 111, 112, 126
Saturation slider, 60
Saving work, 41–43
Screen Mode, 46
Secondary colors, 31
Selecting images, 110
Selection masks
blurring background, 74
in composite image. See Composite images
converting vector paths into, 186
creating figure with fills and, 169
cropping images with, 66–67
de-emphasizing background, 72–73
enhancing value and color, 70–71
features of, 65
improving, 68–69
masking figure, 67–68
in Quick Mask Mode, 75–76
sharpening figure, 72
Selection tools, 68–69
Shadows
adjusting value and, 59, 92–93
changing light source and, 98–100
creating, 98, 101–103, 106–107, 115, 129–130
Shape layers mode, 178, 183
Shapes, types of, defined, 27–28.
See also Painting (with shapes)
Shape tools, 182–184
Sharpening figure, 72
Sketch Filters, 174–176
Sky, replacing, 98
Smart Objects, 91, 95, 100, 129, 206
Space, 32–33
Sponge tool, 61
Spot Healing Brush tool, 79
Stamp Filter, 175–176
Style
"accidental" trendsetters and, 212
color palette and, 214
consistency within composition and, 215
finding your own voice, 209–221
foreground vs background and, 216
general mood and, 213
line quality and, 213

questions to ask yourself about, 217
reacting to outside world, 212
stylistic choices and, 213
subject vs, 213–217
texture, pattern and, 216
Subtract from Selection tool, 68, 69, 165
Swatches Panel, 146, 147, 152–154
Tabloid size prints, 224
Tertiary colors, 31
Texture(s)
adding, 130–131
filters, 206
found, 191
pattern and, 34, 130–131, 216
style and, 216
Thaw Mask tool, 122
3D Art, 28, 241–242
Threshold slider, 72
TIFF (.tif) files, 43
Tools Panel. See also specific tools
about, 49
Application Bar and, 47
Transform tool, 111
Turbulence tool, 122
Twirl Clockwise tool, 122, 199
2D Objects, 28
Typography as art, 243
Underpainting, 151, 153–154, 157, 159, 194, 199, 234
Undoing actions, 16, 49, 82, 92, 122, 148, 153
Value
adjusting, 59–60, 92–93
contrast and, 30
de-emphasizing background, 72–73
defined, 29
effects of, 29–30
enhancing color and, 56–62, 65, 70–71
focal points and, 30
Value sliders, 59
Vanishing point, 33, 109–111
Vanishing Point environment, 109–111
Vector layers, 39, 178, 184, 186, 243
Vector masks, 186
Vector modes, 178
Vector paths
adding stroke with Layer Styles, 185
converting into selection masks, 186
creating new layer, 180
creating with Shape tools, 182–184
defining background, 182
drawing with pen tools, 179–180, 181
filling, 180
functions of, 178
improving path selections, 181
mode, 178
saving, 180
Vector tools, 178
Vector vs pixel, 39
Vibrance Panel, 71
View menu, 47
Visual language, 23–35
about: overview of, 23–24
composition and, 25
contrast and, 30
design principles and, 23–24
line and, 26
pattern and, 34
shapes and, 27–28
space and, 32–33
synergy and, 35
texture and, 34, 130–131
value and, 29–30
Volume, 28
Workplace Switcher, 48
Zoom tool, 50